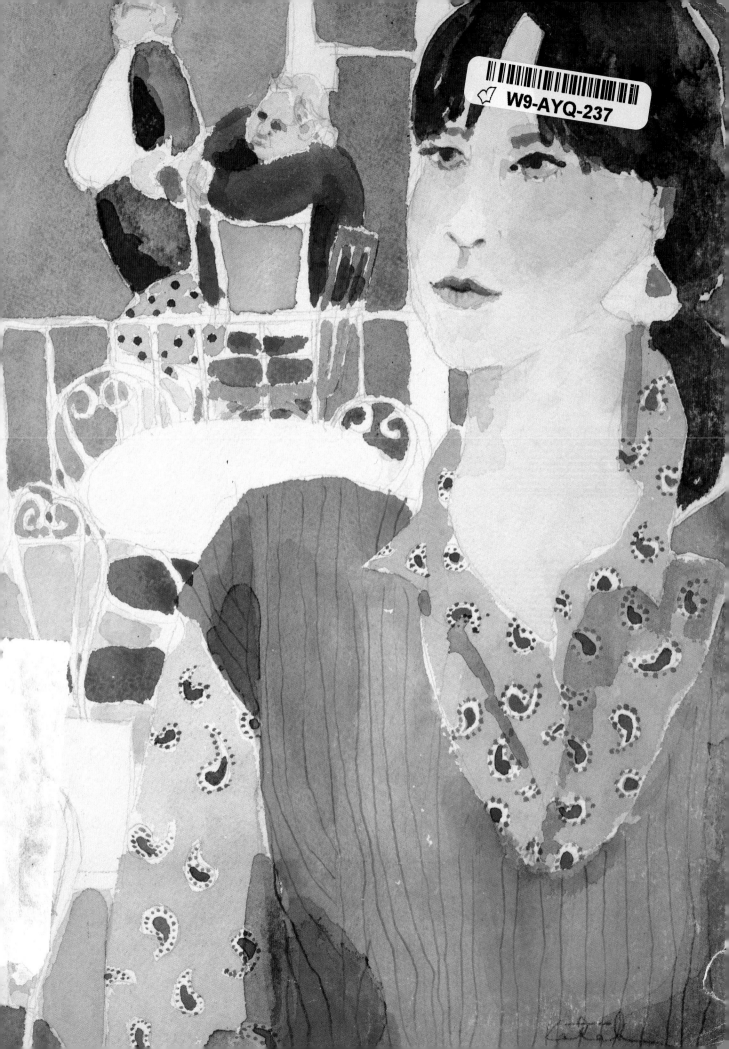

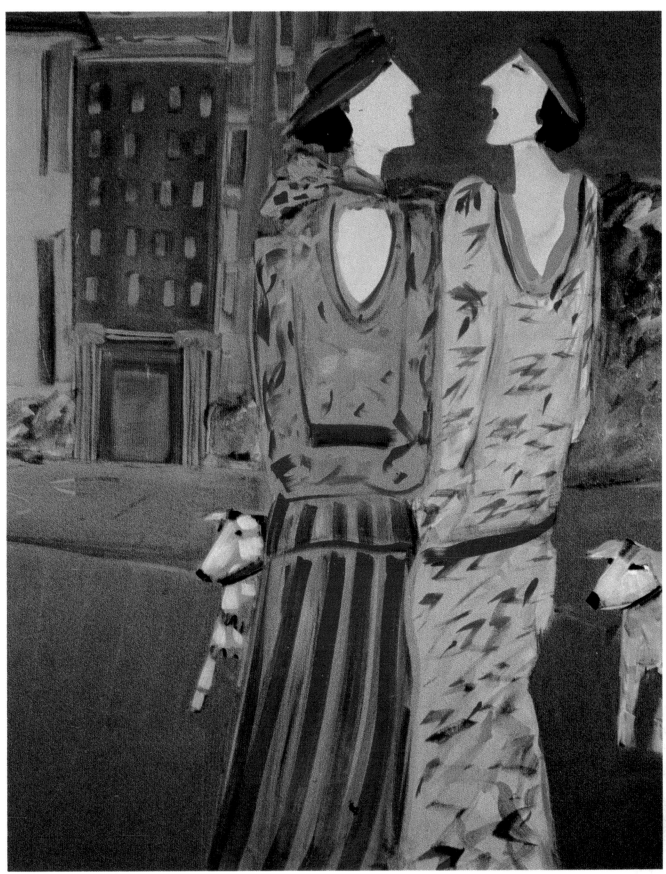

■ **PUTTIN' ON THE DOG,** by Patti Cramer
48" × 40" (122 × 102 cm)
Acrylic on canvas
Collection of Auer's Women's Shop, Denver

PAINTING FACES AND FIGURES

CAROLE KATCHEN

Patti Cramer
Deborah Curtiss
Deborah Deichler
Joseph Jeffers Dodge
Edwin Friedman
Lucy Glick
Stephen Gjertson
Pauline Howard
Bill James

Carole Katchen
Milt Kobayashi
Linda Obermoeller
Alex Powers
Constance Flavell Pratt
Scott Prior
Wade Reynolds
Will Wilson
Stephen Scott Young

WATSON-GUPTILL PUBLICATIONS / NEW YORK

Frontispiece
■ **SHAWN IN LITTLE ITALY,** by Carole Katchen
12" × 9" (30 × 23 cm)
Watercolor on paper

Carole Katchen has been a professional writer and artist for more than twenty-five years. In addition to writing 12 books, she has written numerous articles for major art and general interest magazines in the United States and abroad. Her paintings have been exhibited in galleries and museums in North and South America.

Katchen lives in Los Angeles where she is Director of Public Relations for Hurrah! Productions and writes and produces feature films. Her art is represented by Saks Galleries, Denver, and Hensley's Gallery of the Southwest, Taos.

First published in 1986 by Watson-Guptill Publications, a division of BPI Communications, Inc., 1515 Broadway, New York, N.Y. 10036

Library of Congress Cataloging-in-Publication Data
Katchen, Carole, 1944–
 Painting faces and figures.
 Includes index.
 1. Human figure in art. 2. Face in art.
3. Painting—Technique. I. Title.
ND1290.K38 1986 751.4 86-11136
ISBN 0-8230-3621-9 (pbk.)

Printed in Malaysia

Paperback Edition
First Printing 1993

1 2 3 4 5 6 7 / 99 98 97 96 95 94 93

This book is dedicated to Sam Katchen, my father, who had never even set foot in an art gallery or museum until one of his daughters became an artist. Thanks, Dad, for your tremendous support and encouragement.

A special thanks to Doug Dawson and all the wonderful artists who contributed their paintings to this book and also to my great editors, Mary Suffudy and Ginny Croft, and my designer, Areta Buk.

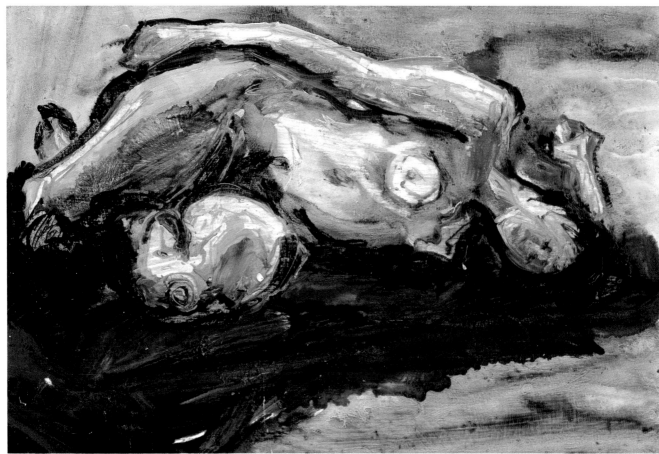

■ **RECLINING FIGURE ON RED CLOTH,** by Lucy Glick
12" × 15" (30 × 38 cm)
Oil on panel
Collection of the artist

CONTENTS

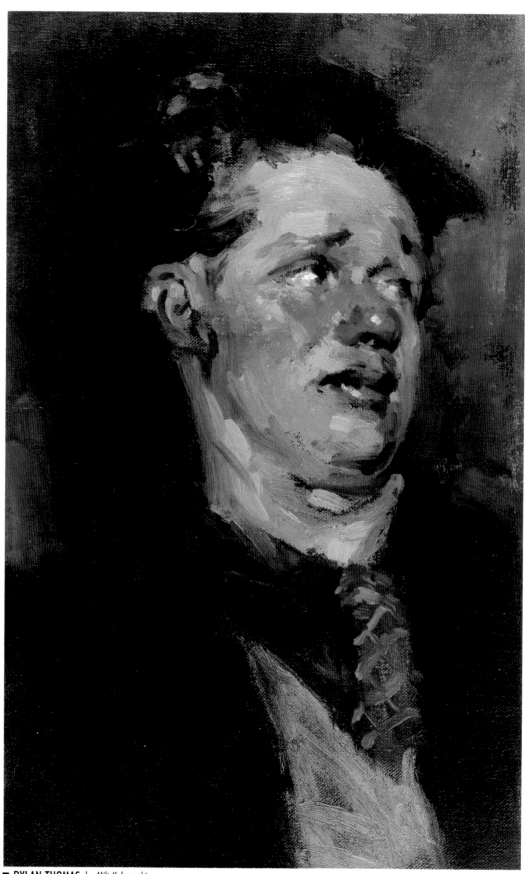

■ **DYLAN THOMAS,** by Milt Kobayashi
14″ × 10″ (35.5 × 25 cm)
Oil on canvas
Collection of the artist

INTRODUCTION

The human figure—complex, elegant, powerful, rarely still—has always presented the ultimate challenge to the artist. Unlike inanimate subjects, the figure reflects both the artist and the viewer, demanding a personal involvement from each.

This book was designed to introduce a cross-section of very accomplished artists who paint the figure. They work in different styles and different media, each one presenting his or her own vision of the human form. Portfolios of their work show the vast array of possibilities that exist for the figure painter and provide information about how paintings are created.

For purposes of discussion, I have grouped the artists into three main categories: Exploring Technique, Creating a Likeness, and Expressing a Point of View. Of course, every artist deals with all of these areas when painting the figure.

The most obvious characteristics of any painting relate to technique—how pigment is applied to the surface. Each medium has its own demands, and this book includes works in oil, acrylic, pastel, and watercolor. However, even within a given medium there are tremendous options.

Look, for instance, at the watercolors of Bill James and Stephen Scott Young. James works quickly, wet into wet, placing spots of complementary colors next to and on top of each other to create a vibrating surface. Young, on the other hand, works slowly. Mixing the three primary colors into varieties of gray, he gradually layers these colors over each other in glazes, as many as thirty glazes in just one section of a portrait.

With oil the diversity is even greater. Several artists work in a classical manner, building their values slowly and then painting the color on top. In contrast, Scott Prior visualizes his paintings so well that he can start at one corner and work across the canvas, applying immediate finished color in only one layer. Still another way of working is presented by the expressionists Ed Friedman and Lucy Glick. For them the act of painting is an exploration of color and form; they work intuitively, never knowing quite where they will end up.

Creating a likeness is not only a problem for professional portraitists; any artist who wants to paint the figure needs some of the same skills. In the second section of the book several artists pass on their methods for capturing a likeness. When do you use photographs and when must you paint from life? How do you convey a sense of the subject's personality? Can you flatter the subject and still have an honest portrait?

One of the special considerations of portraiture is pleasing a client. How do you create your own personal art and still meet the expectations of your audience? This is a challenge for Constance Flavell Pratt, who has painted thousands of successful portraits in pastel. Pratt and others describe their procedures for seeing the three-dimensional human form in front of them and transforming it into a two-dimensional painting.

The third section illustrates the differences and impact of point of view. Pastel artist Pauline Howard sees the world in an unemotional way and paints graceful, comfortable views of dancers, sunbathers, and spectators at a polo club. At the opposite extreme, Deborah Curtiss' acrylics are all emotion; they are passionate, intuitive explorations into the subconscious. Some artists paint to comment on what our society is; Patti Cramer's lively pieces are satirical statements about who we are and how we live. In contrast, Stephen Gjertson paints the world as it could be—beautiful, harmonious, at peace.

This book was designed to present the greatest possible contrast in representational figure painting while still maintaining a high level of artistic competence. It is meant to stimulate the mind as well as the eye, to make the reader ask: What is a figure painting supposed to look like? What do I want my own figure painting to look like?

Writing this book was a great challenge for me as an artist. Faced with the task of presenting and analyzing some of the strongest figure art in this country, I wondered how I would feel about my own art when I got done. Compared to the precision of Wade Reynolds, the grace of Will Wilson, the humor of Deborah Deichler, would I still like what I do?

This is a very real problem for every artist who does not live in total isolation; the strengths of other artists seem to illuminate our own shortcomings. What I learned writing this book, though, was that the greatness of one artist should never diminish another. The work of each painter in this book, including my own, contains strengths and weaknesses, and we can learn from both.

There is no one way to paint that is the "right" way. Each artist must find what he or she wants to express and then strive to express it in the most powerful and refined way possible. I hope that reading this book and becoming acquainted with the artists presented here will help to achieve that goal.

ALEX POWERS
Combining Realism and Abstraction

Alex Powers is a watercolorist whose style is traditional in its realism and contemporary in its abstraction. He begins a painting by making a realistic rendering of the model, but includes only those lines and details that are vital. Then he places the figure in an abstract background where the colors and shapes work in a nonnarrative way.

Contrast is the key to Powers' work—contrast in style and contrast in technique. He uses transparent against opaque paint, watercolor against pencil and pastel, fine line against loose splatters and dribbles.

Powers says he gets his inspiration from the model. Although he believes anyone can be painted successfully, he finds that more interesting subjects inspire more interesting paintings. He likes models who look different, act eccentric.

Although his paintings look spontaneous, they are very well planned. Before he went to art school, Powers was a computer programmer, and he says this discipline en-ables him to organize his art. He doesn't plan everything; that would be impossible with his fluid use of watercolor. What he plans are the three elements that make up the design:

1. The movement of light. First Powers places the most interesting shape, usually a light shape within the figure. Then he lays out the other lights, defining rhythm with the movement of light in the foreground and the background.

2. Use of space. Powers likes to use both two-dimen-sional and three-dimensional space within the same painting. He usually puts the strong value contrasts that create a three-dimensional feeling at the top of the rectangle. At the bottom he paints a brighter, flatter area. In the middle he adds a transitional band of color to unite top with bottom. He also uses the shapes of light to move the eye across the page.

3. The pose. Powers doesn't like working with a symmetrical composition; so he often places the figure to one side. He also avoids symmetry in the pose itself. Since he doesn't like the model's eyes looking straight forward, he often will pose the figure looking to the side or looking down to capture shadows in the eye sockets.

He always starts out working transparent, but will go wherever the painting leads in terms of opaque paints, pastel, charcoal, or conté crayon. As his paintings have become more graphic, this has increased. To enhance the graphic nature, he works with stiff-haired brushes, paints with the paper vertical, uses a very smooth paper, emphasizes surface texture, and often draws with char-coal or chalk into the watercolor.

WORKING METHODS

For practical reasons Powers often paints from photographs. He uses slides, projecting them onto a permanent daylight slide screen, three feet square, with the projector at the rear.

He draws his image onto the watercolor paper with a dark 6B charcoal pencil. He does not like to sketch onto the paper with light pencil and then pretend the lines are not there. On the contrary, he makes his very obvious lines part of the painting. He often continues to draw on the painting in progress; if he needs to draw into wet color, he uses a 6B Stabilo pencil.

Powers' other materials include Winsor & Newton watercolors and gouache, gesso, compressed charcoal, conté crayon, and Rembrandt soft pastels. He has worked on different types of watercolor paper, but he now prefers Strathmore high-surface Bristol paper, which is very slick. This smooth paper allows him to scrub and lift off color because the color sits on the surface rather than being absorbed. Also, the smooth paper makes it easier to draw into the painting with pencil or pastel.

Often he works on toned paper, either introducing color to a fresh sheet or scrubbing the dark color off an old painting. He prefers toned paper when doing low-key paintings because it allows him to keep his darks more transparent.

To reuse an old painting, he scrubs off the dark paint with a stiff-bristled kitchen brush. He uses the color that is left as his tone. Sometimes he deliberately leaves some of the underlying shapes. While the paper is still wet, he staples it to homasote or bedding board.

Powers paints with his paper tilted almost vertically. This makes the paint dry faster, keeps the paint lively, and adds to the graphic effect. He paints with large, loose brushstrokes, using a 1½″ (3.8 cm) flat, short-haired bristle brush to scrub in color and attack the paper, and a 2½″ (6.4 cm) flat, short-haired mottler for larger areas. He does a lot of splattering, and he often sprays water with a plastic spray bottle to soften edges.

His palette consists of the transparent, staining primaries—alizarin crimson, Winsor blue, and new gamboge yellow—and the more opaque burnt sienna, cadmium red, yellow ochre, and cerulean blue. If he wants to veil a color that is too strong, he floats acrylic gesso, thinned with water, over that area. He places the paper flat on a table and pours a mixture of two to five parts water to one part gesso over the color to be muted. The opaque gesso, when dry, imparts an interesting granulated texture and also makes the painting lighter in that area.

Powers often juxtaposes transparent watercolor with opaque gouache within a painting. He says it is important to use gouache for its opaque quality, not trying to paint transparent washes with it, but using it for thick areas of solid color.

■ STUDIES OF AUBREY

23" × 29" (58 × 74 cm)
Watercolor, gouache, and charcoal on paper
Collection of the artist

This piece gives us an excellent example of Powers' use of toned paper as the basis for a watercolor. In this case the tone was not only color, a light beige, but also texture, what looks like stiff brushstrokes through the painting.

This texture creates a two-dimensional quality that Powers bounces against the three-dimensional rendering of the faces.

He used two views of the same model here to break his habit of composing with a single figure. Another compositional element is the contrast between the areas of transparent watercolor and the shapes of opaque white gouache.

EXPLORING TECHNIQUE

■ SOLDIER STUDY I

17″ × 17″ (43 × 43 cm)
Watercolor on paper
Collection of the artist

*Powers photographed this subject during the
filming of a television drama on the Civil War.
He changed the color of the hat for the sake of
design. This is a good example of his use of
selective realism, painting only those aspects
that are necessary for recognizing the subject.
With his fast, immediate style of painting,
Powers must select only the most important
lines and shapes to include in the painting.
This selection process is an intuitive one that
improves with experience.*

*Knowing when to stop is often the greatest
problem with watercolor, Powers says, because
it is so easy to overwork a painting, and he
warns that it is usually better to "underdo"
rather than "overdo" a watercolor. He got some
help with finishing this piece—he was inter-
rupted while working on it, and by the time he
returned, he was able to see that it was already
finished.*

■ DETAIL

*Here we get a good example of how Powers
mixes realistic with abstract elements. Using a
minimum of detail, he placed the eye, nose,
and ear so that we know what they are and
where they are. Then he used color within
those features more for abstract design than for
literal description. Look at the red of the nose;
that color works along with the deep red of the
cheeks and the background to keep our eyes
moving through the painting.*

*We can also get a sense here of how he
applies his paint in runs and splatters to get a
rich, organic feeling throughout the painting.*

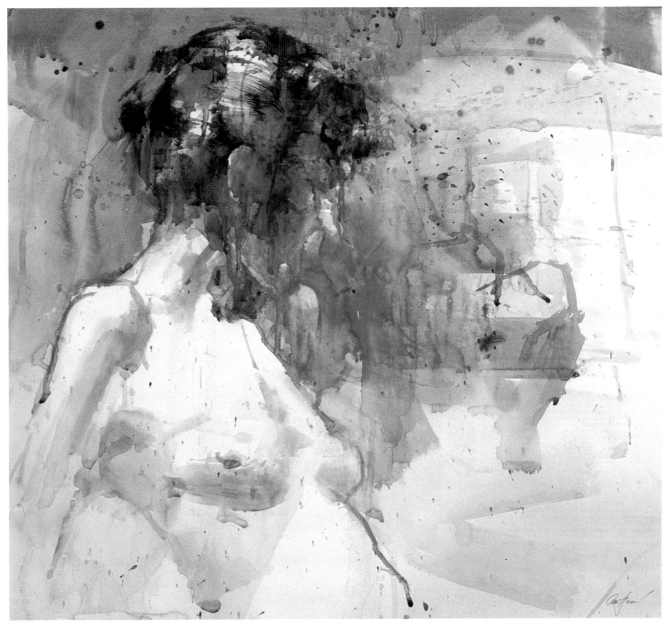

■ NUDE WITH FACE IN SHADOW
23" × 25" (58 × 63.5 cm)
Watercolor on paper
Collection of the artist

The subject for this painting was a model in a sketch class. Powers likes to draw unusual-looking models; his least favorite subjects are attractive women. In this case he has hidden the model's face, making her more mysterious.

This painting is uncommon in that he drew the initial image with watercolor rather than his usual 6B charcoal pencil. Also he painted almost the whole painting in browns, adding the complementary blue toward the end. Notice how he balances the blue of the background

with the accents of blue in the figure. To create interest in the background without specific shapes, he worked to achieve a sense of very lively paint.

Powers considers the lost-and-found aspects of the face in shadow to be the most successful element in this work. The challenge was to use the head as a dark shape connecting with the dark background and contrasting with the light body but still keep the head connected to the body. He maintained the connection by using just enough realism in the face and head so that we know intellectually that they are connected and by leaving spots of highlight in the hair and profile to relate to the light torso.

EXPLORING TECHNIQUE

■ **GRAY NUDE**
22″ × 30″ (56 × 76 cm)
Watercolor, gouache, charcoal, and red chalk
on paper
Collection of Nancy and Eugene Fallon

This painting grew out of the use of a paper
toned to a middle gray. Because he was work-
ing on a surface that was already a middle
value, Powers painted with watercolors darker
than the toning and white gouache for lighter
values. Then he added charcoal and red chalk
for definition and dramatic accents of color.

As in all of his work, contrast is very impor-
tant. Look at how the exuberant stroke in the
upper background plays against the somber
color and still pose. There is also the contrast
of opaque and transparent paint. Powers says
that when you use both watercolor and
gouache, you should not try to use the gouache
for transparent washes, but let it provide areas
of solid color for contrast.

■ **NOONDAY STORIES—DARCY II**
21″ × 21″ (53 × 53 cm)
Watercolor, charcoal, and chalk on paper
Collection of the artist

The subject here is a fisherman Powers met at
a marina. The background consists of ab-
stracted shapes from the cabin of the subject's
shrimp boat.

This painting shows how Powers works from
a solid, three-dimensional type of painting at
the top of the rectangle to flat, two-dimensional
space at the bottom. The upper painting con-
tains the subject's face with its careful attention
to detail of form and value. Also the top has the
greatest background detail. In contrast, the
bottom is all very light, abstract shapes.

Powers accomplishes a successful transition
by gradually diluting his colors so that there is
a natural flow from dark to light. Also he uses
pastel and charcoal strokes to bring more
interest to the middle. Look at the interesting
interplay of diagonal stripes in the center sec-
tion near the chin, the ribbing of the hat (upper
left), and the detail of the boat (upper right).

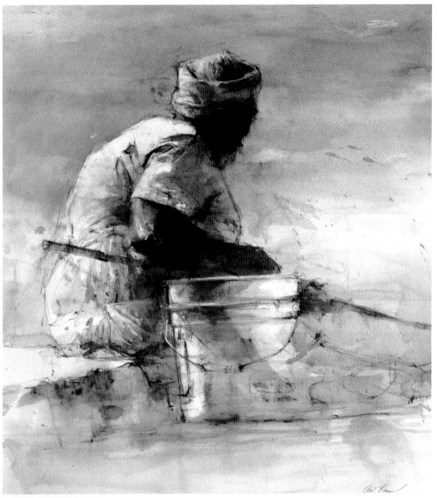

SUGGESTED PROJECTS

Powers suggests three exercises for improving your watercolor figure painting:

"Do a painting of a head (or any subject). Repaint it using just half the imagery as the first time. Repeat until it becomes as poetic and selective as you want. This exercise is good for any artist, even for artists whose paintings are novels rather than poems.

"Sketch a subject in the usual way, including background shapes. Pick out no more than twelve shapes in the rectangle. Outline these and erase previous lines inside the twelve shapes. Paint by placing detail where one shape changes to another—not inside any shape. This is an exercise in simplifying and grouping shapes.

"Tone a paper to a middle value. Sketch your subject in the usual way. Begin, not with transparent colors darker than the toning, but with opaque whites and off-whites lighter than the toning. The purpose of this exercise is to become familiar with gouache whites. The trick to using gouache white is not to try to use it transparently. Use it thickly and mix it with transparent watercolors as needed to make opaque off-whites."

■ **RIVER FISHING I**
22″ × 19″ (56 × 48 cm)
Watercolor, charcoal, and white chalk on paper
Collection of Joy and Jay Burton

Powers considers this piece more of a drawing than a painting because the rendering of the figure and scene are of more concern than the abstract design of the total piece.

This painting gives the illusion of a very solid image, but most of the piece is actually very loose and ambiguous. Powers achieved the solid effect by tightly rendering a few details of form and value—the elbow, the rim and

handle of the bucket, the wrinkles of the skirt, the shading behind the arm and in the kerchief. All the rest is only implied, and the few details pull it together into a solid, believable whole.

Powers achieved a wonderful integration of several media in this piece. He used watercolor for its wide range of values, from the light tones in the background to the intense brown of the skin. To that he added loose strokes of charcoal for contour and detail. Finally he created a sense of bright sun by using white chalk for intense highlights. Notice how sensitively they all work together.

WADE REYNOLDS

Creating a Glow with Pointillism

Every square inch of a Wade Reynolds' painting is a treat to the eye. The total painting is built up with virtuoso attention to draftsmanship, composition, and value, but it is the pointillistic application of paint to the surface that makes the painting glow. With a tiny brush Reynolds adds complementary colors, reflected colors, and darks against lights to give his colors depth and vibrance.

Reynolds began drawing recognizable figures at age three. At ten he took his savings and sent off to Sears for a set of oil paints. He learned to mix paints by trial and error, trying to duplicate what he saw.

Despite his early interest in art, Reynolds did not think of painting as a career; he wanted to be an electronics engineer. So he joined the navy and studied engineering. Later he worked as an engineer to support his studies and early career in acting. After some success as an actor in New York, he gravitated back to design and painting.

His earlier careers seem to have had a definite influence on his art. He designs and executes his paintings with the precision of an engineer. His work is intensely realistic, although not, he says, photorealistic. He analyzes and organizes each element of a painting. He has a fascination with how everything works, never accepting anything at face value.

Reynolds' theatrical experience shows in the elaborate "staging" of his figures. He must always have the right pose, setting, and light. How does he know when it is right? "From my own innate sense of what will work for me," he answers. "When I start a painting, I have already seen in my mind what it will look like finished."

He also tries to find a dramatic surprise in every painting, something in the light, balance, or pose that is unexpected. In his portrait of Leza, for instance, he was working with a glamorous woman in an elegant situation. They tried numerous costumes and poses, looking for something that would make the painting a bit more exciting. Finally when Leza dressed in her robe and put her foot up on a glass table, Reynolds saw what he wanted. Suddenly she was no longer the typical glamorous woman. The foot on the table expressed her candid, artistic side. She was still glamorous, but now she was something more. That is the kind of surprise Reynolds wants in his paintings.

Reynolds is not attracted by the commercial sense of beauty. He says his subjects must have a flaw, a counterpoint, to make them believable. He chooses by intuition and must feel that his subject is someone he wants to paint, someone who warrants the time and commitment needed to produce one of his beautifully rendered portraits.

WORKING METHODS

Reynolds paints on either linen or cotton primed with two coats of plain gesso and two layers of titanium white toned to a light gray with raw umber and phthalo blue. These are applied with a 2″ (5 cm) brush in crosshatch. The third step is the same toned acrylic applied with a ½″ × 2″ (1.3 × 5 cm) broad-tipped, flexible palette knife. He sands lightly, if necessary, to remove any small lumps after each coat.

Reynolds uses a water-soluble felt-tipped pen in umber to draw the image onto the canvas. Then he develops the entire image in line-drawing form using thinned umber acrylic and a no. 1 or no. 2 round sable brush.

After the image has been established in line form, it's just like a coloring book. The light and dark relationships are first blocked in crudely with umber washes applied with no. 12 sable or sable-type brushes. These are refined and intensified with heavier and heavier succeeding layers until there is a strong but unrefined image. Next Reynolds paints a simple blue scumble over the entire surface, followed by a drybrush of mixed blue and umber to intensify and refine dark areas and edges.

At this point he gears down to no. 5–000 brushes, which are the largest he will use for the remainder of the painting, except for occasional drybrush. Colors and patterns are laid in as broadly as is possible with a no. 5 and then refined somewhat with smaller brushes. The colors are mixed to approximately what the eye sees. Then every area is enhanced with small points of pigment in cool and warm variations.

Many artists would stop at this point with the colors and values close to what the eye sees, but for Reynolds this is just the underpainting. At this point he "takes down" the entire painting with succeeding drybrush scumbles first of umber, then of phthalo blue, and finally a deep, deep red. These are applied carefully only to tone, not cover up, the previous painting.

Then he starts all over again, painting the colors and values as they appear to the eye, gradually building back to the light with the finest dots of color. He uses a little red or umber to warm the cool spots and blue to cool the hot ones. Tiny dots of the deepest blue and the deepest red intensify dark edges next to light and bring highlights back to full intensity.

Reynolds says this is where the excitement begins. He goes back over the entire canvas and introduces the complementary color into every color area. The reds get green; the greens get red. He says it is the painting of complements next to each other that gives his colors the glow of reality.

In the final steps he takes down and builds up all the colors one more time. All the areas that should go into shadow get taken down with drybrush of deep red; again, this is just a very subtle toning. All the highlights from outside light sources get toned with blue, and all the highlights from interior lights or reflections get toned with umber. Then he goes back and picks out the highlights again with whited dots. If a highlight should glitter like glass or metal, he surrounds it with a halo of deep red and blue dots to make it seem to leap from the canvas.

Reynolds intensifies his final darks in two ways. In those areas that are dark because of absence of light, he introduces cadmium orange for more depth. All the blacks that are receiving light are reinforced with dark blue and red.

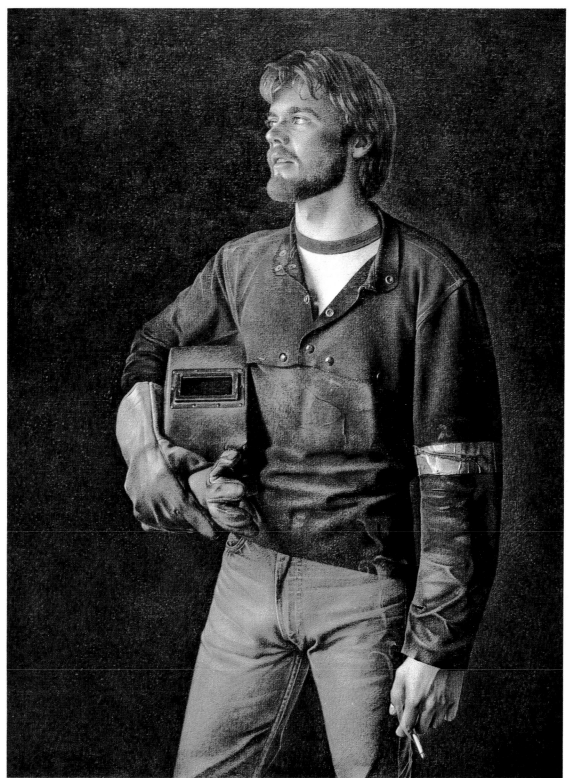

■ BART
40″ × 30″ (102 × 76 cm)
Acrylic on canvas
Collection of Mr. and Mrs. Allen Feldman

When Reynolds has asked someone to model, they pursue the subject's normal routine of activities until something clicks that justifies a pose in terms of reality. With Bart, the welder, it was a quick cigarette break when he would step to the edge of the welding booth, still clutching his mask under one arm. ("This had to be an early break or we would have had to deal with a substantial amount of grime on his face.")

Reynolds paints unusually sensitive portraits of men. He explains that he has a great antipathy for the accepted macho image of what a man is supposed to be about. He sees a period in life when all a man's options are still open to him; that is what he tries to capture in his portraits of men. In the portrait of Bart, he wanted to show that when this welder comes out of the black booth, he is a young man full of promise.

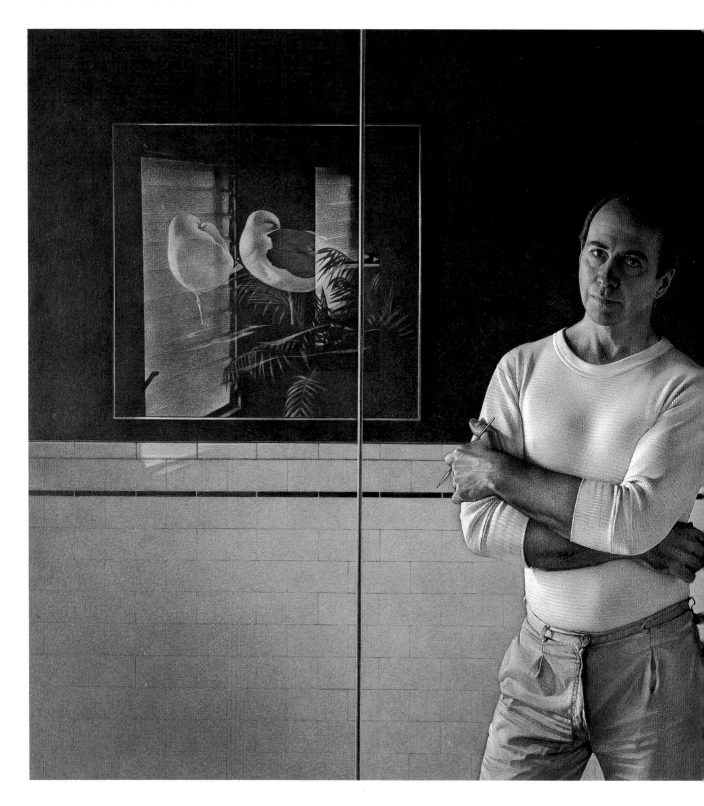

■ **MIRROR IMAGE**
36" × 48" (91 × 122 cm)
Acrylic on canvas
Courtesy of James Corcoran Gallery,
Los Angeles

This self-portrait was painted with all the advantages and disadvantages the artist has when using himself as a model. The advantages, obviously, are the availability of the model and the fact that the model understands the exact nuances of the desired expression and pose. The difficulties are in trying to pose and draw at the same time, and in presenting a truly honest view of one's self.

Reynolds says this was an exercise in composition and light. The background is divided basically into a dark half and a light half, with its severity tempered by the door and the framed graphic. Most of the shapes are marked off with sharp, straight lines. This geometric effect is softened by the pose. Notice the S-curve of the figure; imagine a line beginning in the subject's head, curving through his right shoulder, then dropping down and curving back through his left hip.

As in all of Reynolds' work, the light is beautifully developed. See how the highlights and shadows model the figure. Notice the highlight on the seam of the mirror as it changes intensity going from the dark background to the light background.

■ **DETAIL**

In this detail we can see how Reynolds builds up a believable skin tone from a wide variety of colors. Notice especially the reds and greens against each other. It is this juxtaposition of complements placed as distinct spots of color that makes the painting glow.

■ STUDY FOR LEZA
25½″ × 19½″ (65 × 49.5 cm)
Acrylic on paper

The artist did one very careful preliminary painting for the portrait of Leza. He composed this study just as it would appear in the final version. Often he begins with a study that shows a larger area than he wants to include in the major painting; then he can work out his format by cropping the study. He experiments with "framing" by using two right-angle cardboard cutouts, adjusting them on the page until he finds the most desirable format for his subject.

After he finished the study, having worked out the pose and composition, he added a grid and used that to transfer the image to the larger canvas.

■ LEZA
72″ × 60″ (183 × 152 cm)
Acrylic on canvas
Collection of Mr. and Mrs. Eric Lidow

Many elements combine to make this an outstanding portrait. First of all, there is the treatment of the subject herself. Reynolds picked this pose because it showed Leza as a strong, assertive artist, as well as a glamorous woman. The pose is also integral to the composition; the standing figure provides a necessary contrast to all the horizontal shapes in the painting.

It is remarkable that the artist was able to interweave so many facets and still maintain one unified image. Notice the balancing of the intricate patterns at top and bottom, creating a frame for the simple, solid shapes in the center.

Also, look at the rendering of detail throughout the painting. There are the obvious details of the Oriental rug, the painting within the painting, the jewelry and lamps, but also notice the carefully developed reflections and the delicate interplay of highlights and shadows. What makes these details more exciting is the fact that they are developed not with lines and solid colors, but rather with layers of dots. Notice the modeling of the sofa, the sheen of Leza's slacks, and the spots of bright accent that add sparkle to her eyes.

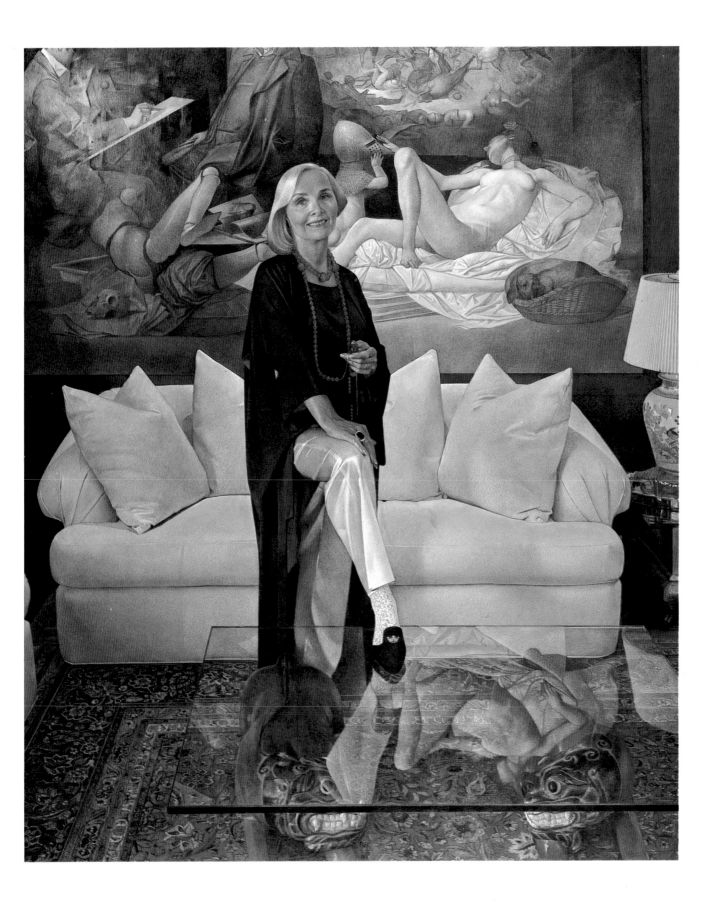

EXPLORING TECHNIQUE

■ PRELIMINARY DRAWING
19" × 25" (48 × 63.5 cm)

He used this simple composition study to decide how to "frame" the painting. Notice how he brought the edges, marked by the white lines, in from the sides to make a stronger vertical format.

■ PRELIMINARY DRAWING
22" × 16" (56 × 41 cm)

This sketch was to help work out the shapes and gesture of the main figure. Reynolds likes to work out all the elements of a painting so that he can see the finished work in his mind before he even starts to paint.

■ DETAIL

In this detail we can appreciate Reynolds' draftsmanship. Look at the delicate rendering of Mimi's face and hand. We can also see how he uses light. Notice the gradation of values from the lightest area on the back of the hand where light is falling directly, to the dark, shadowed area on the inside of the thumb. You can see how his pointillistic approach works here. The brighter areas are achieved with light-colored dots and the darker areas with dots of deeper values.

You can also see a subtle portrait of the artist hidden in the reflections on the poster. This is an example of the kind of surprise Reynolds likes to include in his paintings.

■ ME, MIMI & LICHTENSTEIN
54" × 38" (137 × 96.5 cm)
Acrylic on canvas
Collection of Mr. and Mrs. Eric Lidow

Reynolds describes his subject: "Mimi is chef/owner of a delightful country-French restaurant in Venice, California, that I had patronized for sometime, and is the possessor of great effusive charm. When I had finally worked up the courage to ask her to pose, it was with the idea of a standing pose in her kitchen/office or the doorway, where I had usually observed her. When it came to finding a painting, I could not make it work for me; so then we tried various tables in the restaurant. As usual with my work, there was no question that this was it when she sat down at this spot with the Lichtenstein poster behind her."

He says the main focus of the painting is the smile. He rarely uses "out-and-out beaming smiles," but in this case it was vital to the subject. The most difficult problem was dealing with the strong vertical lines that go from below to far above eye level. Notice how Reynolds curved the lines on the large picture frame to resolve the problem.

As always in Reynolds' work, there are many contrasts in this piece. Look at the variety of patterns, how they are set against each other and also against the shapes of solid color. Also notice the strong geometric shapes as they contrast with the feminine, curving shapes of the lamp, vase, and Mimi herself.

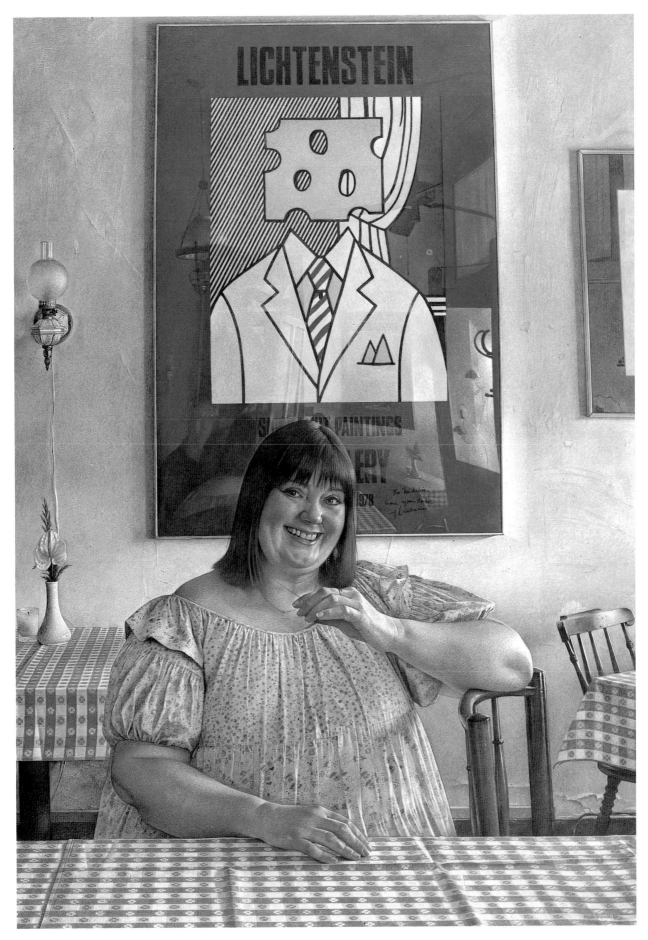

SUGGESTED PROJECT

Wade Reynolds suggests an experiment in using complementary colors:

"I think most people have been introduced to after-vision in game form as children; you study a dot on one page, then look at a blank page and see the image surrounding the dot in a complementary color. It doesn't take very long for the image to form, and I have a theory that you are seeing both the color and its complement at the same time without being aware of it, at least to some degree. I have found that no matter how well something has been executed, it will take a giant step toward reality when the complementary colors are introduced into what your mind tells you your eyes are seeing. The same is true of an intense area of contrast such as a light edge with dark beyond or the glitter of a reflection; the after-image of light is correspondingly dark, reinforcing the dark edge and vice versa.

"There is another area where many otherwise facile artists seem to fall down. How many times have you seen a beautifully painted group of fruit that were static because the artist neglected to establish the interaction of their individual colors? Every surface, even a fuzzy peach, is reflective to some degree and will trade colors with its line-of-sight neighbors.

"So, my project is this: If you've got a painting stashed away that just never came to life, dig it out and introduce complementary colors into what you have and watch a miracle happen. It is absolutely amazing to see what life red will give to green foliage or green will give to pink skin. And if there's an apple and an orange, make sure they're aware of each other—paint some red into the orange and orange into the red."

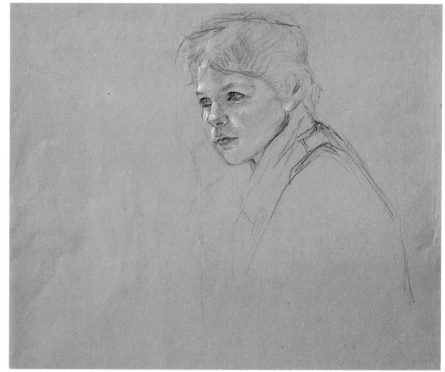

■ **SKETCH**
19″ × 22½″ (48 × 57 cm)

Reynolds likes to familiarize himself with the contours and volumes of his model's face before he begins to paint. This is one of several preliminary sketches for the portrait of Dylan.

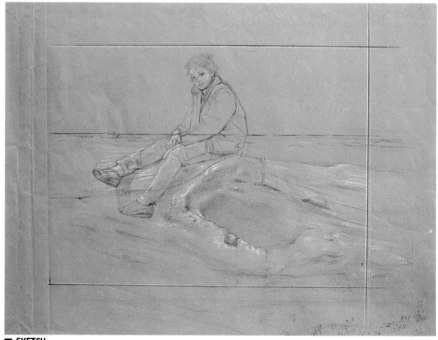

■ **SKETCH**
19″ × 25″ (48 × 63.5 cm)

Here he has drawn the basic pose and gesture that he will use in the final painting. Notice how he has located the horizon line above the center of the page. Since the figure is at the center from left to right, the painting would have been too static with the horizon also at the middle.

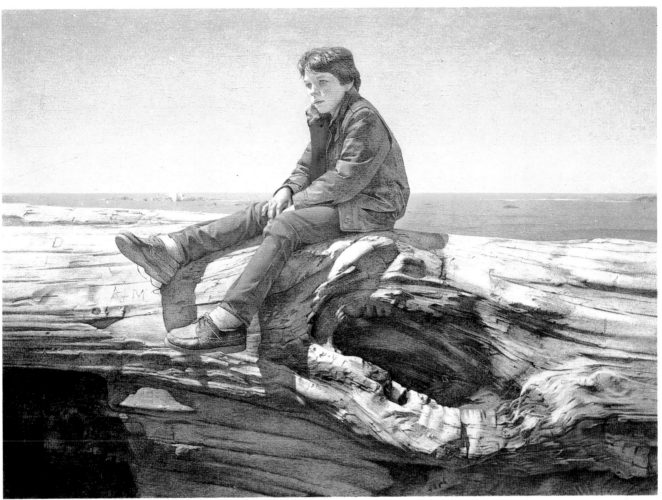

■ DYLAN
32" × 44" (81 × 112 cm)
Acrylic on canvas
Collection of Mr. and Mrs. Don Dennen

In this commissioned portrait of an eleven-year-old boy, Reynolds didn't settle for a stereotypical cute-child picture, but captured a serious young person with his own very definite personality and moods.

To find just the right setting and pose, Reynolds and Dylan spent several days in the Mendocino countryside, with Dylan scampering through old buildings, duck ponds, and beaches and Reynolds following in hot pursuit. When they finally came to the "space rocket disguised as a redwood log," Reynolds knew they had found the painting.

The blue sky and water, the gray log, and the blue and green clothes could have made this a very cold painting. However, the artist's technique of building colors with complements and reflecting colors kept it a warm and inviting scene. Look at the array of colors in the shadows of the log where Reynolds has stippled reds and blues into the basic gray-brown of the wood.

BILL JAMES

Using Complements to Make Colors Vibrate

As a successful professional illustrator, Bill James tried a lot of different techniques over the years. After working for some time in a style of severe realism, he decided he was tired of creating tightly rendered paintings—so he loosened up. The result of that decision is the vibrant images he now develops with bits of color laid on top of each other or next to each other.

He paints with both pastel and watercolor using a separated-color technique. This means that he lays down strokes of different colors side by side. He doesn't blend them, and therefore, up close, the painting looks like a mass of unrelated strokes. However, as the viewer backs away from the painting, the colors are blended optically, creating a strong, unified image.

To get the strongest impact from these individual color strokes, James places complementary colors next to each other. Whether they are exact complements, such as blue and orange or red and green, or whether they are just a warm color next to a cool color, the juxtaposition makes the colors vibrate.

Balancing the complexity of strokes in James' paintings is a bare simplicity of composition. He uses a simple division of space in which there is usually only one figure, sometimes only head and shoulders, against a stark background. The design is made up of the pattern of shapes within the figure and the larger shapes of the figure dividing the negative space.

The simplicity of the composition does not mean that James' portrayal of figures is simple. His subjects are always unusual, interesting-looking people whom he finds at dog shows, at swim meets, or even just lying in the street. He looks for provocative expressions and intriguing situations.

He is often a storyteller in his paintings; even without detailed backgrounds he presents a protagonist at a dramatic moment. A good example is his pastel called Before the Race. *The subject is a young man, emotionally preparing himself to compete. James gives us all the tension of that moment just by showing us the intensity of the athlete's facial expression and the prayerlike gesture of his body. The drama is enhanced by the starkness behind the electric strokes of the figure.*

Many artists are memorable for either their mastery of an unusual technique or for a special content in their imagery. Bill James is an artist who gives his viewers both.

WORKING METHODS

Bill James chooses unusual people as subjects. He looks for strong emotions and interesting situations. Because he likes to capture the subject in a candid moment, he generally works from photographs, not just creating a new version of the scene, but letting the photograph serve as a jumping-off point.

From the photograph he works out small pencil sketches to develop composition and values. He might also do small color sketches, which are especially helpful when he changes the background from the original photograph or when he introduces new colors.

When James works in pastel, his next step is to select a sheet of paper, either on the basis of color or texture. If he is planning to leave an unpainted background, he will choose paper with a strong color. Sometimes he chooses paper in a color that is a complement to the colors he will use for his subject; the complementary paper color will seem to vibrate where it shows through the pastel.

He works with soft pastels, Rembrandt and Grumbacher, drawing the contours with a complement to the color that will comprise most of the figure. He doesn't necessarily use exact complements, such as a blue line where the skin will be orange. Sometimes he simply juxtaposes warm and cool colors, drawing the outline with a cool color and filling in with warm colors.

After he has laid in his drawing, he blocks in the basic colors for the main shapes of the painting. He starts with the darkest values and gradually works up to the lightest. He uses complements for shadow and detail, thereby making all of the colors more vital.

James often paints first in the areas of greatest interest, such as the face. Then he works out from there, often enlarging his strokes so that the face is a fairly tight rendering in small strokes and the background is a looser, almost abstract area of color and pattern.

He takes colors from objects of clothing or background and paints reflections of those colors into the figure; this adds to the total color harmony of the piece. Another technique he uses is to paint a green area, for instance, and then add strokes of blue and yellow, the colors that comprise green, to the same area.

He never uses fixative on his pastels because he feels the fixative dulls the color.

For watercolors James also begins with photos, sketches, and then a drawing on the painting surface. He says the drawing is the most important thing; if it isn't correct, the painting won't work.

He paints watercolors on gesso-coated board so that the paint doesn't dry as quickly. Again he concentrates on complementary colors. For instance, in an area where a warm color is drying, he will work into it with cool colors.

Due to the fluidity of watercolor, the colors tend to flow into each other and blend more, causing his complements to be less obvious than in pastel. To compensate for the lack of control, watercolors give him the advantage of "happy accidents."

With both media his technique has gotten looser and bolder through his career. He says the only thought he gives to his paintings as he works now is in the design and the dark and light shading. The rest is intuitive.

■ **YELLOW HAT**
25" × 19" (63.5 × 48 cm)
Pastel on paper
Collection of the artist

This piece illustrates the artist's powerful contour drawing. Even though much of the painting is highly developed with hatched strokes of pastel, there are places where the figure is defined only by a simple contour line (look at the legs). The fact that those areas seem as solid as the others shows the artist's mastery of draftsmanship.

The contour lines also show the artist's use of complementary colors. In the warm areas of flesh and hat, he has drawn his outlines with cool blues and greens. For the blue bathing suit, he used orange for the contour. Notice how these contrasting lines add visual excitement.

In the solid areas of the body, particularly in the upper back, we can see diagonal strokes of complementary colors in a pattern of alternating colors. The blues mixed with orange and pink achieve the necessary value changes and also add to the total richness of color.

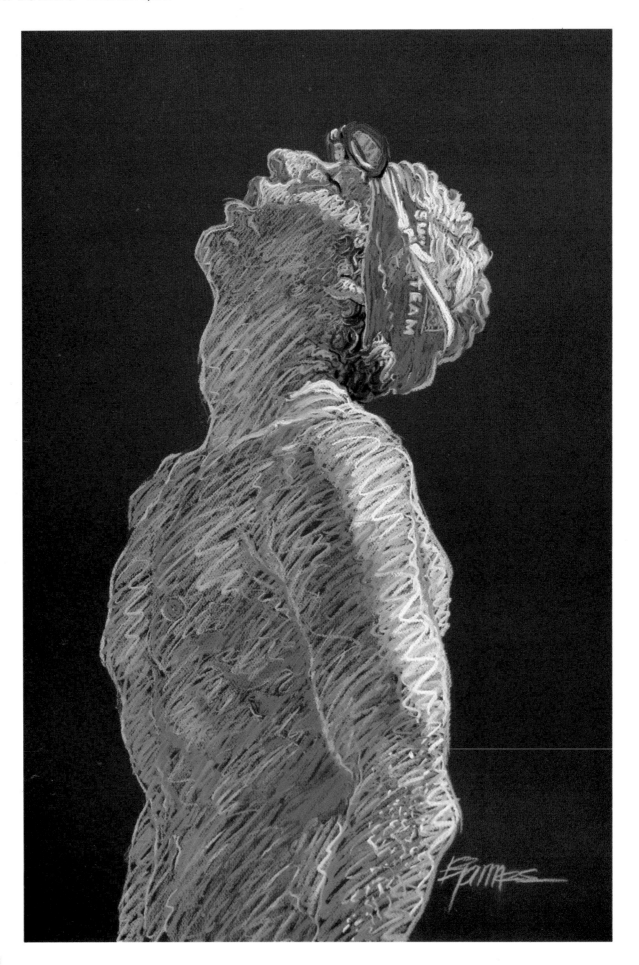

■ BEFORE THE RACE

30″ × 20″ (76 × 51 cm)
Pastel on paper
Collection of Syntex-Anaprox Corporation

James went to a swim meet to capture people diving, but he became more interested in the people who were warming up, the intensity of emotion as they prepared to compete. He decided to create a painting that would show the tension and deep concentration needed to compete in an athletic event. This particular swimmer seemed to epitomize those qualities.

He started with a photograph. He decided that all of the activity in the background of the photo diminished the concentration of the figure. So in a preliminary pencil sketch he extracted the figure and used a solid background to heighten the dramatic effect.

He painted with soft Grumbacher and Rembrandt pastels on a textured paper that would give more vitality to each individual stroke. He used black paper so that he could leave the negative space as stark as possible.

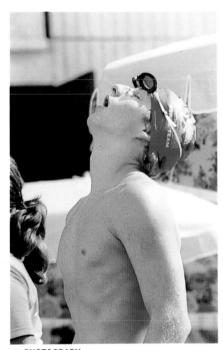

■ PHOTOGRAPH

Notice how the emotion of the figure is almost lost in the chaos of the background. The various textures, the bright yellows, and the sharp angles of intersecting lines all pull the viewer's eye away from the subject. In the painting James eliminated all the background confusion, leaving a simple dark stage for the intense emotion.

■ PENCIL SKETCH

With bold strokes of a soft pencil, James draws in the basic contours of the figure. He indicates values with crosshatched lines for dark areas, pencil smudges for middle values, and white paper for highlights. He makes the edges between major light and middle values with a quick, light line.

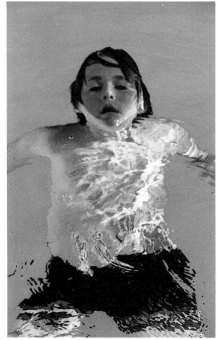

■ PHOTOGRAPH

When you look at this original photograph and then the finished painting, it becomes obvious how James uses the photograph as a reference point to capture values and the basic spirit of the water, but then applies color in an inventive, playful way that goes far beyond the photo.

■ PENCIL SKETCH

The pencil sketch is an intermediate step in which James abstracts the light and dark patterns from the photograph. In this sketch he has also indicated the movement he wants to achieve in the finished painting.

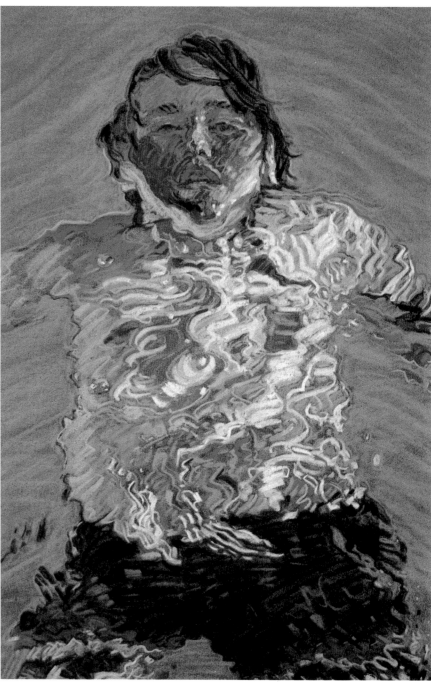

■ BRYAN IN POOL
26″ × 18″ (66 × 46 cm)
Pastel on paper
Collection of the artist

The artist saw his son Bryan playing in the pool one day and got the idea for a painting with rippling water. He wanted to focus on the beautiful patterns of color, but in order not to lose the reality, he drew the subject's head emerging from the water. After studying Bryan in the water, James decided that standing over the boy at the edge of the pool gave the best pose. From that angle he shot a whole roll of film just to get the right rippling of the water.

This painting is a wonderful example of

James' separated color technique. We see here how the artist applies individual strokes of various colors to create interesting abstract patterns and how those patterns combine at a distance to convey a total image. The rhythmic strokes in the water are especially obvious, but look also at the head, where slightly smaller lines of color bounce against each other.

Look at the shadows in the face where the artist has used cool blues against the complementary oranges and browns. Throughout the painting he lays warm colors against cool colors to create visual excitement. Notice how red against blue sustains our interest to the very bottom of the painting.

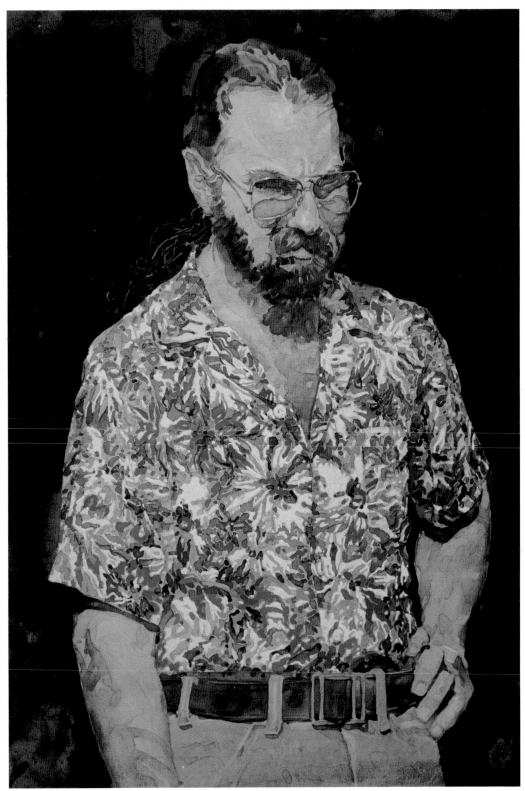

■ **THE FLOWER SHIRT**
19″ × 15″ (48 × 38 cm)
Watercolor on board
Collection of the artist

Bill James frequently attends dog shows. He goes because his wife breeds and shows Doberman pinschers and also because he finds many of his most colorful characters at dog shows. That is where he found this subject.

The focus of this painting is obviously the shirt. James painted the shirt with the same kind of separated color strokes he uses for his pastels. Up close the strokes seem to be random bits of color; at a distance, however, a definite floral pattern emerges. Notice how James used the same type of stroke in the subject's beard and hair, providing greater continuity in the painting.

To provide maximum contrast with the shirt, he painted the rest of the piece in a subtle, almost flat way. He chose the simple background to bring out the pattern of the shirt.

■ PHOTOGRAPH

The original photo shows how freely James uses his photographic studies. He has extrapolated the figure, faithfully reproducing features, pose, and expression, but has totally altered the background and colors.

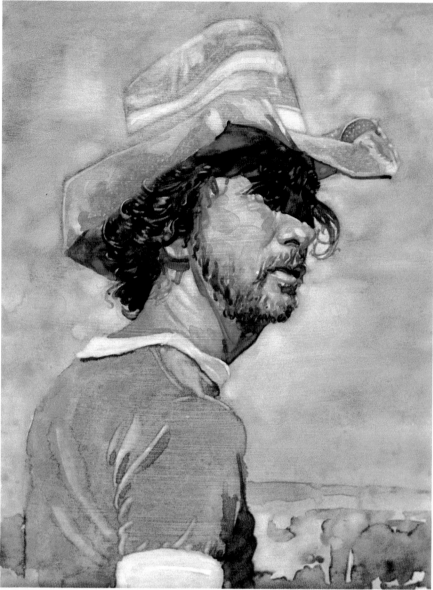

■ AT JUPITER DOG SHOW
16" × 13" (41 × 33 cm)
Watercolor on board
Collection of the artist

James chose this subject because of the shape of his hat and the patterns of light and dark it made on his face. The face was the main focus once James started painting. He says it was the most difficult part of the painting to develop, but also the most successful. Notice how most of the painting is done with soft, loose areas of color; only in the face are the strokes small and definite. It is this precise building up of colors that creates the expression.

James paints on a gessoed board because it keeps the watercolor from drying too quickly. It is the sustained wetness that allows him to blend colors and to float colors in the background and also to rub out highlights as in the hat and shirt.

Most of the painting is executed in the complementary colors blue and gold. For the sake of design, James decided to make the shirt blue, then made the sky a soft blending of gold and blue. A gold underpainting of the shirt shows through the blue, enriching the color. Notice the vibrance of the blue accents against the warm tones of the face.

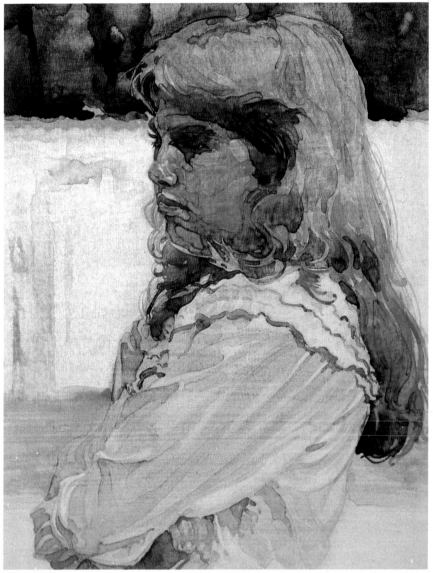

■ CHRISTINE

19" × 15" (48 × 38 cm)
Watercolor on board
Collection of the artist

Although this is a portrait of the artist's daughter, James was more concerned here with capturing a mood than a likeness. He wanted the highest contrast and the center of interest to be around the eyes and therefore positioned her so that the dark shapes of the eye and nose would contrast against the light fence. He waited until sundown to get a golden quality to the light.

After a preliminary pencil sketch, he drew the image with a no. 3 pencil on a gessoed board. He applied his paint in a wet-into-wet manner using Winsor & Newton watercolors and sable brushes. He used no. 2, 6, and 8 brushes, with a 3" (7.6 cm) brush for the background.

As in his pastels, here James relies heavily on complementary colors. Notice how almost all of the figure is painted with blue and orange, often covering one another or bleeding together. The complements provide contrast and the limited palette gives the painting an overall color harmony.

SUGGESTED PROJECT

Working either from a model or a photo, draw a simple figure study using pastel or colored pencil. Select a cool color for the outline or contour. Then loosely block in the main shapes of the figure with the warm complement of the contour color. For example, if you draw the contour lines with blue, paint in the flesh with oranges. (You could also use green and red or purple and yellow.)

Use the blue again to mark the shadows and details of the figure. In larger areas of darker blue, crosshatch over the orange with blue. Do not blend the colors together or you will turn them to a muddy gray. Notice how the individual strokes of blue and orange vibrate against each other.

In this painting or another, find an area that is orange, green, or purple. After you have blocked in your basic color, add more strokes to the area with the colors that comprise your original color. For instance, in an orange area add strokes of yellow and red; in purple, add blue and red. Again, do not blend the colors together. You will see how adding strokes of the component colors enriches the total color.

SCOTT PRIOR
Painting the Illusion of Reality

"I get a lot of satisfaction out of creating an illusion of reality, turning something that was just white canvas into an illusion of trees or a chair or a person. Up close you know it's a painting, but from a distance there is the effect of reality."

Thus Scott Prior explains his work. His large canvases almost convince us that we are looking not at a painting, but at a view out a window. Most of Prior's paintings are landscapes or interiors. When he does include a figure, he considers the painting to be not so much a portrait as a personal landscape or an interior with a person in it. His subjects and settings are always familiar—his wife and baby or dog, sitting comfortably on the porch or in the kitchen. The elements are intimate and personal. He says he hopes they depict an experience or situation that is also familiar to the viewer.

After majoring in astronomy in college and studying printmaking, Prior began painting about fifteen years ago. He is precise, almost mechanical about his painting. He says that after all these years he knows what he wants a piece to look like before he begins. Much of the creative or poetic aspect of his work starts before he picks up a brush.

He relies heavily on photographs to develop the image for a painting, but during the process of painting he constantly refers to reality. He changes the original colors and scale to make his art look more real than a photograph. For convincing subtleties of skin and hair, he must have his model sitting while he paints. Although his art has a sense of photographic realism, it is certainly never a copy of a photograph.

Unlike classically trained painters who work in layers over the whole surface of a canvas, Prior paints in zones. He starts in one section, usually the top or background, and puts in a single layer of finished paint. He moves from section to section, completing each small area of the painting as he goes along.

He says he doesn't worry about continuity even in very large pieces. He explains, "I can usually see the way I want it to end up. I am a steady, disciplined painter and I know what I am going to get when I put down the color. I know it's not the way you're supposed to do it, but I taught myself painting, and that works for me."

Prior is concerned that his paintings continue to improve. Much of his development has been through trial and error, working on his own without the benefit of formal training. However, he doesn't work in a complete vacuum; he has a group of friends, also realist painters, "who come over and point out what's wrong." With each new painting, he says the work gets stronger and he gets more confident.

WORKING METHODS

Prior's approach to painting falls into three phases: preparation, drawing, and the painting process.

He begins with an idea of a setting or a mood that he would like to convey with a figure. He explores the idea with photographs, thirty to forty exposures, which are posed, not snapshots. He lets his eye do as much creative work as possible, editing and eliminating to get a refined composition in terms of light, color balance, pose, and costume.

At this point he considers size and format and crops the photo to the proportions of the painting. Sometimes he also makes sketches to work out specific problems.

He paints on preprimed Belgian linen to which he adds two coats of Winsor & Newton oil gesso, gently sanding in between.

Working from his main photo study, to which he has added a grid, he draws the image on the canvas. The scene he is working from is usually close at hand, and any changes from the photo or the actual scene are made while he develops the initial drawing. At this point he might add or eliminate objects or move elements around. He says he does a lot of changing of scale when he is working from photos. He often enlarges the scale of the slats in a chair or a railing. If done in a subtle way, this enhances the sense of reality by making the objects fill the room a bit more.

When he is finished, the drawing is a simple, light, outline drawing with everything placed just as he wants it to be in the painting.

Prior uses Winsor & Newton oils. His palette consists of titanium white; Mars black; cadmium red, green, and yellow; Prussian blue; Naples yellow; alizarin crimson; and burnt sienna. His medium is half linseed oil and half turpentine. His brushes are small sable watercolor brushes of different brands.

He does not lay down an underpainting. From working outdoors, he says he has learned to paint in one sitting. He works in zones, basically starting in one corner and painting across to the other. He paints one small section at a time, usually starting at the top of the painting. He says it is easier for him to paint a large canvas if he can complete one small section of it every day.

Before painting a particular area or object, he mixes five to eight different values of the color he is using. He then paints the different values where they fit, mixing the values together as he applies them. His image is so clear in his mind that he rarely has to paint over more than a few small spots.

He proceeds through the painting, small section by small section, with the unpainted areas remaining white until he gets to them. After he has finished the entire piece, he occasionally goes back for small changes and refinements.

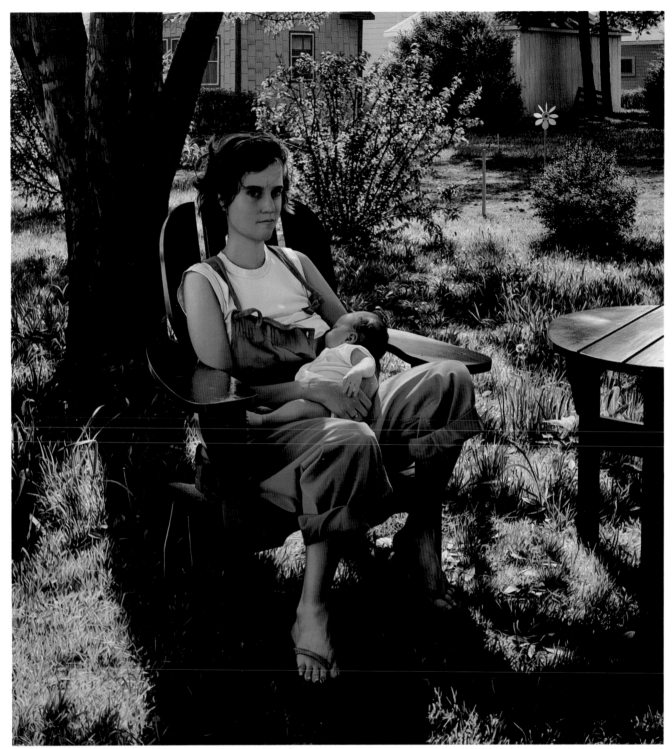

■ **NANNY AND MAX**
58″ × 54″ (147 × 137 cm)
Oil on canvas
Collection of Elise and Jerome Pustilnik

The artist says about this painting, "My wife, Nanny, had just had a baby, and I wanted to do a painting about early motherhood. I wanted Nanny's expression to depict the combined emotions of exhaustion, elation, and contentment. Maxwell was born in April, and I thought

the conjunction of his birth and new life in nature was too good to pass up. The apple tree in the backyard was the only place with shade for a portrait; so I had Nanny sit there while she was nursing Max. I wanted the painting to be about early spring sunlight as well.

"Once again I tried to get it right with the first layer of paint. I reworked the skin areas and the portrait particularly. The grass was painted in a relatively loose manner."

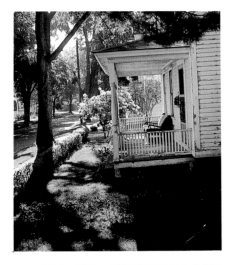

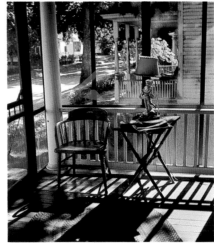

■ **NANNY AND ROSE**
66″ × 58″ (168 × 147 cm)
Oil on canvas
Courtesy of the Museum of Fine Arts, Boston
Gift of The Stephen and Sybil Stone Foundation

Prior describes this painting: "In all of my portraits I've wanted the subject to be personal, something of a documentation of my life at the time. This particular painting is of my wife, Nanny, and our dog, Rose. I rarely consider painting anything that I am not already very familiar with. This is the front porch of our house. At the time we had only been in the house for a month. Since the inside of the house was in upheaval because of painting and refurbishing, we would often have our meals on the porch. This painting came out of many breakfasts we had on the porch. I wanted the feeling of early morning reverie, the quiet time before the noise of the day begins.

"I try to lay down only one layer of paint. Only in a few places do I have to overpaint. I usually start a day by picking an area I know I can finish in a day and then working and finishing that area. In this painting the only parts I had to overpaint were the skin areas and the porch screen, which needed a light glaze over the outside landscape to give the effect of a screen."

■ **PHOTOGRAPHS OF DETAILS**

Prior used these photographs to develop details in the figure and the background. He works out all of the details in the drawing before he begins to paint. Photographs are a valuable tool for this artist, but mostly for developing the initial drawing. Once he starts to paint, he refers as much as possible to the live setting and model.

■ **PHOTOGRAPH WITH GRID**

Prior used this photograph as the basis for the painting Nanny and Rose. The photo was the result of many sessions with the model posing in different positions, lighting, and costumes. After he selected this image, he covered the photo with acetate and drew a grid over the image. From that he drew onto the canvas a light outline of the image he wanted to paint. The drawing was not a simple enlargement of the photograph, as we can see here from the changes in the table, socks, etc.

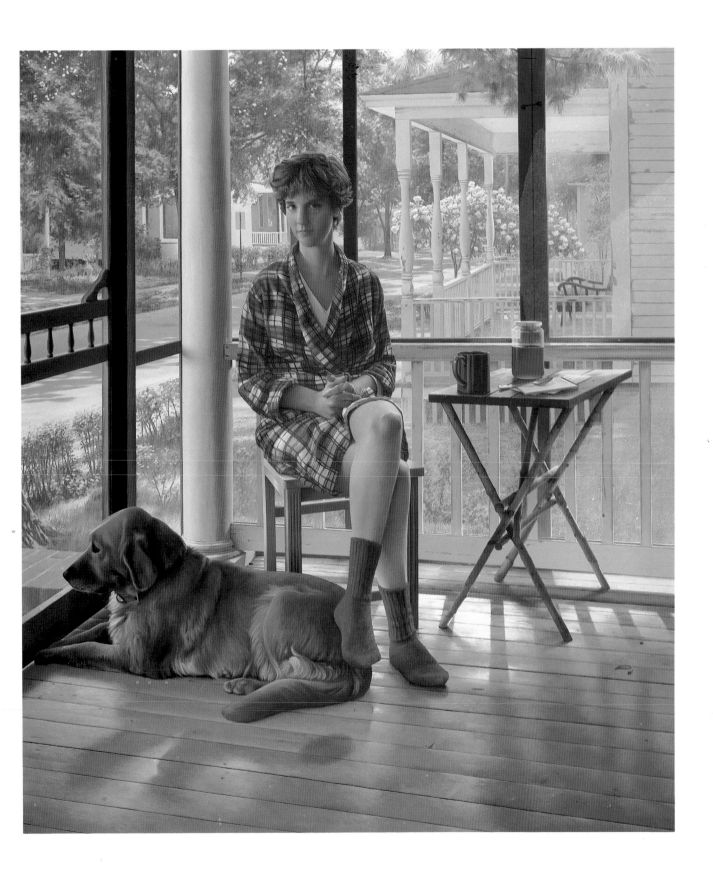

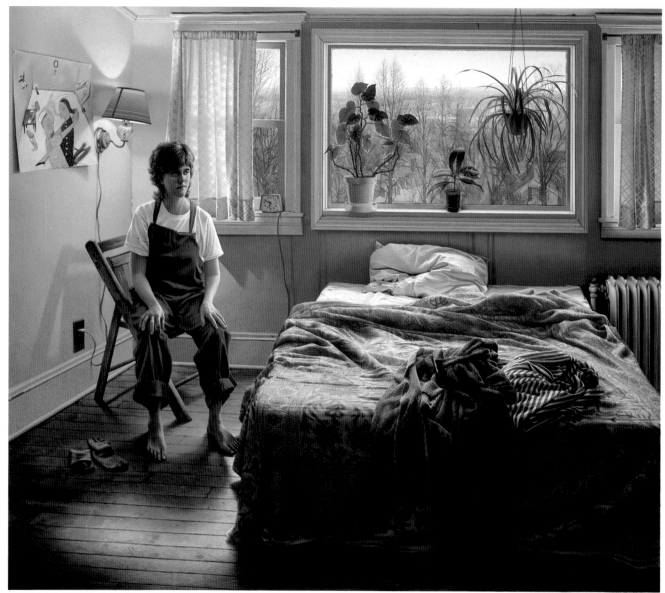

■ EARLY MORNING BEDROOM
78" × 90" (198 × 229 cm)
Oil on canvas
Private collection

"This was the first painting I did where I included a figure," says Prior. "Although I had wanted to include figures in my paintings for a while, I was not sure how I wanted to utilize the figure. I finally decided I did not want to paint the figure for its own sake, but more as a supplemental element in a larger view. I chose to do a painting of a bedroom with my wife included as a part of what amounted to a large, elaborate still life.

"I work in zones that I believe I can complete in one day or a solid chunk of time. In this painting I basically worked from the back to the front or generally from the top to the bottom. For instance, I would complete the view out the window and then paint the plants in the window, or I would paint the wall and curtain before painting the figure."

■ NANNY AT THE DRAWING TABLE
64" × 58" (162.5 × 147 cm)
Oil on canvas

Unlike many artists who use the setting just as a background for the figure, Prior gives equal importance to each element in his paintings. The figure is used as one more shape in the composition, placed in a balanced pattern with the other large masses—tables, rug, windows.

He provides harmony by repeating colors from a simple palette and by maintaining consistent lighting within the piece.

He achieves the very realistic effect in his art through precise draftsmanship and exact placement of color and value. He paints only with small sable brushes, even on very large canvases, so that the individual strokes are visible up close but blend at a distance.

MILT KOBAYASHI
A Tonal Approach to Painting

Milt Kobayashi's paintings have a rich, earthy quality, as if they had grown out of the soil. Much of that feeling is due to the color, gradations of brown with an occasional accent of blue or red. He considers himself a tonal painter rather than a colorist.

Because his main concern is tone or value, he begins any painting with a two- or three-value thumbnail sketch. Then on the canvas he blocks out the large shapes, establishing light, middle, and dark values with his brown tones. Even as he adds other colors besides earth tones, he blends them with gray to sustain color harmony, enhancing the tonal emphasis.

Earlier in his career Kobayashi was an illustrator, painting very naturalistic works. Since then he has flattened out his color and light, creating more pattern-oriented designs. An American of Japanese heritage, he says he has been greatly influenced by studying Japanese woodblock prints. In these prints the image is two-dimensional and figures appear almost as silhouettes.

Kobayashi is more concerned now with shape than with light. He rarely uses any strong light source, preferring a diffused light, straight on, to flatten out the figure. He has eliminated all excess detailing and simplified all the props, making them basic value shapes. He paints just enough detail to show what the figures are about.

He likes to keep the action of his figures tight, restrictive. Even his ballet dancers are very compact shapes. He says that extended figures lose their mass for him; he likes solid forms with no holes in them. Then because the figures are still, he also makes their expressions very quiet. He says he has tried more expression, but it makes the pieces too narrative. He wants his paintings to be timeless rather than moments in time.

Basically he looks at the figures as compositional tools, to provide movement and take up space. Expression is secondary. Most of his paintings are well-constructed, many-figured scenes with people placed amid other shapes to create a total design.

As much as he has flattened out his paintings, would he like to achieve the absolute two-dimensional image of the Japanese prints? No. His art derives from Eastern and Western cultures. The challenge for him is to achieve the synthesis of solid three-dimensional figures set into well-designed, flat patterns.

WORKING METHODS

Kobayashi keeps a sketchbook with him at all times; he says he never knows when he'll get an idea for a painting. He records the ideas in small sketches, drawn with chisel-pointed markers of light and dark gray.

Once he decides on a subject, he develops the concept with drawings and photos of models and backgrounds. He generally paints from photographs and elaborate sketches. He says that painting from life is too inhibiting; he feels it is a waste of his and the model's time. He would rather be free to attack his painting at his leisure and take frequent breaks to assess his work in progress.

He draws many preliminary sketches to work out value, composition, and figure placement. After half a dozen thumbnail sketches, he enlarges the size to 3″ × 5″ (7.6 × 12.7 cm) figure "comps," working out the gestures and arrangement of the figures on this small scale. After he picks his focal point from the selection of small drawings, he makes a larger, more elaborate sketch.

Composition is especially important because he is setting solid figures into a flat picture plane. He may want to keep the figures close to the viewer, in which case he will use contrast and overlapping shapes to make up for the shallow depth of field. Contrast is important in all of his work, light against dark values, transparent against opaque colors, hard edges against soft areas. He uses it to set off one figure against another or one plane against another.

Finally, after all of his sketches, he is ready to work on the canvas. He chooses a smooth surface, sometimes fine linen that he primes with acrylic gesso, sometimes preprimed canvas, sometimes portrait linen. To relieve the stark whiteness, he may tone the canvas with gray-brown washes.

He also will paint over old paintings. He likes the change of pace from working on a clean canvas. The texture of the previous painting feels sensual and grabs the paint nicely. He never paints with heavy impasto; so there are no deep ridges on the used canvases.

He draws the image on the canvas with a loose painted line using a color mixture of Mars orange and olive green. Drawing is very important to Kobayashi; he says it's the core of all his art. After the drawing, he washes in big, blocky shapes of middle and darker values.

He paints with Winsor & Newton, Grumbacher, and LeFranc & Bourgeois oils. He uses a medium of sun-thickened linseed oil that gives his paints a body that suits him well. His pattern is essentially tonal, relying heavily on grays and earth tones rather than a wide assortment of colors.

He uses a variety of techniques for applying paint; after his initial washes, he uses alla prima brushstrokes, scumbling, deeper transparencies, and palette knife work. To create a deep atmosphere, he applies transparent washes of earth colors, then paints with various opaque colors over the top.

Kobayashi says if he has done all of the preliminary work and developed the concept well, he sees the painting in his mind before he even starts to paint. He says a good painting is painted before it goes on the canvas; it seems to paint itself.

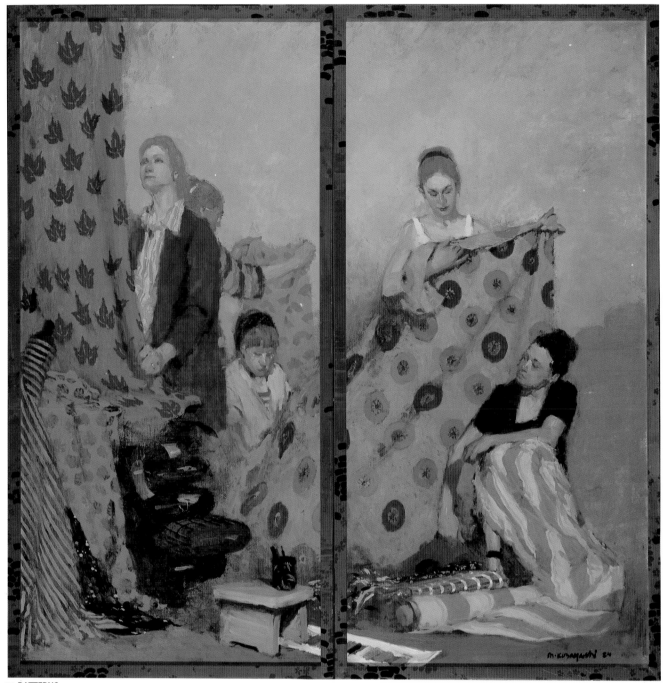

■ PATTERNS
42" × 42" (107 × 107 cm)
Oil on canvas
Private collection

This diptych is Kobayashi's attempt to confront the compositional problems of trying to create two canvases that work well together or separately. The idea of a garment room seemed an appropriate format for the patterns, colors, and abstract shapes he needed.

He did several small black-and-white "comps" in an abstract form because the thrust of the piece was compositional patterns. The "comps" were abstract groupings of rectangles and triangles he played with until he found a pleasing look. The figures were then superimposed over the shapes to complete the image. He says we should view this painting first as an interaction of abstract shapes; then we can better appreciate its various design elements.

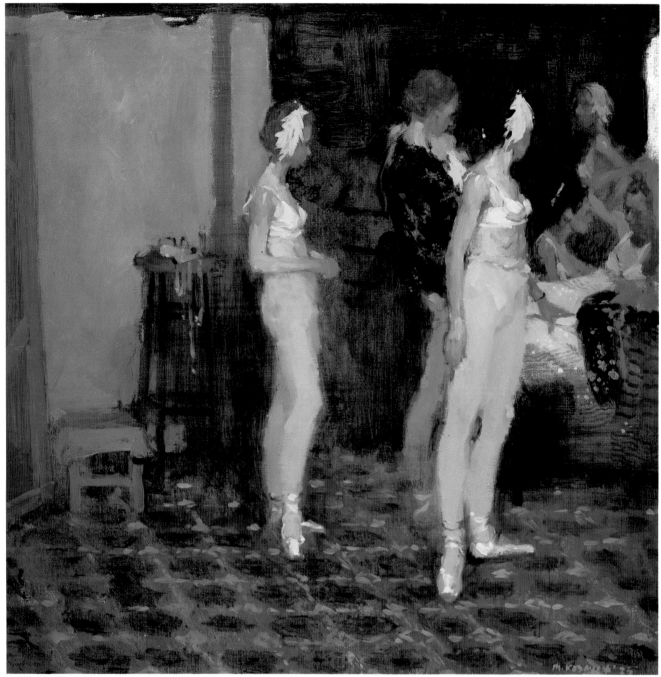

■ BACKSTAGE

21" × 21" (53 × 53 cm)
Oil on canvas
Courtesy of Grand Central Art Galleries,
New York

This painting of ballerinas shows the dancers devoid of the glamour of stage sets, lights, and costumes. Here they are very human, gangly young women with loose bra straps and protruding ribs. The artist says he likes this approach because it is more intimate. Successfully capturing an intimate moment is always difficult, he explains. It comes with years of re-examining until the point when artist, subject, and art become one.

Besides the human element, the backstage environment has other attractions. The ambience of the ballerina's world allows Kobayashi to manipulate the props and space in any direction. He can arrange at will the ballet studio, the dancers, their colorful array of costumes and props, and any other abstract shape he chooses to add to his painting.

He says this painting was so clear in his mind that preliminaries were unnecessary; it painted itself. He added the opaques over a series of transparent washes; the figures were done alla prima, and the floor was scrubbed and scumbled to give it a worn look as well as provide a contrasting texture to the figures. The light tan area behind the figures was applied with a palette knife for the same reason.

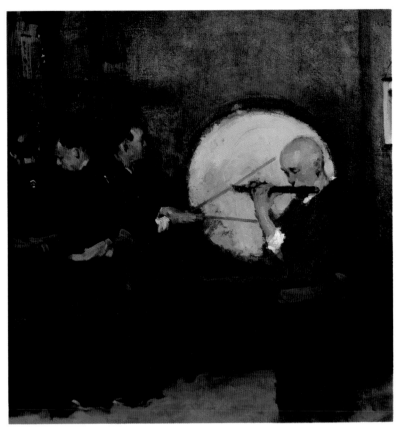

■ JAPANESE MUSICIANS

21" × 21" (53 × 53 cm)
Oil on canvas

Kobayashi chose this subject for the quiet, serene attitude of the figures. He likes depicting craftspeople and other artists because the subject matter is universal and never outdated.

The composition began with the foreground figure, the flutist, placed in front of the bright, round shape of the drum. However, the artist didn't want to become so involved with a narrative portrayal of the main figure that he lost the other figures and the serenity of the composition as a whole. So he moved the main figure out of the center and deliberately underplayed his features. Notice that the faces in the rear are as well-defined as the one in front; this keeps the visual interest divided.

Kobayashi wanted to achieve a timeless feeling in this painting. Notice how the quiet posture of the figures enhances the subdued atmosphere. Also the tones are muted, dark, earth colors that create a silent, serene atmosphere. There is an introspective quality to this painting that draws the viewer into it. All the elements work together: the compositional balance, the subtle color variations in the transparent tones, and the muted accents of vague color.

■ SHEET OF "COMPS"

In this sheet of small drawings from the artist's sketchbook, we see how Kobayashi developed the various aspects of the composition and figures for Japanese Musicians. In the upper right he tried different value schemes with the composition divided into basic geometric elements. Across the middle he worked with the pose of the main figure and his placement against the circular drum. At the bottom he arranged the grouping of the figures. Notice also the notes he made to himself about color.

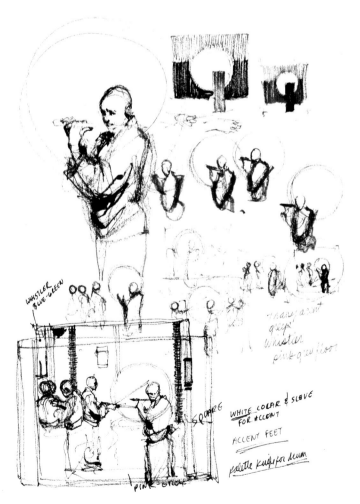

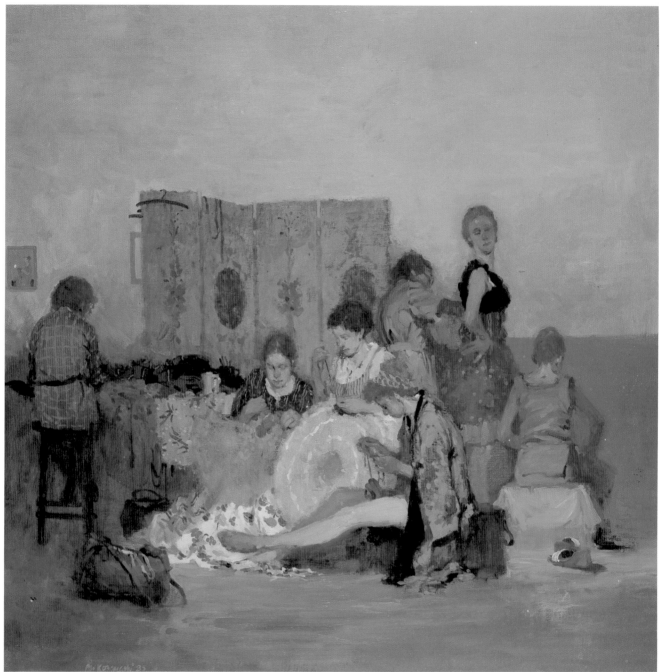

■ **PATCHWORK**
42″ × 42″ (107 × 107 cm)
Oil on canvas
Courtesy of Grand Central Art Galleries,
New York

The artist was inspired here by Utamaru (the eighteenth-century Japanese print artist), who depicted a wide range of women at work in quiet moments. Garment workers, like ballerinas, provide an endless source of colorful props and patterns. As Kobayashi has been more and more influenced by Japanese art, his selection of props and patterns and his use of space have become more simplified. This composition is basically three main shapes: the light negative space at the top, the darker value of the foreground, and the area of intense activity across the middle.

Kobayashi composes with perpendicular lines and shapes. He doesn't like diagonals. He explains that it looks too artificial to him when diagonals are used to draw the viewer deep into a painting. Horizontal and vertical elements work better for the serene quality he likes to achieve.

He says he painted the figures alla prima, a direct application of color, to avoid an overworked look. He used scumbling, transparencies, and palette knife in the rest of the painting for contrast.

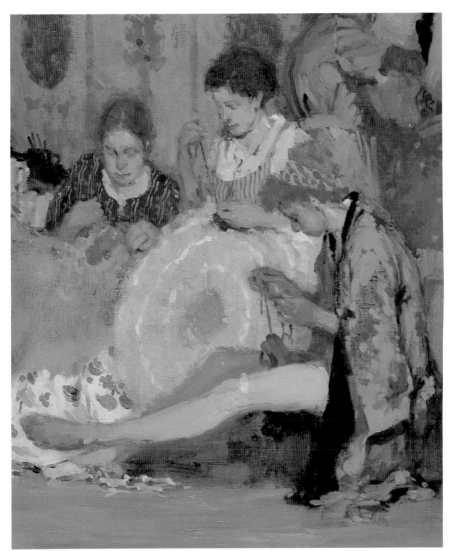

■ DETAIL

This closeup shows Kobayashi's loose brushwork. Notice how many of the features of faces and hands are not tightly rendered, but merely suggested. We also see here the wonderful contrast of the transparent brown washes appearing between areas of flat color. Notice how the textural patterns are created with specific strokes of opaque color. Also notice the use of red in the hair, shadows, clothes, and background. This repetition of color provides a unity of color to help balance the complexity of pattern.

■ DETAIL

Influenced by the Japanese, Kobayashi includes a minimum of detail. Those props that he does include are reduced to simple value shapes. In this bag there are no specific details. The artist created a believable sense of the bag with only the use of subtle value changes and directional brushstrokes.

CAROLE KATCHEN
Making the Impossible Work

In writing about other artists, I compare my manner of painting with theirs, and again and again I find that the things they say can't be done are the things that I do. I rub my pastels together, I erase them, I paint light over dark and dark over light—and I still end up with color that has a strong impressionist quality.

This unconventional, uninhibited manner of working with pastel grows out of my lack of academic training. Instead of taking art courses, I made funny, little line drawings of people doing things. By the age of twenty I had sold a children's book that I wrote and illustrated with those simple cartoon drawings. It was only after I had a fair amount of commercial success (that first book, I Was a Lonely Teenager, sold nearly a million copies) that I began to feel the lack of academic art knowledge.

I took classes in drawing, painting, and design wherever I happened to be living at the time. By my late twenties, when I decided to be a gallery artist rather than an illustrator, I had developed a strong line and an intuitive sense of color and design, but still had little academic knowledge of perspective, anatomy, and classical painting techniques. That has come later from teaching, looking at art, and writing about other artists.

Painting in Colorado where most of the successful artists have a representational style, I felt my lack of classical training as a severe handicap for years. Finally, though, I see that it has been as much an advantage as a disability.

Before I even began to paint, I knew exactly what I wanted to paint. I wanted to portray people involved with the world and with each other, concentrating on specific gestures and emotions. All I had to do then was figure out the best way to create each image, and since I had not learned the "right way" to paint, I was free to explore until I found whatever method worked.

What is it that this freedom of technique allows me to achieve? Like the French Impressionists, I am more concerned with activity and mood than virtuoso rendering. Rather than making statements about the subject, my paintings ask questions: Who are these people? What are they doing? What are they thinking?

My technique allows me to use bold, slashing strokes to convey excitement and then, in another part of the painting, to provide a sense of serenity by blending the colors together with my finger or a cloth. I overlay strokes of color so that every square inch of the surface becomes an interesting abstract painting in itself, and solid sections of color from a distance become unexpected bouquets of color close up. I want the viewer to become involved with the scene or figures in my paintings, but then to continue to be intrigued by the hidden surprises in stroke and color.

WORKING METHODS

Most of my paintings begin with a candid pencil sketch of a person or scene I have observed. I develop the idea further in a small watercolor study, concentrating on color and composition. Usually I work from life and memory; sometimes I refer to photos for details in a commissioned portrait.

I work on large sheets of heavy Morillo pastel paper of a middle tone or black. I do the initial drawing with Othello pastel pencils for a fine line; this is a simple outline drawing to show gesture and accurate contours. Next I block in my main areas of color with loose parallel strokes. I use Grumbacher, Sennelier, and Rembrandt pastels.

I usually start with only a few colors of different values so that as I place my color, I also begin to establish lights and darks. In the figure, for instance, I might use a light ochre for skin, a violet for middle tones, and a deeper purple for the darks. I often use grayed violets and purples to establish initial values. By using one main color in the underpainting, I can provide basic color harmony regardless of what colors I add later.

If I want strong surface texture in the finished painting, I leave all the strokes as they go on. For a smoother effect, I rub out the first layer of color with a rag. I do not remove all of the color, just enough to leave a smooth, transparent layer over the whole paper like a watercolor wash.

I develop color in layers rather like glazes, using hatched and crosshatched strokes of pastel. If I have begun an area of skin with ochre, I will hatch over it with pinks, light umber, and additional ochres until I get a solid skin tone. For shadowed areas I usually add darker cool colors—violet, green, or blue.

I do not rub or blend these colors together unless I am trying for an unusually smooth effect or I don't like the color I have put down and I want to wipe it out. Generally I put the colors on in individual strokes of pastel, creating layers of color with bits of the previous colors still showing through.

After I have arrived at the general colors, I work toward subtleties of value and intensity. I never use black to darken an area; instead I use combinations of deep blue, red, brown, purple, or green added in one layer or more of crosshatched strokes.

If an area is too bright and I want it to recede, I will gray the color by adding a layer or more of its complement—orange on blue, green on red, and so on. Sometimes if the total piece seems to lack harmony of color or value, I will lightly hatch over the entire piece with a unifying color like a soft gray-violet. For additional spark, I often add strokes of arbitrary color to the contours or details of the piece.

I finish my pastels by spraying them with Krylon Workable Fixative to minimize the pastel dust falling onto the mat or sticking to the glass. (Static electricity from washing the glass will tend to pull the chalk off the paper.) I use several light coats of fixative sprayed from twelve to eighteen inches away. Sprayed lightly and evenly, the fixative does not alter the surface or color of my painting.

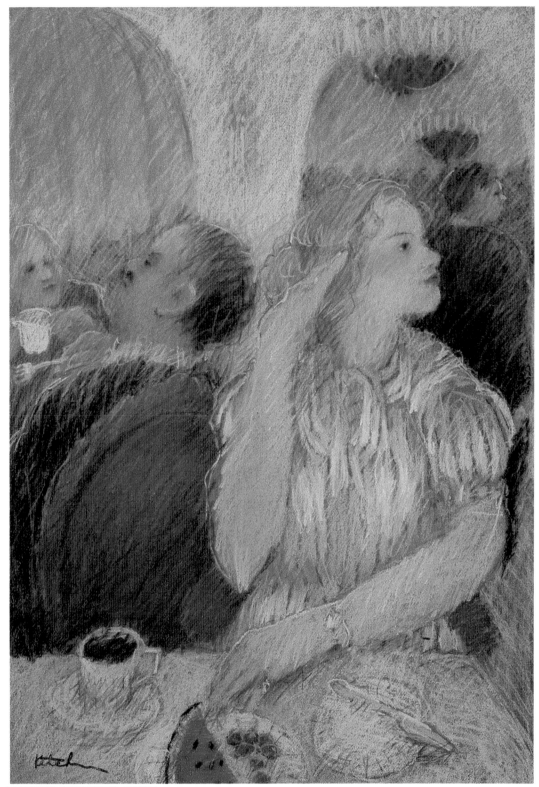

■ **BRUNCH AT THE HOTEL GALVEZ**
39" × 27½" (99 × 70 cm)
Pastel on paper
Private collection

On Galveston Island, Texas, there is a grand
old hotel where an elegant Sunday brunch is
served. The building is replete with columns
and chandeliers and just enough scent of
mildew to mark it as a genuinely old beach
resort. Sitting in the restaurant one Sunday, I
realized the setting was perfect for a portrait of
my breakfast companion, Frederica, a young
French woman who is also charming and
elegant.

I did a pencil drawing in the sketchbook I
always carry with me and made notes about
colors and details. I completed the painting
back in my Denver studio. I liked the contrast of
the red, white, and blue, but to provide har-
mony, I added ochre as a "mother color," a
color that I blended into all the others to give a
sense of unity.

■ STUDY FOR SACCO CAFFE
9″ × 12″ (23 × 30 cm)
Watercolor on paper
Collection of Margaret Gaskie

This is a favorite cafe where I often meet a friend for coffee when I am in New York. One rainy afternoon I stopped there for lunch. I happened to have a block of watercolor paper with me; so I drew an initial sketch right on the watercolor paper. On a separate sheet I made notes about details and colors so that I could complete the study later.

When I took my first painting trip, an excursion to Ethiopia in 1971, I deliberately took sketching materials and no camera. I felt that I would be forced to see and remember more if I didn't have the convenience of photographs. Although I don't remember everything, over the years my memory has improved to the point that I can look at a quick sketch of a market in Nigeria and recall not only shapes and colors, but also sounds and smells.

Step 1 This drawing was the first step for the painting shown on page 50. I always use a toned paper so I can add both lighter and darker values; here the paper is green. I chose a yellow pastel pencil to draw the image because yellow would show up on the dark green. The emphasis here was on placing all the elements of the composition and establishing accurate contours and gestures.

Step 2 Here I began to establish values and colors. The lightest areas are the skin, a light ochre, and the background, very light grays. The darkest values are placed with Caput Mortuum. The middle shades are green, violet, and a red-brown ochre. The color is drawn in with a loose diagonal or hatched stroke, generally covering the whole paper.

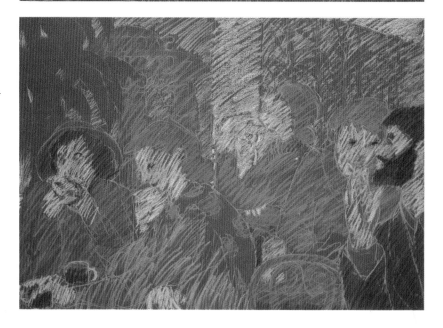

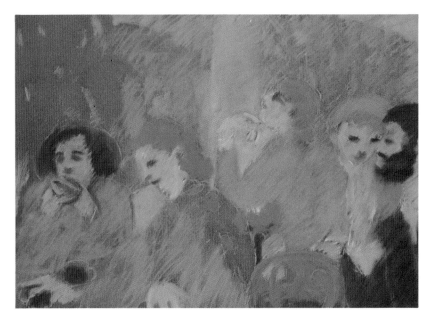

Step 3 Because the feeling of the original watercolor was light and airy, I wanted to develop a smoother base of color. So I softly blended each area of color with a rag, leaving the colored shapes separate. With a corner of the rag that had dark chalk on it, I marked the facial features and other dark details.

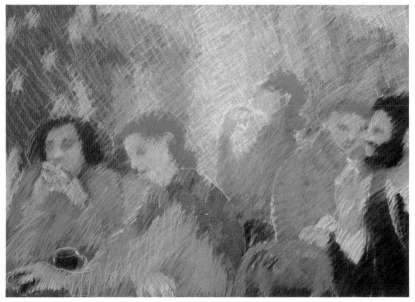

Step 4 After wiping down the colors, I redrew the same shapes with the original colors to make them more intense. Then I began to layer other colors, almost like glazing with watercolors. This is very obvious in the plants, upper left. You can see that the original color was green; over that was added a layer of light, blue strokes.

Although I was building toward final colors, I was more concerned at this stage with establishing form and value. Notice that all four women's clothes were painted with the same violet, blue, and ochres.

I had begun to indicate highlights from the windows by marking edges with a very light umber.

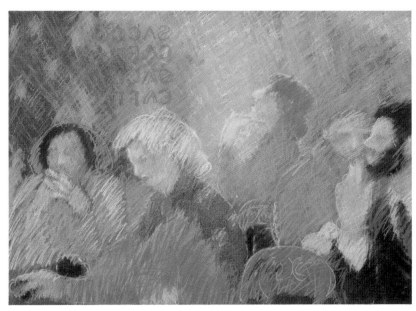

Step 5 Here I was beginning to develop final colors, adding bright yellow, orange, and violet. Notice that the same orange was used throughout the piece wherever a bright, warm color was needed. This repetition of color adds to the color harmony. Notice the gray area in the background where the texture seems smoother. To soften selected areas, I wiped out areas in diagonal strokes with a paper towel over my finger. I smoothed some of the skin areas by rubbing them with my finger.

I had decided that the intense value contrast of the small watercolor wouldn't work as well in the large pastel, so I was gradually building up a deeper background color.

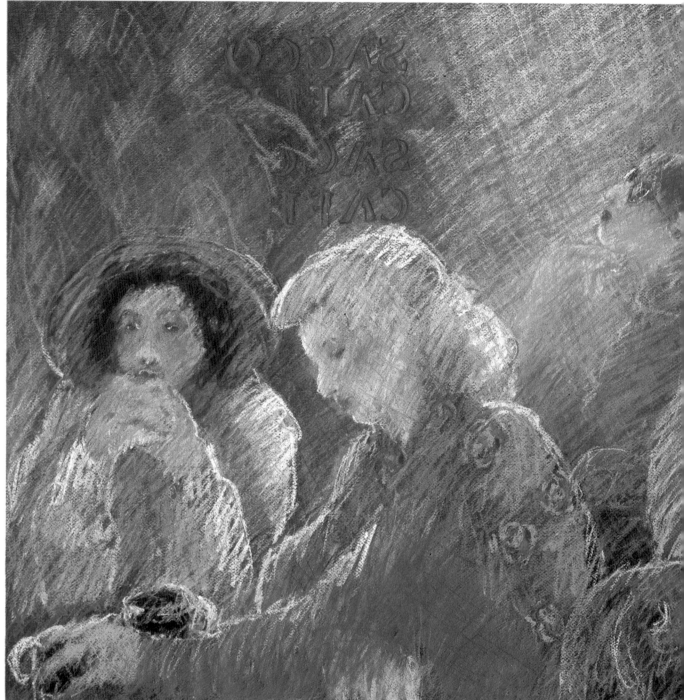

■ SACCO CAFFE
27½" × 39" (70 × 99 cm)
Pastel on paper

In the finished painting, each area of color is actually a combination of many colors layered in hatched or crosshatched strokes. A yellow area, for instance, may consist of many yellows, ochres, orange, and even violet.

After the basic colors and values were established, I redefined contours and details. In most cases I drew the details, like facial features, with specific strokes and then crosshatched over them with a basic skin color to maintain the same looseness throughout the painting.

Notice the short lines of rose and blue on the contours of the figures and plants. I often add these arbitrary accents of color to give the final painting an extra spark.

■ DETAIL

This detail shows how each small section of color is actually comprised of strokes of many different colors. I like my paintings to have a lot of activity in subject and execution. Activity on the surface is provided both by the rough texture of the paper and by the variety of individual strokes.

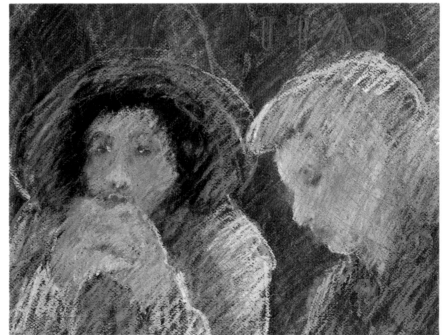

■ DETAIL

I wanted the woman on the left to have a dreamy expression; so I blended some of the color around her eyes with my finger. Generally I like details in my art to be more suggested than tightly rendered. Look at her hat; we know it's a large hat, but the color and shape are left ambiguous. I was working toward a total mood or impression rather than an exact representation of a scene.

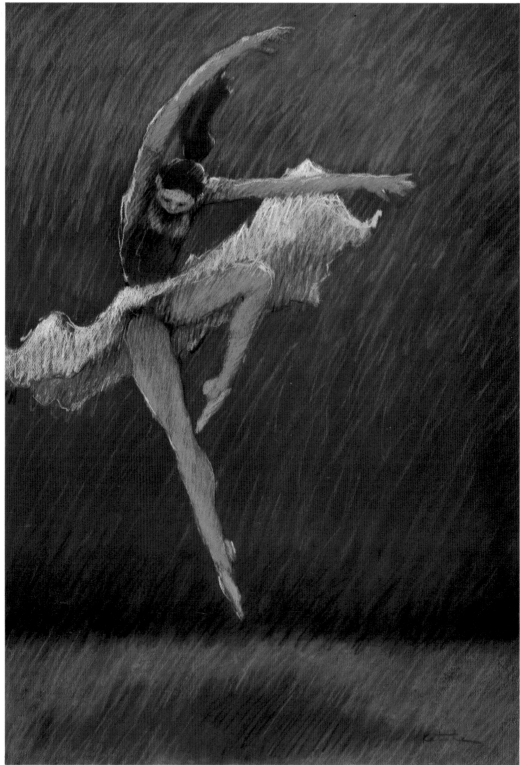

■ **SUSPENDED**
39" × 27½" (99 × 70 cm)
Pastel on paper
Courtesy of Saks Galleries, Denver

Painting dancers in motion is a tremendous challenge, because even if you get the anatomy and the pose exactly right, you still might not convey a sense of the movement. This painting works because of a combination of anatomy, gesture, stroke, and placement on the paper. Notice how the slashing stroke and the shape of the skirt add to the effect of upward motion.

I rarely draw anything from photographs and especially not dancers. In order to capture the movement, I have to have a sense of where the dancer is coming from and going to; in photographs that continuity is missing. I have taken years of dance lessons and I have spent untold hours sketching in dance studios and theaters. When I see a dance gesture that I want to draw, I feel it first in my own body. Where is the stress? Where is the weight? What is contracting or extending? After I sense the movement in my own body, I can put it on paper in a few lines.

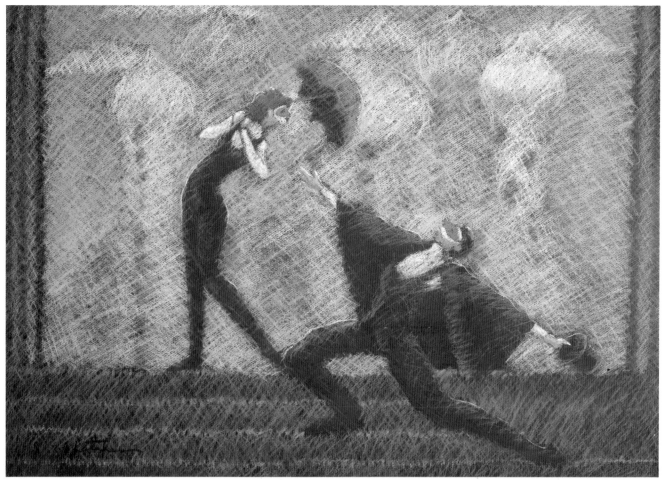

■ MIME LOVERS
27½" × 39" (70 × 99 cm)
Pastel on paper
Courtesy of Dr. and Mrs. James Friedman

This is a scene from The Nose, *a production of the University of Houston Mime Troupe. Like mime itself, I wanted to convey the total scene with no more than a few props and the actors' very expressive gestures.*

Besides showing his ardent devotion, the man's outstretched arms serve a compositional function as well. Notice how the diagonal of his arms divides the space and also offsets the horizontal and vertical lines of stage and curtains.

Originally I painted the background with as much contrast and definition as the figures. Then I decided it should recede more; so I went over the whole background with several crosshatched layers of pink and violet strokes.

JOSEPH JEFFERS DODGE
Evolving into Simplicity

In 1940 Joseph Jeffers Dodge graduated from Harvard with honors in fine arts. Although he has spent much of his time since then as curator and director of art museums, he has also continued to paint the figure. In an art career that spans nearly half a century, Dodge has explored subjects and media, colors and compositions to arrive at what is now a strong and simple style. For some artists technique means virtuoso brushwork and dramatic color combinations. For Dodge, technique is an elegant simplicity.

The surface of his paintings is smooth and placid. He paints many thin layers of oil. Brushstrokes are blended together so that they present a solid rather than fragmented surface.

His early paintings were filled with symbolism and allegory. The compositions included nudes and sunbathers, guitarists and trombonists, tourists and rock climbers, all painted in a stylized realism. They were placed in elaborate environments with tightly rendered details to show who the people were, what they were doing, what they were thinking.

Dodge says that although almost all his current paintings are still about something "more than meets the eye," now they are simpler. He uses one object instead of ten. In a figure painting he focuses on the expression and the gesture of the model to convey who the person really is without resorting to involved scenes and props.

He describes his work: "It is realistic, somewhat idealized in the classical sense. I tend toward order, balance, and clarity; it isn't a conscious process. I look for subjects that have some sort of resonance or emotional overtone."

He is concerned about light, in a way more like Vermeer than Monet. He doesn't think consciously about the light while he is painting, except for the direction of the light source, which makes the light and shadows throughout the piece consistent. He also concentrates on the relationships of light in one part to another; he adjusts everything in the painting to work together, striving for a glow of lights and shadows.

Unlike some artists who are constantly looking for new, unusual models, Dodge has found a few models over the years whom he has painted again and again. He prefers painting beautiful women. He must like their looks and personality and they must enjoy modeling for him. The challenge for Dodge is not in exploring new subjects, but rather in expressing new facets of a model who has become comfortable and familiar.

Explaining the evolution of his work, Dodge says, "When you are younger, you can be more romantic, poetic. As you get older, you get simpler."

WORKING METHODS

Dodge works from photographs, sometimes putting in several all-day sessions with a model for one painting. He then uses simple pencil sketches to place the figure in the format or to combine elements from different photos—the pose from one, the background from another.

His favorite painting medium is oil. He dislikes canvas because of its rough texture; so he usually paints on paper board (100 percent rag). He coats the board with one to three layers of gesso, then sands it to a fairly smooth surface, what he calls "an eggshell surface."

He begins the painting with many thin layers, working delicately and tentatively at first. He says the paint begins to go on better after he has built up a foundation of three or four layers. As he adds the layers, he makes "infinite" corrections and refinements of shape, contour, and color. He works until he can see nothing that he is able to improve. His paintings progress from the general to the specific, often a long process of distillation.

He blends his oils with a medium of one-third linseed oil and two-thirds artist's rectified turpentine. His painting tools include "bristle and sable brushes, sometimes my fingers, and a painting knife."

He strives for a thin, matte effect. He blends each layer toward a final smoothness of color and surface, which he feels gives his paintings an appearance of greater unity.

Besides oil he works with a variety of less favorite media. With acrylic he works thinly, as with watercolor, but also uses some white. He prefers acrylic to watercolor because it is easier to paint in many thin layers.

For preliminary studies he often uses ink or pencil. With finished studies, not simple sketches, he also works in layers, slowly building up his values. He dilutes the ink so that he can paint in thin washes.

In his paintings he generally sticks to a limited range of earth colors: ochres, umbers, siennas, blues, black, and white. Only occasionally will he go outside that range for an accent or some tone he can't get otherwise. Primarily he is concerned with composition, form, contours, textures, and light—not color or personalized brushstrokes or decoration.

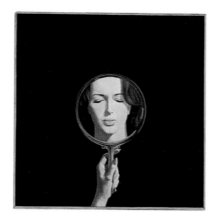

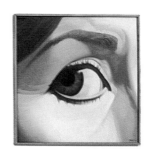

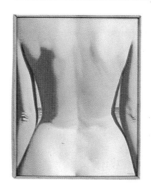

■ PORTRAIT OF LAURA JEANNE—SELECTION

This group of twelve oil paintings is only a small selection of the forty-five oils that Dodge painted in his segmented portrait of Laura Jeanne. This project was based on the assumption that no one image of a person is more than a part of that person's appearance or personality and, furthermore, that the viewer rarely sees the subject as a whole but sees, or focuses on, different parts and different expressions over a period of time.

Although this group shows different parts of the subject's face and body, the project was not an attempt to catalogue her anatomical parts. Rather, the artist wanted to project a total sense of the woman's personality and emotions. Even though many of the paintings show parts of her body other than her face, they were also chosen to reveal aspects of the subject's feelings and identity. As in all of Dodge's work, the painting on the surface is an attempt to lead us into a deeper awareness of the subject.

■ **PORTRAIT OF LAURA JEANNE—REAR TORSO**
20″ × 16″ (51 × 41 cm)
Oil on canvas
Collection of the artist

For this composition Dodge used only a segment of the model's back; yet it reveals much of the artist's perception of this woman. The pose and the portion of the subject's body show a perfect "hourglass figure," the traditional ideal of femininity. It is not a soft, passive femininity, though, because he painted her with a strong, assertive, straight posture. With the little bits of beach and ocean showing in the negative space, he suggests an adventurous spirit.

He drew the subject onto the canvas with charcoal first, then painted with his usual technique, a gradual layering of color. He used his usual palette, but in a range and intensity to suggest the sunlit beach. He says the most difficult part of this painting was modeling the form from the waist down to the upper buttocks with its change of color and its subtle changes of shape.

■ **PORTRAIT OF LAURA JEANNE—DRAPED TORSO**
37″ × 24″ (94 × 61 cm)
Oil on canvas
Collection of the artist

Dodge painted this piece on preprimed canvas that was toned to a warmish middle value. With a brush he blocked in the outlines and shadows with umber and the lightest areas with white. The only colors he used were white, raw and burnt umber, and burnt sienna.

He decided to paint the subject draped because the drapery motif seemed a good way to suggest the beauty of her figure. He liked the suggestive combination of modesty and sexiness, as well as the visual pleasure of the drapery's rich shapes and patterns of darks and lights.

He says, "In my best work there's always an element or overtone of mystery or suggestive ambiguity, as well as a delight in the abstract elements of shape relationships. Neither realism for its own sake nor decorativeness are my aims."

■ INTERLUDE ON THE ROCKS #4
22" × 30" (56 × 76 cm)
Acrylic on paper
Collection of the artist

Figures and rocks are among Dodge's favorite subjects, singly or in combination. He says that in quarries, seashores, or ruins, rocks provide a wonderful setting for figures, giving the contrast of soft against hard, curves against angles and smooth against rough. This particular background is an outcropping of "coquina" rocks on the Atlantic beach in Florida, between St. Augustine and Daytona.

He worked here with a model who has been a favorite for nearly twenty years. They spent several all-day photo sessions using the same pose with and without a skirt and a cloth wrapped around her head. He executed five preliminary studies in color or pencil, relating the figure to different combinations of rocks and backgrounds.

His interest was to convey "the visual pleasure of shapes and their relationships, the fantasy of the rocks and the mood or poetic overtones suggested by all the elements of the composition." Despite the solid realism of the painting, the artist has succeeded in creating an other-worldly effect.

He painted this piece using acrylics. To achieve the same smoothness as his oils, he diluted the acrylics with water and created the image with many thin layers of color.

■ INTERLUDE ON THE ROCKS #2
(Preliminary study)
10½″ × 13½″ (27 × 34 cm)
Ink on paper
Collection of Mr. and Mrs. Edward Klempf

*Dodge tried the figure in this pose with a variety of costumes and backgrounds before he decided on the composition in his final painting (*Interlude on the Rocks #4*). This piece is one of the variations. He painted this study with ink and occasional use of opaque white. He says his palette was limited by the three or four colors of ink he had on hand. However, it is typical of his work in that it is executed in basic browns and blue.*

The artist says the hardest aspect of completing this study was not making mistakes while working with ink. He diluted the inks and worked with thin washes, and despite the unforgiving nature of ink, he achieved his usual smooth surface.

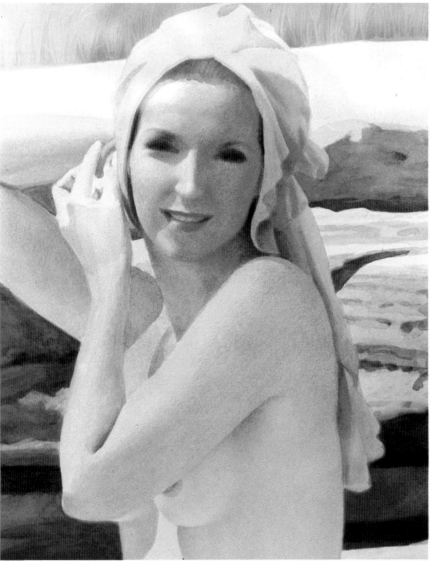

■ DETAIL

In this closeup of the model's face we see the soft, smooth quality of Dodge's completed painting. He achieves this solid-looking surface by patiently applying layer after layer of color. He approaches the background with the same meticulous attention as the figure. Look at the strong definition of the rocks and the individual grasses along the horizon.

In this painting we can also see Dodge's preoccupation with light. He has carefully established a consistency in the highlights and shadows, both in direction and in color temperature. In the background as well as the figure, it is obvious that the light is coming from the upper left, making the shadows fall to the lower right. All of the areas in sunlight are painted in warm tones; the shadows are cool. Look at the model's hand; notice the drama Dodge has created by leaving almost-white highlights.

■ TIA
18½" × 22½" (47 × 57 cm)
Oil on paper
Collection of the artist

This is one of the most recent of Dodge's paintings. It is consistent with his earlier figure paintings in that the model is a pretty woman, the pose is simple, the palette consists of basic earth tones, and the brushstrokes blend together. The differences are that the woman is more real than the romanticized women Dodge painted in the past and she is set in a totally austere environment.

The subject of the painting is the artist's eldest daughter, Tia. While she was visiting, she unself-consciously sat in a graceful pose in the light of a sliding glass door. Dodge shot a roll of film and then did several pencil drawings and two oil studies. He started the final painting by drawing with charcoal on gessoed watercolor paper; then he painted with brown oils over those initial lines.

He tried for a balance of warm and cool colors, all grayed a bit. His palette included Venetian red, ultramarine blue dark, burnt and raw umber, yellow ochre, black, and white.

He also sought balance in the composition. Look at how the face (upper right) balances the hand (lower left). Also notice the balance and repetition of the arched shapes in the chair and face and the lovely interplay of light and shadow throughout the painting.

■ STUDY FOR TIA
14" × 15½" (35.5 × 39 cm)
Oil on paper board
Collection of the artist

This is one of the oil studies Dodge did for his portrait of his daughter Tia. By comparing this study to the finished painting, we can get a better sense of how Dodge develops a concept for a painting.

Here he made the dress orange and the chair blue, painting in the herringbone pattern of the
upholstery; in the final painting he reversed the colors, using a warm chair and a cool blue dress to contrast with the warm flesh tones of her face. He changed the background from a cool, yellowish color to a deep warm tone similar to, but lighter than, the chair. By using a similar color for the chair and background, he further simplified the composition. Finally he turned the subject's face more toward the viewer and gave her a softer, less intense expression.

SUGGESTED PROJECT

Dodge suggests that you choose a model you like and with whom you have rapport artistically. Gather a selection of garments, a camera with a portrait or zoom lens, lots of film, some refreshments, and take all to a location which appeals to your sense of design, mood, nostalgia, or other sense. Let the model do his or her "thing," with general suggestions from you, and take lots of pictures. Keep in mind the light—its source, direction, intensity.

Look at the resulting pictures for several weeks; put them away; look at them again after a month or so. Look at them upside down and in the mirror. Look especially at parts you weren't conscious of when taking them, like the background, the drapery, the cast shadows.

Then, combining *two or more* (that is, elements from more than one picture), work up a composition that satisfies whatever needs you have that made you take up painting in the first place.

WILL WILSON
Recreating a Classical Era

Will Wilson has painted elaborate scenes with many figures and much activity, but his favorite paintings are simple portraits. He explains, "I feel like there is a whole world in a face."

Wilson is one of a family of artists. He decided to become an artist at the age of nine when he saw an N. C. Wyeth exhibit at the Brandywine Museum. His art training started at the classically oriented Schuler School in Baltimore when he was fifteen.

His classical training and his love of the old masters are obvious in his portraits. They are painted with the attention to anatomical detail and the subtlety of color of another era. Many of his subjects are chosen because they evoke the feeling of an earlier time.

Wilson's main concern in a portrait is capturing a likeness of the subject, both a spiritual and a physical likeness. His paintings often have a thoughtful, even melancholy air. "If I were to paint a room full of people," he comments, "they would be more somber than happy. I'm not a negative or sad person; actually I'm rather outgoing. I guess I'm just sensitive to those feelings."

Another of his main concerns is creating a depth of atmosphere or space. He wants his paintings to show light and form in space. He says he wants people to see the back side of the object he is painting. He pursues this goal with subtle variations in color and value, explaining that a flat, monotone surface will stop the viewer's eye. He finishes each painting with transparent glazes, creating a luminosity that lets the eye move through the painting.

Despite its classical feeling, Wilson's work is not painted in a timid or ponderous way. On the contrary, he applies his strokes and colors with exuberance, blending the surface color after it is laid down in thick, fast strokes.

He is constantly striving for "good flesh" because, he says, there is no such thing as flesh color no. 1 or flesh color no. 2 that you can just squeeze out of a tube. There are many colors in flesh and the artist's job is to separate out those colors, looking for the areas that are warmer and cooler, brighter and grayer. Wilson is not afraid to exaggerate the colors in order to give them greater impact; if the cheek color looks warm, for instance, he might paint it with an intense red.

Wilson says he is not trying to paint in a particular style. He believes style is something that you let happen. He is more intent on quality. "One of my main concerns," he says, "is that I remain as critical of my work as I am now so that ten years from now I am that much better."

WORKING METHODS

Wilson has a definite procedure for developing his portraits. He begins with thumbnail sketches, approximately 4″ × 5″ (10 × 13 cm), to formalize his idea. It might take as many as ten small drawings before he is ready to develop the idea further. In these he concentrates on basic gesture, values, and composition.

Next he searches for the right model. Often he will work with friends or relatives; sometimes he looks in bars for just the right person.

Before he approaches the canvas, he completes at least one detailed drawing with charcoal on paper. This is to familiarize himself with the model and to develop expression. He prefers working from life. He says it is essential for developing the face and hands. However, he occasionally refers to black-and-white photos for details of drapery and such. He stays away from color photographs because of color distortion.

Finally he is ready to work on the canvas. The linen canvas is primed with two to four coats of rabbitskin glue, one part glue to forty parts water; then two or three coats of white lead are applied with a palette knife. Finally the canvas is toned to a light grayish color. Sometimes he draws the image onto the canvas with charcoal, but generally he starts working with paint immediately, blocking in the main shapes with raw umber. He tries to establish his value range from the very beginning.

By the second day he is using full color. He mixes his own paints, powdered pigments ground with a cooked, cold-pressed linseed oil and litharge. His brushes are oxhair filbert brushes, all brands, and Kolinski sable brushes. His medium is maroger medium; he uses cold-pressed, washed linseed oil, adds lead and cooks until it is black, then adds mastic varnish. He believes this medium is close to what the Flemish masters used. It lets the paint glide off the brush for a longer stroke, allows transparent glazes, and dries quickly because the oil is cooked.

He paints from thick to thin, starting with heavy brushstrokes. He says he is usually working on six to ten paintings at once; so if he begins a piece with quarter-inch impastos, he can let it sit and dry for six months.

He uses thick strokes initially so that the color will be more intense. The strokes are blotchy and uneven; then he blends the colors together with sable blending brushes so that the total effect is very smooth, especially within the figure. Often he leaves heavy, loose strokes unblended in the background to provide an interesting texture.

In the next stage he redraws the image over the first layer of paint and then repaints it. He continues this process of redrawing and repainting, refining the image with each step, until he has achieved the accuracy of shape, value, and color he is seeking. He is especially concerned with correcting lighter values before he begins the final step.

Finally he adds glazes of paint mixed with more medium to change hues, enhance colors, and deepen values. He says a typical portrait will take five days to three weeks.

■ PATRICE
22″ × 20″ (56 × 51 cm)
Oil on canvas

This portrait of a young woman is more playful than much of Wilson's work, a wonderful blend of realism and fantasy. He painted the face and figure with his usual precise realism; look at the tight rendering in the face, the beaded earring and glove, and the silk blouse. Then in the background and the curls of the hair he made a transition to loose, abstract patterns.

The color is especially adventurous for Wilson. Besides the complementary red and green in the figure, he has used a full rainbow spectrum for his background. This painting was less fully planned than most of his work. He says he developed the background as he went along. The painting succeeds because Wilson has the skill to create a deliberate contrast between tight realism and loose abstraction.

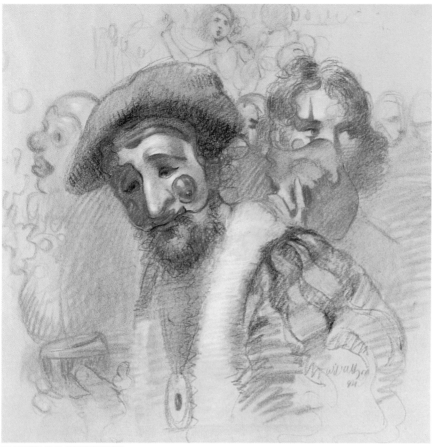

■ **STUDY FOR MASQUERADE**
11½" × 16" (29 × 41 cm)
Pastel on paper

*This is one of the many preparatory drawings
Wilson did for his large oil* Masquerade. *These
two figures, the man in the striped robe and the
woman with the mask, appear to the left in the
finished painting.*

■ **MASQUERADE**
40" × 60" (102 × 152 cm)
Oil on canvas

*This piece was inspired by a masquerade ball
the artist attended. To develop the painting, he
used family and friends as models; costumes
were provided by a friend who let the artist
select from his store, and the background was
made up as the artist worked. He made "many,
many sketches," then ten to fifteen larger draw-
ings and one small color sketch. He says the
hardest aspect was developing the composi-
tion with all of those figures.*

*The painting is not so much a realistic party
scene as a fantasy or dream image, an effect
caused by the interweaving of realistic and
distorted figures, the overly brilliant colors, and
the telescoping of the background.*

■ **STUDY FOR SELF-PORTRAIT**
24" × 16⅝" (61 × 42 cm)
Charcoal, chalk on paper

In this preliminary drawing Wilson was work-ing out the pose and expression for a painting in oil. He used dark charcoal here to establish the basic value patterns within the figure. He made a simple, basic pose into a more interest-ing composition with opposing directions of movement. Look at the diagonal line, from upper left to lower right, created by the head, neck, and edge of his shirt under his armpit, and then notice the opposing diagonal created by the front arm.

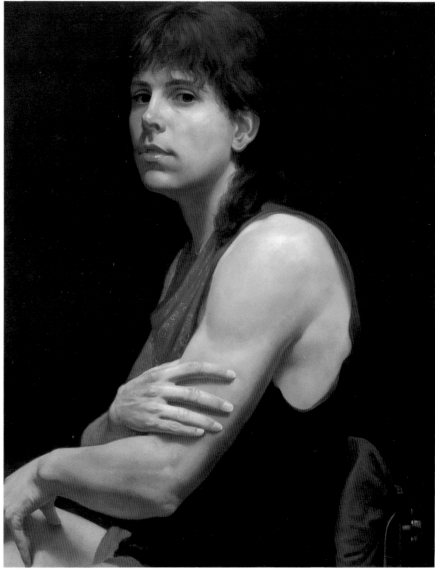

■ **SELF-PORTRAIT**
22" × 18" (56 × 46 cm)
Oil on canvas

One of the changes in this painting from the original drawing is the increase in tension. The chin has been tilted up and the eyes made more precise to give a wary expression. Also, the left hand has been drawn in with a tight, angular placement of the fingers and thumb.

The painting is basically monochromatic,

developed in umber, except for the red accents. The scattered use of red makes the viewer's eye move around the painting rather than just settling on the face.

Wilson says the most difficult aspect of this piece was working out the foreshortening. Be-cause the left shoulder and right hand are closer to the viewer, they have to be proportion-ately larger than the face and the rest of the figure.

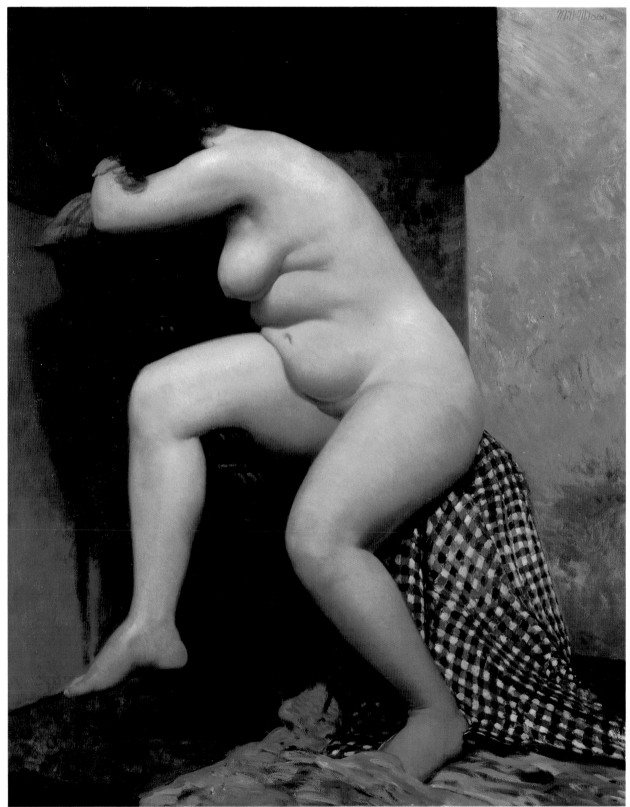

■ **SEATED NUDE**
24" × 20" (61 × 51 cm)
Oil on canvas

In a society where thin is considered beautiful and fat ugly, Wilson visualized this heavy model as the subject of a beautiful painting. He saw the woman in terms of her voluptuous masses and feminine curves and created an elegant painting.

The painting is about flesh, and that is what the artist has taken the most care to develop. Look at how carefully he has built up the volumes with subtle variations of warm and cool, light and dark skin tones. As in all of his paintings, Wilson paints the skin first with rough, heavy strokes; then with soft sable brushes he blends the color together to give a smooth feeling.

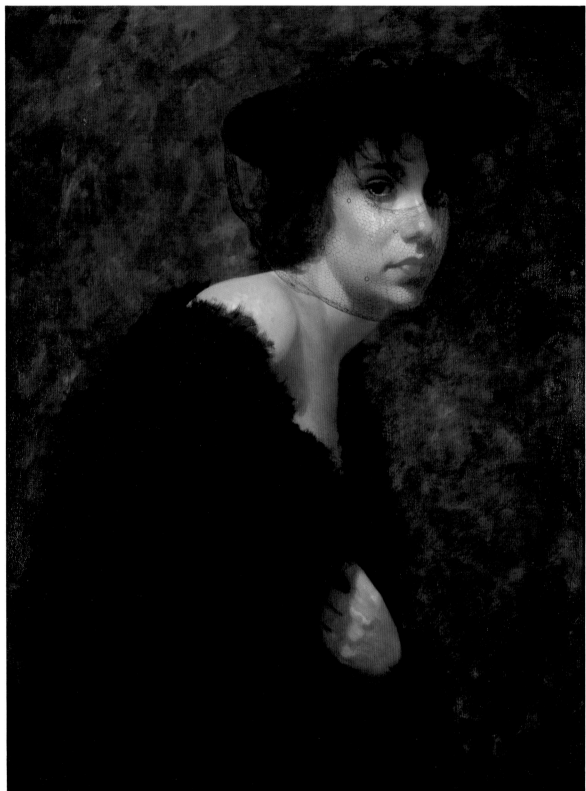

■ EVE SANS ADAM
24" × 18" (61 × 46 cm)
Oil on canvas

Wilson says he envisioned this painting long before he started it. He was at a friend's funeral, and the sorrow of one of the mourners moved him to paint this subject. He looked for about a year before he found a model with the face he wanted.

He worked with natural somber colors, ex-cept for the bright reds which he chose as contrast to the melancholy mood and for dra-matic effect. Notice how he used red in the background as well as the figure.

He added movement to the painting with the curved shapes of the background and the pose and with the vital brushwork in the back-ground. The head placed in front of the shoul-ders gives a more dynamic shape to the figure than a simple, straight posture.

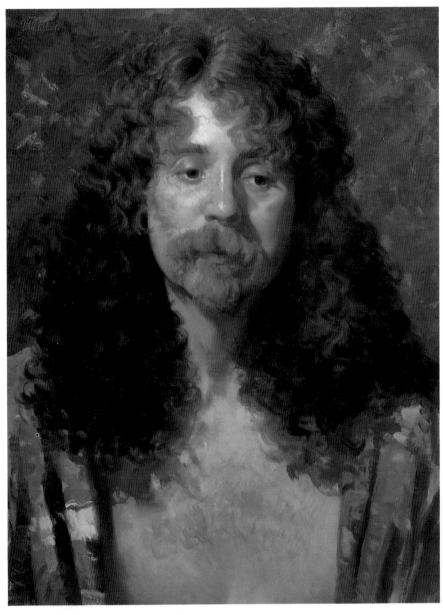

■ CHARLES
20" × 16" (51 × 41 cm)
Oil on canvas

Wilson is always observing people, looking for possible new models. He saw this man in a bar and decided to paint him because he looked like he had just stepped out of Rembrandt's Night Watch.

As in much of Wilson's work, the color is very simple, warm browns with accents of red in the face and yellow and violet in the robe.

He begins his paintings with heavy brushstrokes. In this piece he blended the strokes together to give a smooth surface to the skin. He left more defined strokes to show the texture of the hair, and very loose, abstract brushwork in the background to make it recede behind the figure. Notice how the rhythm of the strokes in the hair is repeated in the background, although looser, to add to the continuity of the painting.

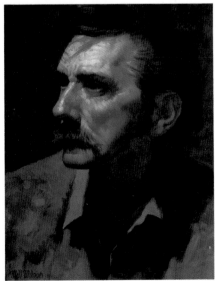

■ BOOTS
12" × 10" (30 × 25 cm)
Oil on canvas
Collection of Dr. and Mrs. Peter Noce

The subject of this painting was a man who shared a hospital room with the artist's grandfather. Wilson wanted to paint him because of his strong bone structure, which is so obvious in this painting. Adding to the strength of this portrait is the dramatic intensity of the light.

One of Wilson's aims in all his paintings is to convey a sense of three-dimensional space. Here we have a definite feeling that the head is a solid form thrust forward from the background and the rest of the body. This effect is caused in part by the dark background and by the grayed color of the shirt contrasting with the pure, warm colors in the face. Usually Wilson blends together the strokes in the face for the smooth look of skin, but here he left the individual strokes to blend optically. This creates an interesting paint surface and also gives the subject a more weathered look.

CONSTANCE FLAVELL PRATT
Seeing the Likeness as a Constant Challenge

Even after painting thousands of portraits, Constance Flavell Pratt says, "Nothing is ever easy in portrait painting." It is this sense of challenge that keeps her work looking fresh.

After art school, Pratt worked at fairs, malls, and department stores, painting as many as fifteen portraits a day. Her paintings got better and she charged more money, but basically she is still doing today what she did all those years ago—simple, strong, direct portraits that she loves to paint.

After rendering so many noses and eyes and ears, how can she maintain her excitement about drawing yet another face? This is the core of her professionalism, that she approaches each new commission as a challenge. While accepting the responsibility of capturing a strong likeness and creating the kind of portrait her clients will want to live with, she pushes herself for more. She is always trying to reach her ideal—a fast, no-fuss portrait with a "smashing" feeling for the subject in likeness, gesture, and characteristic spirit.

Since most of her paintings are commissioned portraits, capturing the likeness is the keystone of her work. She says simply that an exact likeness comes from being careful as she works. Basically it's a matter of measuring and comparing. She says that often one's instincts are not good enough; so one must "measure, measure, measure."

Pratt is constantly comparing one part of the face with another. She says it is possible to get every feature exactly right and still not have a likeness if the relationships between the features are not right. She makes herself work over the total surface of a painting rather than concentrating on just one part of it at a time.

She plans where the head will be. If it is placed too high, it will appear to be full of helium. If it is dead center, it will be dull. If a profile is pushed too close to the edge, it will be too crowded. Unless the painting is for a public library or the state house, the head should not be larger than life. She explains, "Larger-than-life is called heroic, but it looks coarse or gross in an average six- or seven-foot-ceilinged room."

She also plans the composition of the body. It looks awkward, she says, if the hand ends at or is bisected by the paper's edge. The model should have breathing room in front of her. Everything in the picture should lead to the center of interest, usually the model's face.

This artist's concerns are pragmatic: what works and what doesn't work for creating a portrait that is a good likeness within an esthetic painting. Strong composition, rich colors, vibrant strokes and a pleasing likeness— these are the elements of Pratt's paintings.

WORKING METHODS

Pratt works standing at a perpendicular easel. This allows any excess pastel to fall without dragging across the paper and gives the artist more freedom to draw with her whole arm and to back away from the easel to assess the work in progress. She says it also avoids the perspective problems that can result from leaning over a drawing table.

She seats the model on a stand that places the model's face at eye level. She either chats with the model or turns on a television set so that the model has something to concentrate on. She likes to begin with warm-up sketches, either on a separate sheet of paper or lightly drawn in vine charcoal on the same paper her painting will be on.

Pratt works with a variety of papers, pastels, and watercolors. Her requirements are that they be of good quality and acid-free. She says that some of her older pictures were backed with cardboard, which is acidic, and there are now dark spots in the faces and figures caused by acid.

Sometimes she underpaints with watercolor washes. (If the piece is large, she will stretch or mount the paper on a board.) With watercolor she indicates lights and darks and general areas of color. The washes make the finished colors look denser, more intense.

One reason she likes to work directly from the model is that it is easier to develop the beautiful colors of the flesh. She says that after "thousands and thousands of portraits," she doesn't think about color anymore; she just sees it and concentrates on warm and cool. As she is painting, she tries to look at color as an experience separate from the drawing, forgetting the shapes except in a big, general way and reproducing the pure colors that she sees. She allows herself to exaggerate a bit.

She applies color with strong, vigorous strokes. She uses the principle of "fat over lean"; with pastel this means applying color first with hard pastels and then with soft. She uses a lot of pressure, virtually pushing the pigment into the texture of the paper so that she won't have to use fixative.

She often uses the direction of the strokes to help model the three-dimensional shapes of the figures. She tries never to blend or rub the strokes of color. She mixes colors by laying them over one another or next to one another, letting them blend optically. She places an extra strip of the same paper she is painting on next to the portrait. On that strip she tries out new colors before she applies them to the portrait. This is especially important with toned paper because the color of the paper will appear to change the color of the pastels.

Because it is vital for Pratt to achieve an excellent likeness, she has developed many ways of checking her painting as she works. She backs away from the painting so that she can see its total effect. She shoots black-and-white Polaroid photos of the painting in progress and compares those to photos of the model. She looks in a mirror over her shoulder to see the model and the painting backwards. Reversing the image allows the eye to see it in a fresh way. To study masses and values, she looks at the painting and model through red cellophane or a red sunvisor; she says this drains the subject and painting of color, allowing her to see both in black and white.

Constance Flavell Pratt

■ MOTHER
26" × 20" (66 × 51 cm)
Pastel on paper
Collection of the artist

This painting of the artist's mother shows how Pratt tries always to portray an honest, positive view of the subject. In this piece she has neither romanticized nor denigrated old age. She says the pose and expression were natural: "She just sat and looked at me." Pratt provided the hat and sweater, thinking their patterns and tex-

tures somewhat echoed the old-age wrinkles.

Notice how the richest color is in the face, bringing our eyes there to the center of attention. The sweater and blouse were done with thin, light strokes of cool color, with much of the paper showing through. The lightness brings that part of the image forward. The background was painted in darker, thick strokes where she used the stick of pastel on its side. It provides a rich, warm contrast to the more delicately drawn figure.

CREATING A LIKENESS

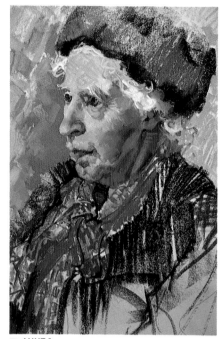

■ AUNT 1
25″ × 19″ (63.5 × 48 cm)
Pastel on paper
Collection of the artist

Pratt painted this portrait of her aunt in two three-hour sessions. She chose the near-profile pose thinking it wonderful for the long, aristo-cratic nose and the hidden eyes. She says her favorite subjects are strong-featured men and women. This painting is a wonderful example of the balance Pratt achieves with color. See how the ochre of the background is balanced by the yellow and ochre in the scarf. The blue-gray appears in the hat at the top of the composition, in the clothing at the bottom, and also in subtle little accents of color through the face.

Notice how many different colors have com-bined to make up the skin tones—rose, pink, gray, umber, sienna, blue, and more. Notice the delicate treatment of the eyes. Even with this opaque medium, Pratt has created the illusion of transparency in the eyes.

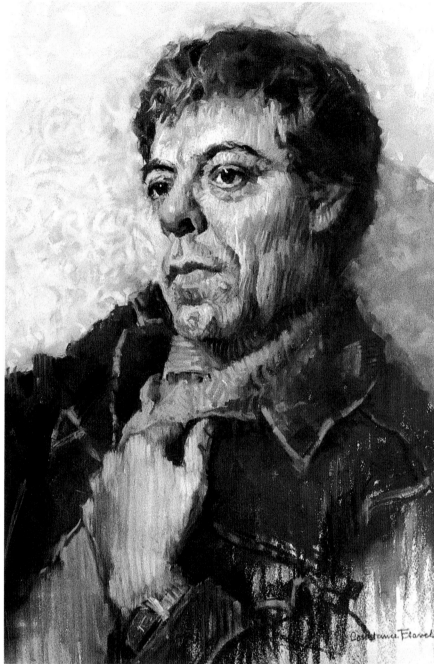

■ MIKE
25″ × 19″ (63.5 × 48 cm)
Pastel on paper
Collection of the model

This painting shows the full range of strokes Pratt uses in her work. First look at the broad, smooth strokes in the background (right) and in the jacket. Drawn with the pastel on its side, they give the effect of a smooth surface.

Next look at the fine, hatched lines in the face, hand, and shirt. The hand, painted with

all parallel lines, looks flatter than the face, where the directions of the lines conform to the three-dimensional shapes. Notice how individ-ual strokes seem to radiate out from the model's mouth and right eye, enhancing the roundness of the shapes. Combined with warm highlights and cool shadows, this type of stroke gives the face a sculptural quality.

Finally, look at the contrast between those stiff, straight lines and the lyrical swirls in the background.

■ OWEN

26" × 20" (66 × 51 cm)
Pastel on paper
Collection of the model

Pratt created a dramatic effect in this portrait by sitting below the tall model and shining a strong light from above. She says she deliberately applied the pastel in heavy strokes to achieve a painterly surface.

She has divided this painting almost in half diagonally, with the warm, highlighted area on the upper left and the cool shadows and shirt in the lower right. Throughout the painting she has developed the lighted areas in warm colors—pink, magenta, and brown—and the shadows in cool blues and purples. Even the brown of the jacket is warmer on the left.

As in all of her work, the colors are laid down in individual strokes next to or on top of each other rather than blended together.

SUGGESTED PROJECT

Pratt has worked for several years as a courtroom artist for a Boston television station. In that position she must achieve a good likeness very fast, sometimes drawing as many as six people in ten minutes. She says that the fast, direct drawing under pressure is great fun and also gives her the chance to improve her drawing—and seeing—skills.

She suggests keeping a sketchbook with you at all times and making quick, candid drawings of people in public. Look for the large features of the face and the shadows they cast, also characteristic posture and gestures. Notice and remember other details to add if the subject moves or even leaves while you are drawing.

At first these sketches may appear to be mere scribbles, but in time you should be able to capture a likeness in minutes. She says to draw at every opportunity, explaining that the rate at which you improve is directly related to the number of drawings you do.

DEBORAH DEICHLER
Making Portraits Surprise and Amuse

*Deborah Deichler is an artist of contrasts and contradic-
tions. She paints serious studies of people, well drawn,
designed, and painted, that capture both the appearance
and the personality. Then, so that we don't take these
paintings too seriously, she surrounds the subject with
bits of flotsam and jetsam from her own life—flowers,
toys, vegetables, coins, medals—objects that often have
no apparent relationship to the subject.*

*She generally begins with the subject, usually a person
who is very familiar, and for several months studies that
person. She likes to take photos of the subject and hang
them in her home so that even when the person is not
present, she can still be observing and developing the
future portrait.*

*Meanwhile she picks out the setting, props, and cos-
tume—or rather, she lets them pick themselves out; it is a
totally intuitive process. She says, "I have all kinds of stuff
around here and I'm always acquiring more. If I like
something, I put it into the current painting if possible."*

*Deichler took art lessons from the age of thirteen, when
she first began studying oil painting and design. She
attended the Philadelphia College of Art from 1966 to
1970, studying art education. After "one terrible year of
teaching," she became a waitress and made art a hobby.
She says she didn't seriously think of becoming an artist
until 1975, when she returned to school at the Pennsyl-
vania Academy of Fine Arts.*

*Her training is academic, and that is the style of
painting she finds most comfortable. She works with
eloquent precision, but unlike many classical painters,
she is totally unself-conscious, surprising and amusing
her viewers with her exuberant humor and flair for the
dramatic.*

*She explains, "My mechanism for keeping sane is
having my imagination come out in a fairly rebellious
way. I always look for a different twist, either in the
objects I add or the lighting. Shadows and strong lighting
will always give a mysterious sense to a painting. In
draftsmanship I try to keep as close as possible to what is
real, but I enjoy some kind of psychological element, an
emotional intensity."*

*She adds, "I don't like artists who smear themselves all
over the canvas so that you can't get away from them, but
I feel that the artist should add something extra—so you
feel you have had some contact with the artist."*

*In Deichler's portraits we always are aware of the
subject, the appearance, personality, and mood of who-
ever is posing, but at the same time we are also con-
scious of the artist sharing an emotional challenge or a
subtle joke.*

WORKING METHODS

Deichler begins a painting with photographs. She sets up the
model and a likely assortment of props and shoots a number of
photos. These photographs are not to paint from, however; they
are merely to help the artist visualize and clarify her ideas.
Sometimes she will study the photos for months before she
begins to paint.

She generally blocks out the major shapes and values of the
composition in a preliminary drawing. She divides the drawing
with a loose grid then transfers it to canvas with pencil or pen
and India ink, "not every single squiggle and line, but whatever
seems enough to indicate things." Sometimes she uses an
opaque projector to transfer the drawing.

She sketches out much of the piece before the model sits;
then once she starts to paint, she works from life as much as
possible. She doesn't use the photos again; from this point, she
says, they are dead things. She has the model sit several times.
She keeps the props set up in her studio, and sometimes she
drapes garments over a mannequin so that she can continue
when the model is not present.

Because she is very conscious of conservation, Deichler
works on a fine grade of Belgian linen mounted to aluminum
panels with a wax substance. She sizes the canvas and then
applies several, at least five, coats of Winsor & Newton oil
primer, which dries very quickly and does not contain lead. In
between coats she smooths the surface with an electric sander.

Over the drawing she may apply an imprimatura, a very thin
layer of paint to give the canvas a tone. She usually adds some
medium to the paint and rubs it down to keep it thin and even.
She may wipe out areas of the imprimatura to indicate bright
spots. Sometimes she applies actual color right away, or she may
begin working with black and white to establish value and then
add final colors and details on top of that.

Deichler always follows the rule of fat over lean paint. She
often uses no medium in the first layer, or a medium containing
alkyd resin but no oil. Then in the last layer or two she may
introduce linseed oil. She applies the paint thin or medium-thin
over all.

She says that since paint becomes more transparent with age,
it is important to consider what is painted underneath a color. If
she wants something like yellow to stay very clear and bright,
she leaves the spot under it white. If she wants a bright yellow
later on in the painting, she will paint the area white, let it dry,
and then paint yellow over that.

Her paints are mostly Winsor & Newton oils; sometimes
Rembrandt, Sennelier, or Lefranc and Bourgeois; rarely Blockx.
She uses a wide variety of brushes, from big coarse bristles to
small red sables. She also has badger-hair brushes and a couple
of fan brushes for blending. She likes very cheap, bushy brushes
for blending also, because they are very soft. She prefers big
cheap brushes for scrubbing and putting on a lot of paint in a
hurry because she doesn't have to worry about ruining them.
She finishes a painting with smaller-tipped brushes.

■ **DREAM ANGUS**
40⅛″ × 30⅛″ (102 × 76.5 cm)
Oil on canvas
Private collection

This is a painting that looks like it should be telling a story. We look at it and ask, Who is this woman and what is she thinking? The pose and expression are so soulful that we assume there must be some profound sentiment here. Then we notice that she is eating radishes and honey with her coffee and we reflect, Maybe this is not so serious after all. There is no narrative here; the painting is an amalgam of a model in an interesting costume and a bunch of interesting but unrelated objects.

Deichler describes the random way that this piece came together: "I wanted to paint Maeve because I was familiar with her from a previous painting. I saw her strike this pose at our kitchen table wearing the same clothes as are in the painting. She agreed to pose. Since I wanted also to paint the crèche figures and the narcissi, they were included. The plant just happened to be blooming at the time. The crèche figures had shown up when Bill's father wanted to get rid of them from his house. As I went along, I put in the cat's shadow and the other cat. We have three cats who walk all over everything. The red screen was better than the actual pale wall in the room where I paint, and I liked the color. I put Bill looking from a crack in the screen because that's typical of him."

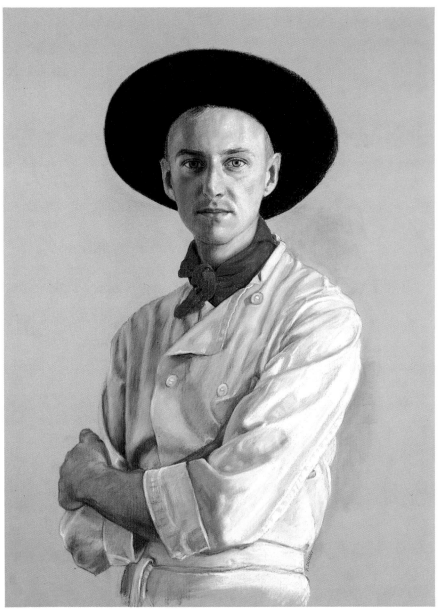

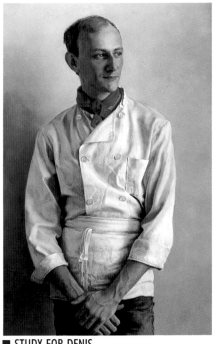

■ STUDY FOR DENIS
14⅛" × 9" (36 × 23 cm)
Oil on canvas
Private collection

In this oil study she removed the hat and worked with a different pose. While she worked with Denis, she had him assume several positions with various angles to the light. She decided to use this pose in the larger painting she is planning.

■ DENIS
25¼" × 19" (64 × 48 cm)
Pastel on paper
Collection of the artist

Both of these paintings (above and upper right) are color studies for a larger oil painting the artist is planning. When Deichler first met Denis, she knew she would enjoy painting a portrait of him. She was taken with his height,

his angularity, his "great French nose," and the fact that he is a chef.

She did the pastel as an exercise to familiarize herself with his appearance and to see if she wanted a lot of color or something simpler. She decided to keep the painting light and neutral like the white of his uniform. Notice that Deichler works for the same smooth refinement of pastel that she achieves with oil.

■ DETAIL

Here we see how Deichler's paint surface looks in progress. This detail was shot at an intermediate stage of the painting, after a light sanding and before the final layers of paint. After the initial drawing, Deichler blocked in the hands with large areas of value. She established the three-dimensional shapes of bones and veins by carefully placing her lights and darks.

■ DETAIL

In the top layer of paint she added more colors, various pinks and oranges, to make the skin tones richer. Also she smoothed out the rough blocks of value in the underpainting. The smooth finish comes from blending the edges of strokes together with a soft brush.

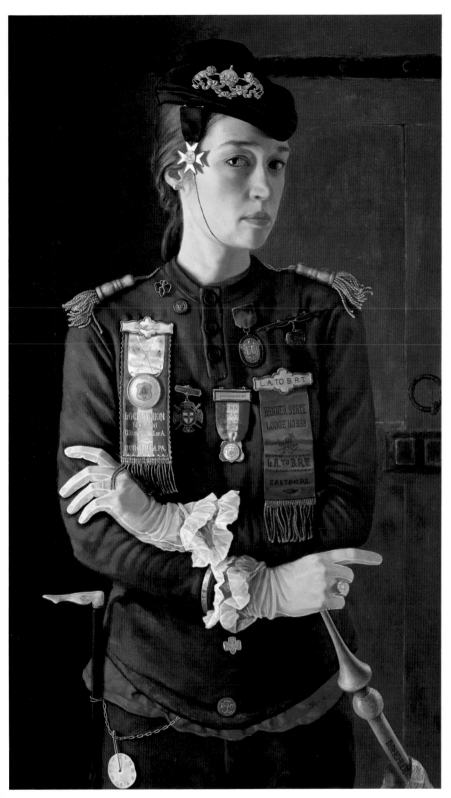

■ UNION SUIT

38¾″ × 22⅜″ (98 × 57 cm)
Oil on Masonite panel
Private collection

Deichler explains this self-portrait: "For my birthday Bill gave me a long underwear suit and a lot of assorted medals and pins he found in a second-hand shop. I put them on and we admired them all. He insisted that I paint them, so I did. For the background I used the subdued green of some old shutters I pulled out of the trash somewhere, which I liked a lot. I set up a mirror next to a window, and using north light I tried various angles. I thought this the most interesting over all.

"It is another frontal, vertical, in-the-center composition. The eyes are turned out to the viewer, although the face is averted; so attention still goes to the contact made with that person, with her possible state of mind."

As in all of Deichler's work, we tend to accept this initially as a serious painting making a profound statement, just because of its fine craftsmanship. It is only as we take the time to study the strange elements in the costume— long underwear decorated with medals, and sheer, ruffled gloves—that we understand how humorous it really is.

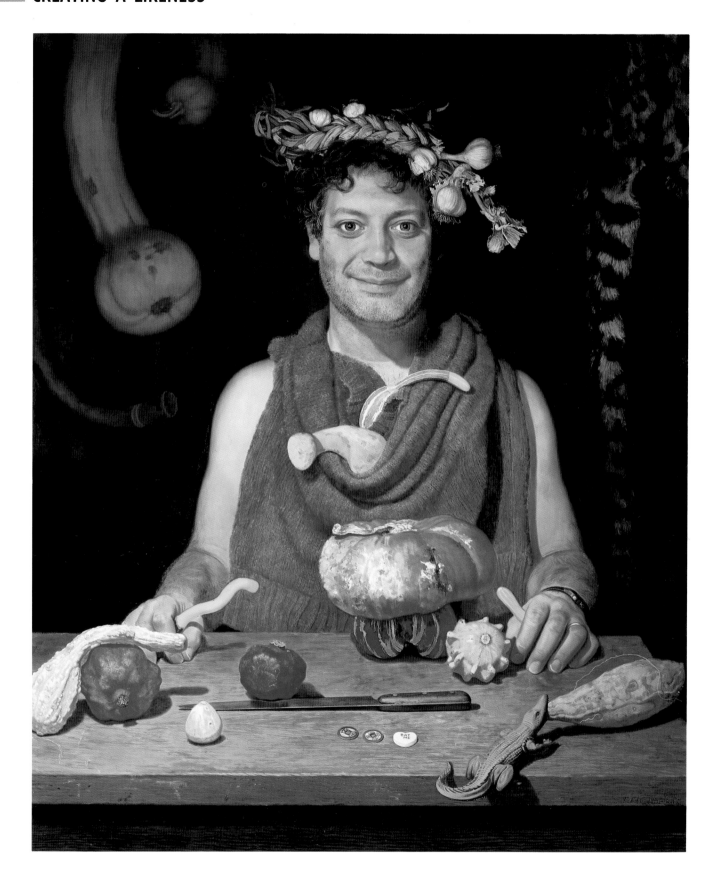

■ A HERO'S LIFE

36" × 30" (91 × 76 cm)
Oil on canvas
Private collection

Originally Deichler was going to paint her husband, Bill, at the table with some sugar-coated almonds in front of him because she liked their colors. Then she became attracted to the fall squashes and pumpkins at a little vegetable stand and decided to use them instead. She also found a spotted animal skin at a thrift store and bought it to use in the background. Since Bill drives a truck, she added a piece of radiator hose to the background, and because he is Italian, she placed a garlic wreath on his head. "If the squashes assume phallic innuendos," says Deichler, "so be it. I painted things because they appealed to me or fit a spot in the general design where I needed something. But they could all be read as part of the theme of Bill. As the hero."

Look at the hanging objects. They are meant to be seen, but not to be as important or come as far forward as the main figure. So they are darkened and their outlines softened. Besides breaking up space and providing entertainment, the objects have another value. Deichler was worried that the viewer's eye would be drawn totally to the face, with its "frozen smile and frontal eyes." She wanted the viewer to see the face "in bits and glances," as in real life; so she arranged the objects to keep the viewer's eye moving through the whole painting.

■ DETAIL

One of the greatest challenges in portraiture is painting a smile that does not look stiff. Deichler succeeded here by blending the edges to give a soft, natural rendering of the face. That softness is more apparent as it contrasts with the sharp, specific strokes in the garlic, hair, and beard.

■ CORNUAMMONIS

24" × 18" (61 × 46 cm)
Charcoal on paper

This is typical of Deichler's preparatory drawings, which help familiarize the subject. In the black-and-white drawings she works with general values, masses, feelings, and focus.

■ DETAIL

We might wonder why the objects are present, but because they are so precisely painted, we never question their validity in the painting. About the message of the painting, the artist says, "It is only natural to look at the objects and read into them some connection to the central figure, this being very clearly a portrait. If he has this smile and all these objects are around him, what is his relationship to them, what is the 'message'? This is really open for anyone to guess to their own satisfaction."

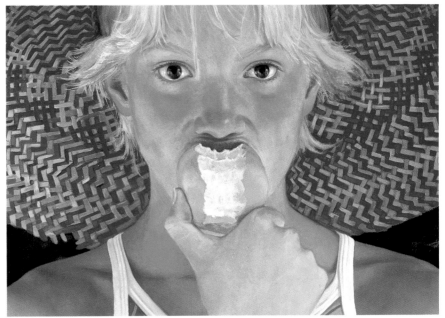

■ PENCIL SKETCH AND THUMBNAIL

This pencil sketch and the thumbnail above it show two stages in the development of the painting. In thumbnail sketches Deichler experiments with the major shapes and gestures of a composition. She expands and elaborates those in a larger drawing, which she then transfers to her canvas by means of a grid.

■ DETAIL

In this closeup we can see what happens when the artist juxtaposes the complementary colors red and green. Cover up all of the red in this detail. Look at the apple, which is a soft, subdued green. Now expose the red and see how the green of the apple jumps out at you. Do the same with the red. Painting complementary colors next to each other makes both colors vibrate with intensity.

■ DETAIL

In this detail we can see how the artist changes the tone and value of a given color to make us see the three-dimensional form of the figure. Pick any one of the pink stripes. Starting at the left, follow that stripe up to the arm, noting all the variations within that one color. See how the lighter areas seem to approach the viewer and the darker areas recede.

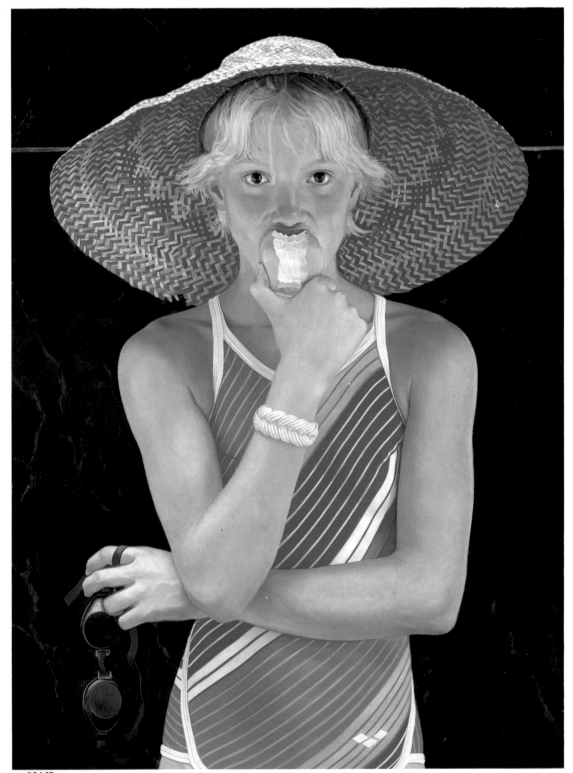

■ **GRACE**
26½" × 20¼" (67 × 51 cm)
Oil on Masonite panel
Private collection

Many artists say it is hard to portray a child as a strong, unique personality, but that is just what Deichler accomplished in this piece. She painted here a girl with wide eyes, elfin in expression; a body that is beginning to show a few curves; and a natural inclination toward high spirits. Because this was a commissioned portrait, a physical likeness and Grace's iden-

tity as a swimmer were both important, but the focus for Deichler was the spirit of the girl. This is Eve, a budding Eve, biting into the apple and still hanging onto her swim goggles.

The overall composition is a simple one, which allows for lots of textural activity. The stripes are featured over and over again, thin in the suit pattern, thicker in the shoulder straps and in the apple, fragmented in the hat and bracelet. Notice also the interplay of complementary colors, red vibrating against the green of the apple, goggles, and background.

LINDA OBERMOELLER
Painting Portraits with Light

Linda Obermoeller paints high-key watercolor portraits in which soft shadows delineate the form and untouched white paper provides shimmering highlights. This style, she says, is a direct result of living in Houston. She explains that the quality of light is different from other places she has lived, more brilliant perhaps, and that the bright, sunny days enable her to work outdoors year round.

Obermoeller's art career began at age six when she had a crayon drawing displayed at the St. Louis art museum. Her father was so excited that he went out and bought her a set of oil paints. She "fell into" commissioned portraiture about seven years ago and says she loves it.

Her favorite clients are confident, relaxed, and outgoing, models who are at ease for photos and for live sittings. She says she doesn't necessarily set out to make her subjects appear more beautiful. For her a person doesn't have to be beautiful in order to be an interesting subject, but she does look for models who are happy with themselves and then she accentuates their positive qualities.

Very rarely are clients unhappy with Obermoeller's portraits. The artist makes sure that a prospective client is familiar with her style before they begin. Then she involves the subject in the process by reviewing together the photographic studies and noting the client's reactions to various poses and expressions. Because the subject is participating as the work goes along, he or she is seldom surprised by the finished piece. Obermoeller is willing to make minor adjustments to please a client, but because she is working in watercolor, it is impossible to make major changes.

She says in commissioned portraiture her most successful work is done when the client gives her the most latitude, when she can strive for something different in pose and/or composition. She likes to crop her paintings close to the subject. Tight cropping gives a more contemporary feeling to the painting and establishes a more intimate relationship between subject and viewer. It also helps her maintain the flat background that she prefers to use.

Obermoeller's portraits are unusual because they are executed in watercolor, an unforgiving medium for any subject, but especially a portrait. She never knows exactly what the paint will do, and that can be especially crucial in painting the face. Because she can't move an arm or paint out a color, she often has to start over. Nevertheless, she says she wouldn't choose any other medium. Watercolor has a luminosity that helps her capture that special Texas sunlight, which is what her paintings are all about.

WORKING METHODS

Obermoeller usually begins a commissioned portrait by interviewing the client on the phone and in person. She says it is vital for the artist to know what the client is looking for and also for the client to understand what kind of work the artist does.

Actual work on the portrait begins with an outdoor photo session. Obermoeller always starts outdoors because she likes the high-key effect of direct sunlight on her models. She shoots several rolls of film, changing angle, pose, costume, and setting.

Then she shows the subject the slides. She says you never know how a person sees himself or herself, but viewing the large number of slides together, Obermoeller can begin to sense which expression, pose, setting, and so forth, appeals most to the client.

Often the artist works out the composition in a small pencil study; this preliminary step is especially important if she must consider more than one figure or large props or background elements.

Next she draws the subject lightly with a 2H pencil onto her watercolor paper. She uses 300 lb. Arches paper; it is heavy enough so that it does not need stretching, and it holds up to some erasing within the pencil sketch. If there are very complicated elements within the drawing, such as a wallpaper pattern, Obermoeller will develop those parts on tracing paper and then transfer them to the painting surface.

The basis of her composition is the pattern of shadows created by the sunlight on the figure; so she begins each painting by washing in the shadow areas. First she paints in the shadow areas of the face, then proceeds to the darks of the hair and the clothing. In order to maintain the bright feeling, she works with light washes, even in darker areas. She then develops the middle values, leaving the white of the paper for bright highlights.

She works from slides to lay in most of the painting. She paints with the paper flat and the slide projected on the wall in front of her. From the slide she is able to establish the general pose, the placement of values, and the basic colors. She leaves the eyes and other details blank until she can work directly from the model. She usually arranges two one-hour modeling sessions with the subject. During that time she paints the eyes, details of the clothing, and refinements in the hands. She says the eyes especially need the subject present because the color is not true in slides and because the sunlit photos usually show the model squinting.

She paints with Winsor & Newton watercolors and with a 1″ (2.5 cm) flat sable brush and Winsor & Newton series 807 red sables no. 3, 5, 9, and 10. She also uses natural sponges to lighten and blend colors and, occasionally, cotton swabs and an X-acto knife to lift out small areas.

She paints successive layers of color to develop the darks in the deepest shadowed areas. In lighter sections she uses only one layer of paint to maintain luminosity. After the painting has dried, she removes pencil lines with a kneaded eraser.

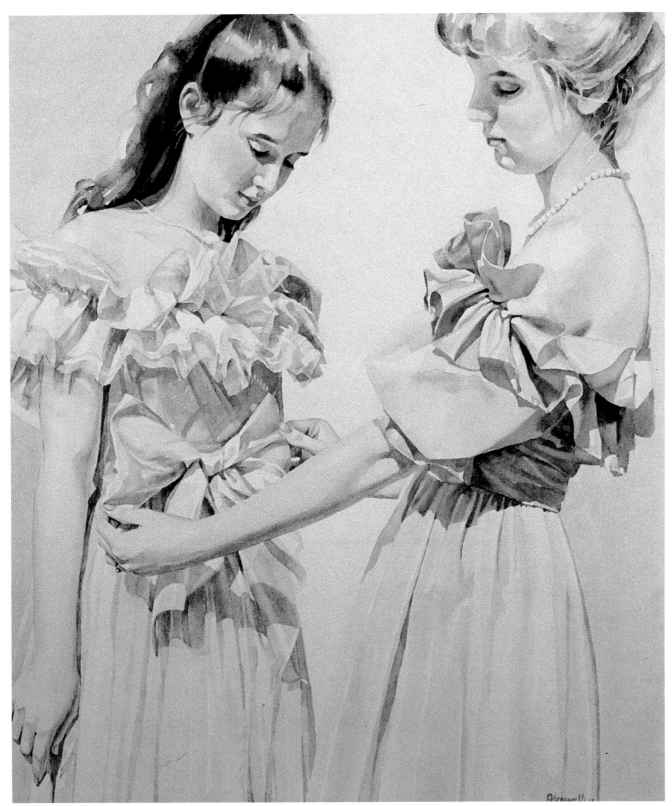

■ **TAFFETA AND NET**
24" × 19¼" (61 × 49 cm)
Watercolor on paper
Collection of Mr. and Mrs. David M. Gosselin

This painting was suggested when Rachel and Alicia, the artist's daughter and her friend, tried on their new dresses for the junior prom. The only props necessary were the dresses.

The shadows in the dresses were especially challenging—the shapes of the cast shadows falling across the various folds and the effect of sun filtering through the net ruffles of the blue dress. She painted the shadows with a variety of colored washes. She used blue and burnt sienna in the shadowed areas of the pink taffeta dress and crimson lake, cadmium yellow, and burnt sienna in the blue dress. She painted with her usual assortment of flat sable brushes and also used a sponge to get the soft, flat effect of the background.

CREATING A LIKENESS

■ **MARY JANE, MARJANA AND KATY LINDSEY**
59½" × 37" (151 × 94 cm)
Watercolor on paper
Collection of Mr. and Mrs. Jim Lindsey

Obermoeller says this piece is typical of her work in that the subjects are portrayed in sunlight at a particular moment in time. She was painting a portrait of a mother and her two teenaged daughters, showing them as unique individuals yet conveying the interaction among them. The focus is clearly on the figures, and the props were chosen mostly to add to the mood, the general feeling of graciousness. The background is barely implied with a light wash of ochre to indicate a horizon line.

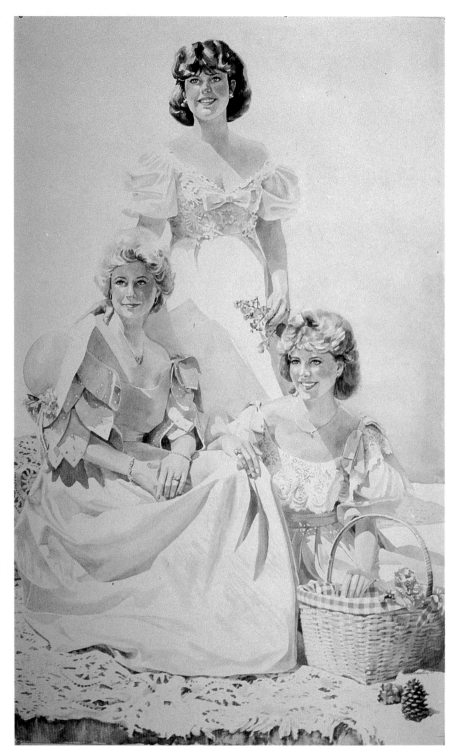

■ **PHOTOGRAPH**

Here we see the original slide Obermoeller used as the basis for this large portrait. The client wanted formal attire in an outdoor setting. The clothing was selected for color and interesting detail. The crocheted cloth and the picnic basket contributed texture and the feeling of being outdoors without adding too much depth. Obermoeller prefers flat backgrounds because they don't draw the eye away from the subject.

Step 1 In the first step Obermoeller has already drawn in the figure with light pencil lines. She is working on Arches 1114 lb. cold-pressed paper in the 40" × 60" (102 × 152 cm) size. She has placed the shadows in the faces, then in the hair, clothing, and the crocheted cloth. Notice that even these shadowed areas are kept relatively light so that the finished painting will have a bright, high-key effect. Also, notice that she has left the eyes blank, to be painted during a live session with the models.

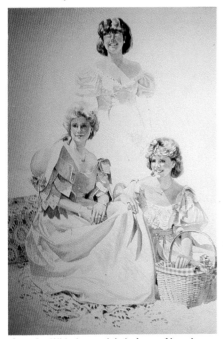

Step 2 With the models in front of her, the artist develops the eyes and details of the hands and clothing. She says these details can only be completed accurately from life. In this stage she has also begun to work out the middle values. The basic colors had already been chosen when the costumes were selected.

■ **DETAIL**
Notice how the lace is created with a selective rendering of details. Not every hole in the fabric is indicated, just enough to give an impression of the pattern. The feeling of lace is reinforced by the cast shadow with its intricate pattern of lights and darks.

■ **DETAIL**
Here we see how the artist leaves areas of white paper for highlights. She must plan from the beginning where each of the whites will be so that she doesn't paint into them. Notice the white dots on the sleeve of the lavender dress; even such little white details as this must be preplanned.

CREATING A LIKENESS

■ PEGGY THACKER
29¼" × 19¾" (74 × 50 cm)
Watercolor on paper
Collection of Mr. and Mrs. Robert W. Thacker

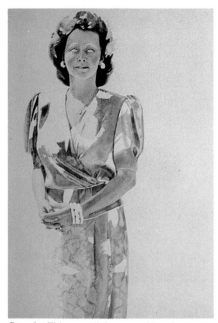

Step 1 This portrait is unusual in a few ways. The pose is a forceful one, with the twist of the shoulders suggesting motion. Also, the placement of the figure to one side of the paper creates an interesting division of space. The pose and composition were laid out in the basic pencil drawing. Most of the shadow areas and the skin tones have been painted in from slides; the artist is more concerned here about value and pattern than color. The eyes, brows, and other details are blank, awaiting a live modeling session with the subject.

Step 2 After the basic values have been indicated, Obermoeller adds the brighter colors to the dress. The eyes and the finished expression are developed with the model present. The wallpaper pattern in the background was drawn in the client's home and painted later in the artist's studio. Notice how well the floral pattern of the background relates to the pattern of the dress. The negative space is especially important in this painting because of the composition; notice the dynamic quality added by the diagonal shadow.

■ **DETAIL**

This section of the painting is a wonderful example of how the artist achieves color harmony by repeating colors. Notice the use of yellow ochre in the plant, the chair, and also the shadow of the shirt. The artist says she was fascinated with the pattern of the shirt, but she painted only enough detail to suggest the total design. A more exact rendering would have detracted from the face as the focal point for the painting.

■ **BILL RAY**
29½" × 22" (75 × 56 cm)
Watercolor on paper
Collection of Woodway Dance Center, Houston

Obermoeller began this painting with a small, rough pencil sketch to establish the best relationship between the subject and the plant in terms of size and placement. Although the shirt and pants were really off-white in color, she chose to leave them pure white in the sunlight for more brilliance. The shadows moved from cerulean blue to yellow ochre for a warmer effect. She simplified the background, removing wall, door, extra chairs, and grass so that our attention is completely focused on the figure. Also she simplified the colors, eliminating most of the natural, intense green from the background and the plant.

■ **PHOTOGRAPH**

This is the slide on which Obermoeller based the portrait of Bill Ray. She took numerous shots in various poses and used the props that were available in the yard where she shot the photographs. The final pose and expression were chosen after looking at all the slides.

CREATING A LIKENESS

■ **STUDY IN CERULEAN AND MAUVE**
28¾" × 17" (73 × 43 cm)
Watercolor on paper
Collection of the artist

Obermoeller enjoys painting teenagers "be-
cause they are often more relaxed and easier to
pose than adults." As models for this painting
she chose her daughter Rachel and Rachel's
best friend, Alicia. The idea was to paint two
friends posed back to back. Since it was more a
painting of the relationship than a portrait of
either girl, the artist began with rough sketches
to decide the exact position of both figures.

She drew the images directly onto the water-
color paper from slides. In painting the print
dress, she worked around the pattern with the
background color. Then she added the colors of
the pattern, lightening and blending in areas
with a sponge.

■ WOMAN IN A STRAW HAT
10¼" × 9¼" (26 × 23.5 cm)
Watercolor on paper
Collection of the artist

This painting is a study in light and shadow. The artist posed the subject so that a portion of her face and neck was lit by the sun. Smaller patterns of light were created by spots of sunlight shining through the hat. In the hat they created linear patterns; in the face they conformed to the spatial contours of the nose and *cheeks. Notice how four spots of white on the shoulder add a little more punch to the composition. Since the piece was executed in transparent watercolors, the artist chose to mark the white areas with pencil and leave them unpainted rather than using opaque white.*

Another compositional characteristic of this artist is her tight cropping of the subject. There is no empty space around the figure to soften the impact of the imperious expression on her face.

SUGGESTED PROJECT

"As a special project," says Linda Obermoeller, "you could study the effects of sunlight on various fabrics, from taffeta to cotton to knits. Notice how light bounces off some materials and is absorbed by others, and how the shadows vary from soft to crisp, depending on the nature of the fabric.

"A camera can be a very useful tool in studying sunlight at various times of day. Take photos of your model at different angles to find the most interesting shadows and to create a pattern down the figure."

EDWIN FRIEDMAN
Painting Who the Person Is

Edwin Friedman says that in every class there is the kid who can play the piano, the kid who can sing, and the kid who can draw. He was the kid who could draw. From kindergarten through high school, it was easy for him to be the best in the class. Then he graduated and went to the Art Center College of Design in Los Angeles. He describes that as a humbling experience; everyone there had been "the kid who could draw."

Surrounded as he was by people who could draw brilliantly with ease, both instructors and students, Friedman decided there had to be something beyond virtuosity. Technical ability was not enough; there had to be a spirit that made a painting art. For the last ten years he has been trying to realize that spirit.

In art school he learned the distinction between form, the ability to say something, and content, having something to say. After school, faced with the reality of making a living, he devoted himself to art restoration, a total pursuit of form. He restored paintings for seven years, learning and using the craft of painting. Then, when he was about thirty, he decided he wanted to paint his own paintings, work that had content.

Since then Friedman has retained enough of the restoration business to "keep any art compromise at a dead minimum." With the income from restoring art, he is able to paint only the subjects that he cares about—abstracted landscapes and very personalized portraits—and to paint them in a way that expresses his own muse.

Most of the subjects of Friedman's portraits are people he knows well. When he is commissioned to paint someone who is not already a friend, he takes the time to get to know the subject before he begins to paint. They go to lunch, go out for coffee a few times, until Friedman has a comfortable sense of who the person is.

When he finds those elements of the subject that appeal to his artistic judgment, he is ready to paint. He doesn't ask how the subject sees himself, and sometimes this leads to a rejected portrait. Friedman says he doesn't mind. Even on commissioned work, he doesn't ask for a deposit. He doesn't want to spend the majority of his adult life making people look thinner or fatter or younger or taller.

He says, "My clients have to look for something in my work other than a photographic likeness. With no hard feelings, I have sent clients to a good black-and-white photographer. That way they can get an aesthetic, permanent image that shows a likeness rather than an interpretation."

It is the interpretation, the spirit, the content that Friedman still pursues.

WORKING METHODS

Friedman paints with oil on gessoed Masonite. He works on board so that he can paint thickly and spontaneously; the rigid surface keeps his paint from cracking as it dries. He tints his gesso with high-quality acrylic so that later, when he scratches through his oil paint, there will be color showing underneath rather than pure white. The choice of color is intuitive, inspired by the model.

Sometimes he does preliminary "color roughs," quick, smaller paintings, to work out the palette and color composition. He begins the actual portrait with a fast, gestural drawing with brush and paint on the Masonite.

Next comes the "lay-in," painting in blocks of light and dark and color with reasonable accuracy in drawing. This breaks up the space into its two-dimensional composition; he is not concerned at this point with detail. Oil paint is so malleable that he can keep working on the lay-in until it feels right. He approaches it with the idea that the rendering can always be refined. This first step merely establishes the main areas of value and color.

Part of this stage is making sure that all the distortion or exaggeration is intentional. He says distortion should never be accidental or occur through incompetence or laziness. In Friedman's work distortion and exaggeration are used for two purposes—either to emphasize an aspect of the subject's appearance or personality or to achieve a compositional effect.

After the lay-in he starts alluding to three-dimensional form. He relies on intuition to determine how tightly the piece needs to be rendered and modeled; it varies from painting to painting and from section to section within a painting. He often likes to juxtapose flat sections against modeled areas or monochromatic forms against highly colored shapes.

He says it is important that the painting have a theme and a focus that are accessible to the viewers. Everything must work toward balance and cohesiveness. The amount of abstraction varies from piece to piece, but even in the most intuitive works, he needs some focus or direction.

He paints with Winsor & Newton oils and a selection of "beat-up, old brushes" and a palette knife. He says he doesn't render enough detail to warrant fine brushes. He thins his paint with turpentine and a little copal medium. Sometimes he uses Dorland's wax as an extender. In a blend of up to fifty-fifty, the wax gives the paint more body. It extends the pigment without losing chroma. It is tough, durable, and stable, retaining the texture of the stroke even with thick palette knifework.

Besides his heavy, spontaneous brushstrokes, Friedman has other ways of working the paint that give the piece more contrast and visual interest. One technique is drawing through the wet paint with a palette knife "or any other handy implement." He is careful not to dig into the Masonite surface itself.

Another technique he uses is scumbling. This involves dragging a brush of thick paint across thick dry paint to achieve an interesting textural effect. This is a slower process because it requires letting the paint dry between coats. The effect of scumbling is to get a mottled or speckled layer of paint through which the previous color shows through in small spots.

■ **PORTRAIT OF SARKISIAN**
30" × 24" (76 × 61 cm)
Oil on board
Collection of H. Medill Sarkisian

According to the artist, H. Medill Sarkisian is an Armenian rug peddler in his seventies and a brilliant scholar who owns one of the best collections of historical Oriental artifacts in the world. The man usually presents himself to the world as a tough, shrewd merchant, but Friedman has seen another side of him, a benevolent side, and this is what he painted.

This is an unusually warm portrait for Fried-

man, both in expression and in color. He says the most difficult job was to realistically paint the jovial smile; the easiest was to capture a good likeness because the subject is "such a character."

There is not a lot of contrast in color temperature here, warm against cool. Even the blues and greens are warm. Most of the color contrast is provided by the wide range of colors; Friedman used a more extensive palette than in many of his paintings. Notice the use of scumbling throughout the piece, which gives the colors depth.

■ RESTAURANTEUR
30″ × 24″ (76 × 61 cm)
Oil on board
Collection of Thom Wise

The subject of this painting is a man who lives his life in a vivid, colorful way. That is what the artist chose to show with the face-forward pose, the brightly colored clothing, and the obvious props.

It is a painting that displays many of Friedman's techniques. We can see how he works warm against cool colors—the red flower against the blue, the yellow tie against the deep green shirt, and within the vest, the spots of pink and green bouncing against each other. Notice also how he balances color by placing the same color in opposing locations, for instance, the light blue in the background and the foreground and the accents of red in the bottle, hair, and flower.

We also can see the many techniques Friedman uses for applying paint to the board. Besides bold brushstrokes, there are many flat, smooth areas throughout the piece where he laid on paint with a palette knife. In the vest he used scumbling. In the bottle's label and the outlines of the arm he created lines by scratching through the wet paint.

■ DETAIL

Here we see how scumbling works. First the artist brushed on a thick layer of dark green. After that dried, he dragged a layer of thick light green paint over the same area. Because the new paint touches just the uneven surface of the dried paint, it leaves a random spotting of the new color and some of the old color shows through. He let the second color dry and then repeated the process with a third color, pink. In the finish, bits of all three colors work together in the same space.

■ DETAIL

The bottle has a black underpainting. To get the detailing in this label, Friedman let the dark paint dry. He painted over the dry black with thick, white paint; then, while the white was still wet, he drew through the top paint with his palette knife. This created the strong lines where the black shows through white.

CREATING A LIKENESS

■ **PORTRAIT WITH SHAWL**
48" × 36" (122 × 91 cm)
Oil on board
Collection of Gerald and Susan Erlich

Step 1 On a board that is tinted to a light ochre, Friedman has drawn the basic gesture with a more intense ochre. Notice the fast, loose brushstrokes he uses to mark the gesture and the pose. The face is drawn with slightly more detail, but still very loose, giving only a suggestion of features and expression. He has placed the figure in the center of the composition. He saw the left side of the model descending and the right ascending; this movement has more impact when the figure is centered.

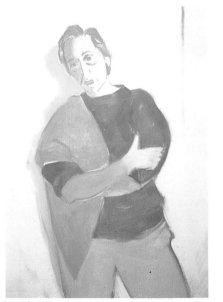

Step 2 Here he has blocked in his values. The background has become the lightest area. The skin tones are slightly darker. The blue clothes and shadow increase in value up to the sweater, which, along with the hair, provides the darkest value. Notice how the cool blue colors vibrate against the warm ochre of the outline.

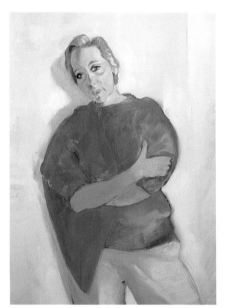

Step 3 In this step he has begun to develop the solidity of the figure. He does this by establishing his light source, painting the highlights on the right and the shadows on the left. This is especially obvious in the trousers. Notice the simple palette he is using, mostly ultramarine blue because of its brilliance and because he wants to create a dramatic contrast with the subject's red hair.

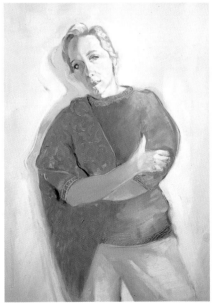

Step 4 Here he is finally beginning to add detail and subtlety of color and texture. Notice the touches of red, also the blue introduced into the face for cool shadows. He has created textures in two ways. He has used heavy brushstrokes for the curve pattern in the shawl, and he has drawn through the wet paint to create the border patterns on the sweater.

Notice how he is developing the large shadow here, working more toward a rhythmic interplay of color and line than a literal rendering of a shadow.

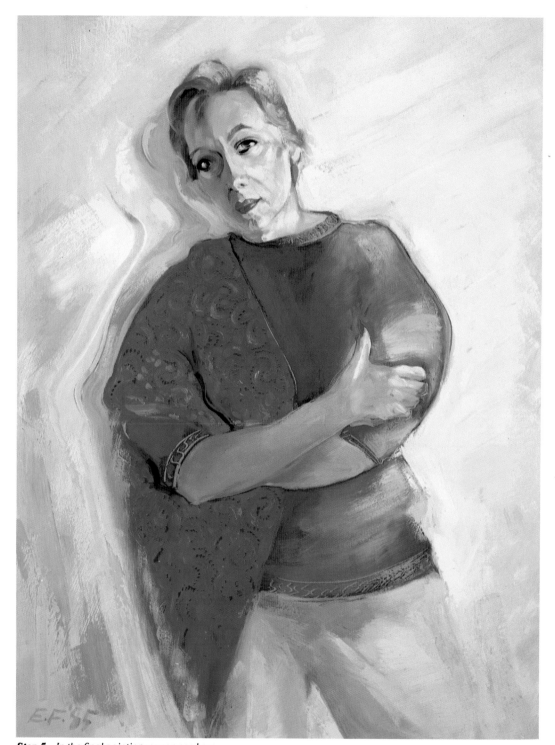

Step 5 In the final painting we can see how
he further developed the processes he began
earlier. He has added more color and pattern to
give the shawl a stronger texture. He has added
more colors to the skin tones—peach, yellow,
and purple. Look at the interesting interaction
of warm against cool on the right side of the
model's face. He has left some of the original
outlines, but in other places he has softened
the edge between figure and background.

 Friedman says he is pleased with this paint-
ing because it achieved his intent, giving the
subject an unmistakable presence looking
straight out at the artist and acknowledging
this portrait.

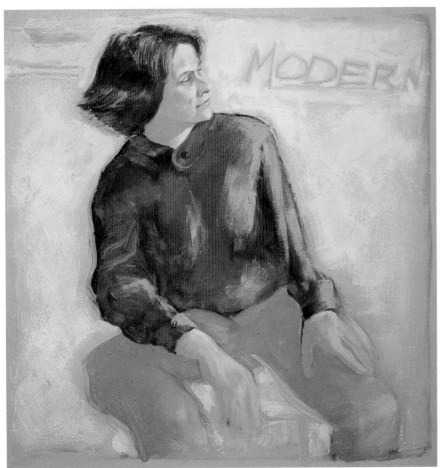

■ MODERN
36" × 36" (91 × 91 cm)
Oil on board
Courtesy of Sullivan-Bisenius Gallery, Denver

Friedman says this is a portrait of an interesting, confident dealer in "modern" art. He says the word "modern" was a joke between himself and the subject, made more humorous by his use of a typical "1940s illustrator palette." This was, in fact, the least modern of a whole series of portraits he painted at that time.

In this painting the face was rendered in a very natural way. In contrast, the body was developed with vague contours and loosely suggested volumes. As usual, the artist was working with warm against cool colors. Look at the halo of cool blue he left around the model's face and sweater to separate them from the warm, yellowish background. Also notice how the brilliant blue accents through the body bounce off the reds of the sweater and the warm gray-green of the trousers.

■ ARTISAN/ARTIST
48" × 36" (122 × 91 cm)
Oil on board
Collection of the artist

Friedman describes this painting as quick, large, loose, and expressionistic. He says the subject is a gangly artist who at times appears to be all hands and feet.

He considers this one of his most successful efforts to create interest by both implying and denying "window space." The foreshortened hands, the modeling of face and arms, and the receding staircase all give us the feeling that this is a solid, real scene that we are looking at through a window. Then the flat strokes and the lines where he dragged a knife through the wet paint remind us that, in fact, this is not a real scene but paint on a board.

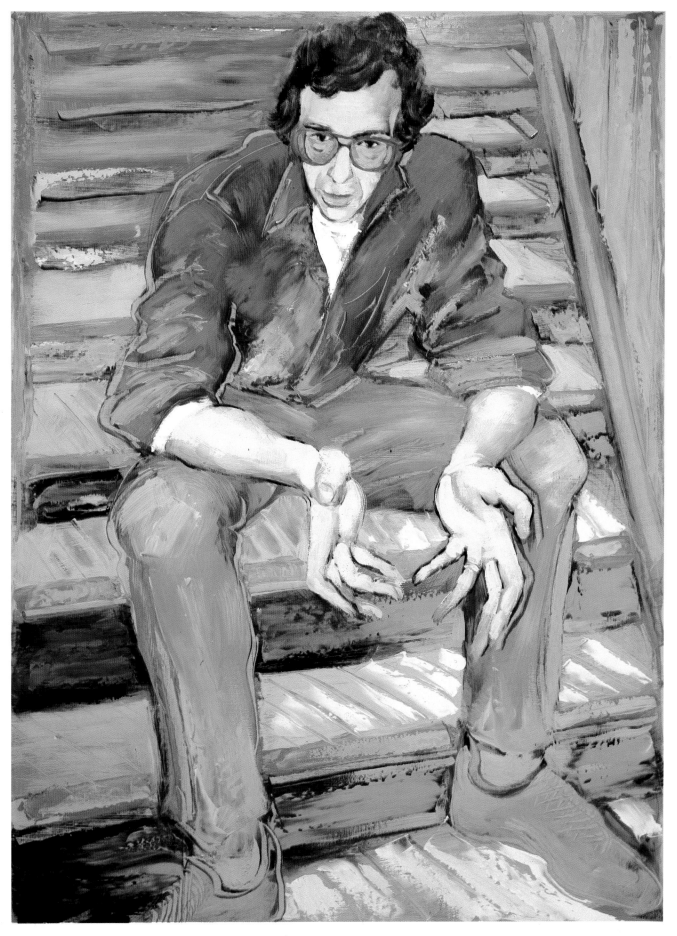

PATTI CRAMER
Painting What Is Funny About People

In one review Patti Cramer was called "the Noel Coward of the easel." Her paintings are urbane, sophisticated, and humorous. "I want people to enjoy my work," she explains. "It's not knee-slapping funny, but I think it is happy work, amusing even if I was in a morbid mood when I painted it. I wish we would all laugh at ourselves a bit more."

Her favorite subjects are people and dogs, always showing a lot of expression and body language. For models she usually chooses friends who have strong personalities. She likes to have them dress up, put hats on, hold a dog on a leash. She thinks most of the people in her paintings look smug—or just self-assured. She says that's not intentional; it's just the way her line works.

Her art reflects her world. She lives in an urban environment. Her studio is downtown, where she can look out the window for a cityscape to fill a background. Every day she drives past city people walking their dogs along the sidewalks. She sees men in suits carrying briefcases, women in afternoon dresses; these are the characters in her paintings.

Cramer is always serious about her work, even when the subjects are humorous. She has a strong academic art background and is concerned with the principles of good design. She says her paintings grow out of her line drawings, which are "not illustrations or cartoons," but very refined drawings.

Lately, since she moved into a larger studio, she has been working on a bigger scale and doing more things with backgrounds. "I love working big," she says. "It's been so liberating to have a bigger studio. I can get more involved with the abstract shapes now and less involved with the subject. It's great to paint with a four-inch brush; it was more tedious to paint a small area with a tiny brush. Of course, when the painting doesn't work, there is a lot more to change or throw away."

The titles of Cramer's paintings are delightful. Titles like A Two Piece—at Her Age *or* What She Does Best Is Lunch *enhance the satirical nature of her images. Sometimes she has a title in mind when she is painting; sometimes the titles comes to her afterwards. For instance, she did a piece with two dogs on the beach. She looked at it and thought, beach . . . ocean . . . dogs . . . of course,* Salty Dogs.

She loves to paint and to be getting better. As she becomes more confident, she experiments with more demanding images. She concentrates more on abstract shapes and intricate textures, but she says there will always be the figure.

WORKING METHODS

Cramer's paintings begin with sketches of the world around her; people in restaurants, shops, and art galleries are all subjects for her witty visual comments. She always has something to draw with, to jot down ideas for future paintings. She says she is uncomfortable drawing in front of people; so her on-the-spot sketches are usually rather small, just enough to record the image. She works out gesture and composition in larger line drawings, which she draws with a Koh-i-noor Rapidograph no. 0 or no. 1 and Koh-i-noor ink on two-ply Strathmore drawing Bristol.

After she has worked out an idea, she brings a model, or models, into the studio. She uses the model primarily for the pose or gesture. If she is painting a group of subjects, she might still use only one model, having the model change pose and position each time she adds a new figure to the piece.

With the model in front of her, she draws directly onto the canvas using a flat-tipped brush and black or another basic color of acrylic. Even though she has done preliminary studies, she is open to change at any stage of the painting. She doesn't feel the need to be literal in developing the drawing or portraying the model. Sometimes one model will become two or three figures in the painting. Sometimes a male model will appear as a female character or vice versa. She often uses her dog, Gretchen, in her paintings; somehow Gretchen, the Airedale, usually ends up as a Dalmatian. Props and backgrounds are all arbitrary. Sometimes Cramer uses whatever objects are available; sometimes she takes props and settings from her imagination.

Once she has the basic contours and shapes laid in, she begins to work with color. She develops color by trial and error. Since she is working primarily with opaque acrylic, it is easy for her to cover and change any area of color. There is no order or pattern to how she develops color; she just keeps experimenting until it feels right.

Cramer works on cotton or linen canvas, acrylic primed. Her paints are usually Winsor& Newton acrylics, unless she wants to flatten something out or cover a large area with no concern for texture; then she uses jars of Liquitex acrylic.

Her brushes are mostly flat-tipped, 2″ to 4″ (5 to 10 cm) for working on large canvases. To clean up or smooth out edges, she likes fan-tipped brushes. She rarely uses any brushes with points. Often she applies paint or smooths it out with her thumb and fingers.

She likes to get interesting lines and textures by drawing into wet paint. For that she uses the handle of a pen or brush or whatever else is handy. Sometimes she uses a colored pencil or stick of acrylic color; she is careful that it is not oil-based, which would be incompatible with the acrylic paint. She cautions against using a sharp tip or too much pressure, which could cut through the canvas.

To contrast with her usual opaque paint, she uses polymer medium mixed with pigment for transparent glazes. She says layering glazes is a good way to build up color patterns and textures. She finishes her paintings with Soluvar gloss varnish, which seals the painting and brings the color up to its original intensity.

■ **WALL STREET WALKAROUND**
36" × 30" (91 × 76 cm)
Acrylic on canvas
Collection of William Oldaker

Cramer says she was driving home from her studio one night and saw some businessmen "yakking" at an intersection. It was just the kind of urban interaction she likes to paint. She used a model in her studio for the drawing. She had him assume three different poses, changing quickly to create a sense of motion. For the background she looked out her studio window and painted the Denver skyscape.

One of her main concerns was creating an interesting urban background that wouldn't detract from the figures. She resolved that problem by painting the negative space in cool hues and bringing the figures forward with warmer colors. She developed the textures and patterns in both the buildings and the suits by layering several glazes of pigment mixed with polymer medium.

EXPRESSING A POINT OF VIEW

■ GALS ON THE CANALS
38" × 48" (96.5 × 122 cm)
Acrylic on canvas
Collection of Julie Seagraves and Richard Kimball

Cramer develops a strong personal interaction with the characters in her paintings. There were originally three figures in this piece, but it looked too crowded. Cramer says she really disliked having to wipe out the other figure. "I liked her," she shrugs, "but it was not good composition."

The background of Venice was an afterthought. At first she was only concerned about the abstract forms of the positive and negative spaces. She added horizontal blues that looked like water. Then the texture she put into the background began to suggest buildings, and it all came together as Venice.

She painted most of the piece with large, flat brushes. She used a fan brush to smooth out the areas around the faces and smaller brushes for the lips and eyes.

■ PASSIONS UNLEASHED
48" × 38" (122 × 96.5 cm)
Acrylic on canvas
Collection of Mr. and Mrs. George Cannon

Cramer decided to do this painting when she saw a couple in tweed jackets walking their dogs. Originally she planned a descriptive park setting with lots of trees, but with two people and three Dalmatians, the trees made the painting too cluttered; so she wiped them out.

As in all of Cramer's work, the body language of both people and dogs is very important. The man has his hands in his pockets and he and his dogs are standing solidly, not moving. The woman and her dog are being the friendly aggressors. Notice how the shapes of the woman's hat and shirt add to the feeling of motion.

The facial expressions are achieved with wonderful simplicity. Cramer created expressive profiles with virtually no outlines; she made a sharp edge of the background against the face by pulling the violet paint next to the skin with her fan brush. In contrast she developed the tweed effect in the clothes with several layers of polymer glaze.

■ **COLGATE '64 UNATTACHED**
12″ × 12″ (30 × 30 cm)
Acrylic on canvas
Collection of Kenneth Whiting

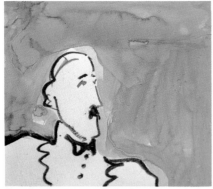

Step 1 Cramer usually begins with one color, which isolates the spaces for her and helps her see them better as abstract shapes. She has planned a flat background because this is a very small painting. Also, she wants the profile to pop out, and extraneous background information would detract.

Step 2 She moves the figure more into the center of the canvas and paints most of the piece red and violet. She develops composition and color by trial and error, working intuitively and spontaneously, never quite sure of where the painting will end up or how it will get there.

Step 3 She has decided she doesn't like the red and then that she doesn't care for blue either. At that point she wipes everything out and almost attacks the painting with an X-acto knife, but she decides there is still something about the subject that she likes enough to keep working.

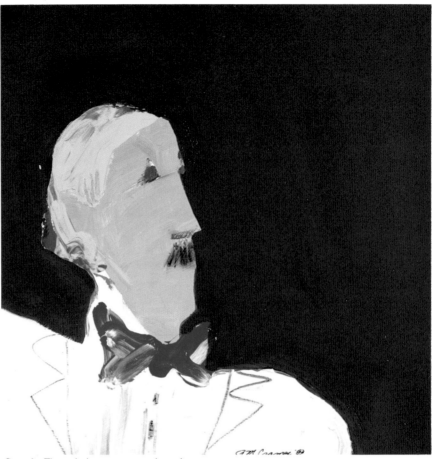

Step 4 The painting comes together when she moves the figure back to the edge of the format, enlarges the face, and simplifies the color. She covers the background with a thick, rich purple. For contrast she paints the jacket with Winsor & Newton white, also thick and opaque. She draws into the paint with a stick of acrylic color to define the lapels, mustache, and buttons. She paints the hair and bowtie with her thumb directly from the paint jar to the canvas.

The title came after the painting was done. She looked at the subject and thought, Doesn't he look just like someone across a crowded room at a class reunion?

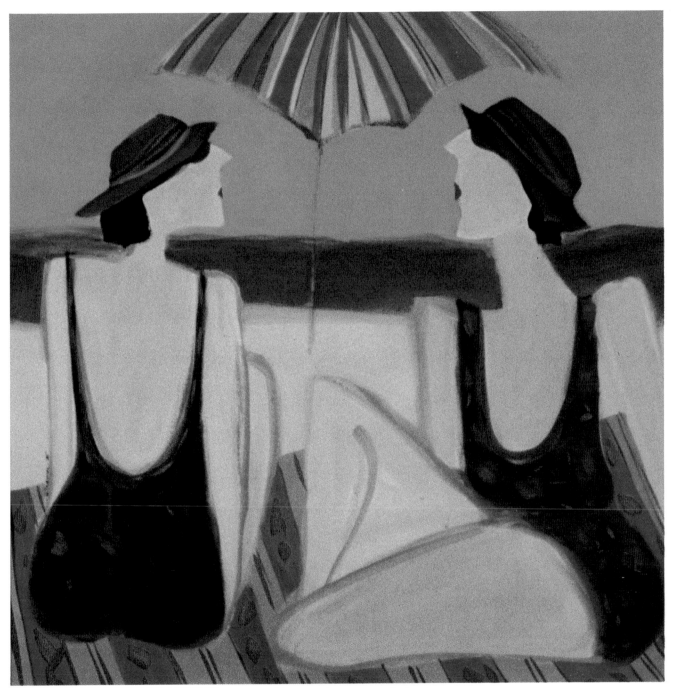

■ WHEN DID A ONE-PIECE BECOME A MAILLOT?
30" × 30" (76 × 76 cm)
Acrylic on canvas
Courtesy of Sullivan-Bisenius Gallery, Denver

Cramer used one model for this painting. On a cloth on the floor of her studio, she had the model sit in one position and drew in that figure; then the model moved into the other pose and Cramer added the second figure.

There are two main sources of interest in this painting. The first is the interaction between the women. They are urbane even on the beach— see how their swimsuits and hats are color coordinated. We see them conversing and wonder what they are saying.

The second source of interest is the interplay between colors and textures throughout the painting. Cramer selected a simple palette of oranges, reds, and blues and used the same colors over and over to provide harmony. Then she provided contrast with her lively arrangement of diamond and striped patterns.

Still Life with Sushi

Best Drive in.

art.

■ **OF COURSE I TYPE**
10″ × 8″ (25 × 20 cm)
Acrylic on canvas
Collection of David Adams

Step 1 *Starting with black paint on a white canvas, Cramer draws in the figure with fast contour lines. Especially when someone is posing for her, she is involved more with gesture and shape than with color. She makes the background darker so that the light figure will come forward.*

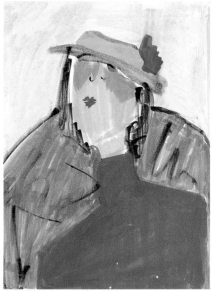

Step 2 *Here she begins to introduce color. Again working quickly, she blocks in areas of bright, transparent acrylic. Her method of working with color is to apply it intuitively and then play with it until she finds what she likes.*

■ **LINE DRAWINGS**

These drawings show Cramer's personal line—loose, fast, and lyrical. She uses as few lines as possible to convey a subject; however, the lines themselves can be almost baroque with their swirls and flourishes. She gets the smooth, unbroken line by working on smooth Bristol paper with a Rapidograph.

She gives equal concern to design and subject. The drawings are always well designed, with a fluid balance of shapes. Her subjects are people, often the interaction among couples or groups. She looks for what is humorous about people, but hers is a gentle satire that includes herself.

Many of her drawings have been published in magazines or newspapers, but she doesn't consider them illustrations or cartoons. They are sophisticated, satirical drawings, the product of a serious artist.

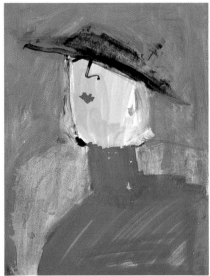

Step 3 We see here how drastically Cramer changes color during the process of painting. The yellow background is now violet; the violet chair is blue; the pink cheeks are gone; the hat is bigger and darker; and the subject is now wearing a necklace. In scrubbing out and painting over, the colors have become more grayed.

Step 4 By now the chair is gone and the whole background is blue. The paint in the face has become thick and opaque. The hat is small and light green again, and the angle of the shoulders has become much more pronounced. Notice how the angle of the hat opposes the angle of the shoulders.

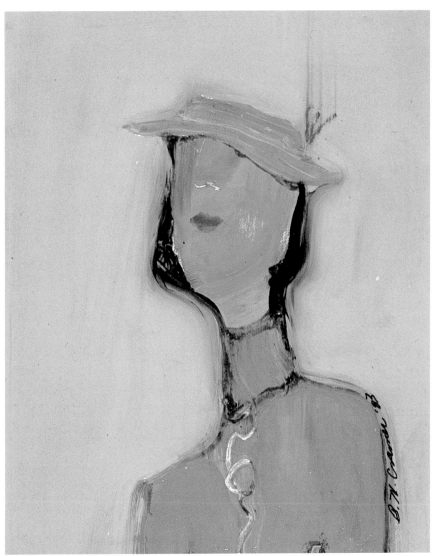

Step 5 Finally the figure comes together into a solid form. The pink face pops out of the complementary green background, and the total figure has a presence. Most of the painting is now flat and solid; Cramer used a fan-tipped brush to smooth out the edges and the background. The white details were scratched into the wet paint.

Cramer says, "They always get ugly for a while, but I love the process. It's not that I don't like it when the painting sings right away, but if it went directly from step 2 to step 5, I would be bored."

DEBORAH CURTISS
Seeing the Figure as a Metaphor

Deborah Curtiss sees the human figure as a metaphor. When she paints the body, she is not painting a particular person, but rather the condition of humanity. She says she is not concerned with portraiture in "any way, means, or form." She admires the architecture of the figure, "nature's most complex and challenging form," but that form is only a vehicle for expressing her feelings about human experience.

Her paintings are of anonymous figures or parts of figures rendered in light and shadow; these figures are generally floating in or emerging from a field of various colors. She paints by staining acrylic polymer paint into cotton or linen canvas, a technique that requires maximum spontaneity and control.

She further emphasizes the abstraction of her paintings by titling them with four-letter permutations of longer words or phrases that serve primarily an identifying purpose. She avoids more narrative titles because, she says, sometimes she doesn't fully understand the emotional meaning of one of her paintings until years later and she doesn't want to restrict the meaning with too specific a title.

In addition to museum and college level teaching in art, Curtiss has an interesting and diverse background of work experience that includes fashion, city planning, vocal music, and writing. All these experiences have affected her art, she says, because they have contributed to who she is as a person. Classical music especially relates to her paintings; there are harmonies and dissonances, rhythm and structure, flow and singing color.

At the age of twenty-one, she began to study art as a graphic design student at Yale, changing to a painting major in the second semester. She had never really drawn much before that. "When I was presented with a life model for the first time," she relates, "I was stunned. Lights flashed, bells rang, and a chorus of angels sang. In an instant I knew I never would be less than fascinated with the human form."

She selects as models people who have a sense of who they are in space and time and to whom she can relate as a human being. Other than that, she doesn't care what they look like. She has the model take a standing, a sitting, and a reclining pose. She walks around the subject, making sketches before she selects a longer pose. She always paints from drawings because, she explains, her technique won't allow her to work directly.

Although she paints figures, Curtiss says she is painting her experience of what she sees more than representing what she physically sees. Her work shows recognizable human forms, but she doesn't consider it realistic. "I have never been taken with realistic painting," she says; "I think it's boring. We have cameras for that purpose."

WORKING METHODS

Curtiss begins with pencil drawings of a model, as many as ten preliminary working drawings, until she gets the quality of volume in space and the expressive reality that she seeks.

She prepares her own cotton or linen canvases by this method:

1. Stretch the canvas tight and very square with the threads. Rinse it to remove sizing.
2. Saturate the canvas with a 50/50 mixture of distilled water and acrylic medium that contains a few drops of flow medium.
3. With the canvas in a horizontal position, pour selected mixed acrylic polymer colors, diluted with equal parts distilled water and acrylic polymer medium, onto the surface.
4. Gently tilt the canvas until the desired surface is covered, and allow it to dry.

She usually has half a dozen such prepared canvases sitting around the studio. She selects a canvas and a preliminary drawing that she thinks will work together. Then with an opaque projector she projects the drawing onto the stained canvas, minimally noting the figure drawing onto the canvas with a 3B–4B drawing pencil.

The colors of the stained canvas represent the lightest lights of the drawing. Working with the drawing at close hand and adding diluted acrylic colors onto selectively wetted areas, she stains in the shadow areas with relative shades of color wash. Because she is working with a permanent medium, she has no chance to make any corrections or change her mind. She must work quickly and assuredly while the areas are wet. When she does make mistakes, the paintings are discarded.

Curtiss paints with acrylic polymer paint and synthetic brushes, mostly watercolor rounds, broad flats for washing in larger areas of color, and a few choice sables for detail. Her medium is acrylic polymer matte.

She selects colors intuitively. She explains, "As the most emotion-laden and emotion-conveying element in painting, color expresses whatever feelings, state-of-mind, or mood that I have at the time. My choices are not conscious or theoretical, but are based upon a kind of resonance with certain colors and their combinations."

The value range is developed in response to the shadows required by the drawing. The colors of the stained canvas represent the lightest lights. Highlighting with a lighter and more opaque color kills the translucency, the inner light, which she feels is important to her work. Thus she is always working with shadowing washes, building up the darks.

■ AKEN
60″ × 50″ (152 × 127 cm)
Acrylic polymer on canvas
Collection of the artist

This is an excellent example of Curtiss' use of prestained canvas as an underpainting for the figure. She began this painting by dripping acrylic onto a dry, unprimed linen canvas. While the paint was still wet, she tilted and turned the canvas to achieve the intricate pattern of dripped lines and splotches in the background and through the figure.

She has drawn the body as a solid form, and the exaggerated foreshortening gives us a sense of a figure emerging from the background. There are no cast shadows to anchor the figure; so we see it floating in space. These conditions of the body—emerging, floating in space—are the type of metaphor that Curtiss uses for the emotional conditions of human beings. She wants the viewer to look at this floating body and to recognize the sensation of being psychologically or emotionally ungrounded or unanchored.

■ SHIFT/NESI-d
10½" × 9¼" (26.7 × 23.5 cm)
Graphite on paper
Collection of the artist

For each painting Curtiss draws one to ten preliminary pencil studies. In the drawings she focuses on divisions of space and on relationships between highlights and shadows. She draws directly from a model whenever possible; then she paints from the drawings.

Earlier in her career she drew the figure with contour line only; now she focuses on the value contrast within the forms. She says she is concerned with "the power of light and shadow to both reveal form and conceal it, erode its edges."

■ SHIF/HIFT
30" × 48" (76 × 122 cm)
2 canvases 30" × 24" framed together
Acrylic polymer on canvas
Collection of Richard and Suzanne Misher

Two slightly different fragments of the same figure drawing were worked on as separate paintings, but Curtiss liked the dialogue they set up when placed side by side. When she decided to frame them together, she added some unifying washes of color.

"It was the first and, so far, only set that I framed side by side," she says. "I am so excited by the evocativeness and sometimes enigmatic aspects that such juxtapositions can provide that I am pursuing this theme by inserting a smaller canvas in a larger canvas in my most recent paintings."

Adding to the usual abstract patterns of color in the background were the effects of failed paintings on the backs of these two canvases. Some of the colors in the old pieces had bled through, and Curtiss used those colors to enhance the new paintings.

■ HESH
24" × 40" (61 x 102 cm)
Acrylic polymer and pastel on canvas
Collection of the artist

With this painting Curtiss bounces us in and out of reality. The random pattern of color flattens out the picture plane, but the figures are rendered with three-dimensional shadowing. The body parts are drawn in a fairly representational way, but they appear more abstract because we are given only fragments of the two figures. This duplicity suits Curtiss' intention of giving her paintings more than one level of meaning.

This painting has sharper outlines than many of her works because she used Othello pastel pencils for drawing the contours and they left outlines when joined by the washes.

■ EDTA
23″ × 24″ (58 × 61 cm)
Acrylic polymer on canvas
Collection of the artist

This is a soft, intimate painting with gently curving shapes of similar values flowing into each other. There are no harsh contrasts of value, shape, or color. The area of highest contrast is the face, with its brilliant highlights set against the softly shaded brow, eye, nose, and mouth.

The division of space is interesting in this painting. Curtiss cropped the figure within the head, foot, knee, and shoulder so that the negative spaces would consist of interesting shapes. Then she subdivided the masses of negative space into areas of highlight and shadow. She similarly broke up the total shape of the body into light and dark masses. The result is a two-dimensional division of space as intricate as a jigsaw puzzle.

The total effect of the painting is not two-dimensional, however. Look at how the well-drawn shadow of the foot convinces us that the painting contains a real foot that exists in space.

SUGGESTED PROJECT

Experiment with Curtiss' staining techniques using watercolor and paper. Start with a sturdy sheet of watercolor paper. Wet the whole paper or sections of it. Drop a few splashes of one color onto the paper. Tilt the paper in various ways to make the color spread and run in abstract patterns. Experiment with more or less water, more or less color. Try additional colors in layers. Drop several colors at the same time. Notice how the paint falls on the paper, how it spreads in the wet areas, how it runs when you tilt the paper.

Stain several sheets of paper in this way. After the stained papers are dry, use them as the basis for figure paintings.

PAULINE HOWARD
Painting with a Journalist's Eye

Pauline Howard is a visual journalist, recording what she sees without editorial comment. She says the world is her subject. Her particular world is charming and gracious, filled with lovely people involved in stylish activities— ballet classes, polo matches, moments on the beach.

Howard says there are no messages in her art. She is content to paint a calm, gracious way of life without probing the physical and emotional stresses under the surface. When she draws dancers, she shows their forms, concentrating on the romantic colors and the exquisite contours of the ballerinas without hinting at their sweat or pain.

She prefers a candid approach to her subjects. She says she likes to paint people who are unaware of her presence because they look more natural. She often paints figures with their faces turned away or thrown in shadow. This places more emphasis on the activity that is taking place and the gesture of the bodies.

Although her paintings are basically peaceful, there is often a quiet tension in the gestures of the figures. Her people on the beach, for instance, are not lying placidly in the sun; they are involved, at least visually, with whatever activity is surrounding them.

Howard admits that she is a romantic, but she is also a serious professional, and it is her unwavering competence as an artist that gives her art its strength. Her figures are beautifully rendered; the composition is strong; the highlights and shadows are well placed.

She says that light is most important in her paintings. Sometimes she uses a very strong light source to get the most dramatic interplay of lights and shadows, sometimes a more diffused light for softer highlights and more subtle shadows. In her beach paintings she deals with both the direct light of the sun and the light reflected off the sand. Always she is concerned with the consistency of light throughout a painting and with the patterns of dark and light in the total composition. She strives for anatomical accuracy in both her human and animal subjects, and she uses the placement of light to help her render contours and model volumes.

She says she cannot take a figure and place it in the center of an empty page. She needs a strong, specific environment where people are doing things in order to make her paintings work for her. She needs balance and order, everything working together within a painting. When we look at Howard's paintings, it is this unity that makes us feel we have walked into her world.

WORKING METHODS

Pauline Howard says she works with pastels because she has two young children and pastels are easier to put down and pick up again. She feels that wet media would be too difficult because of all the interruptions.

She begins her pastel paintings with photographs. She will shoot three or four rolls of film in a given situation, then select two or three shots as the basis of her composition, often picking and combining elements from different photographs. She often uses the viewfinder of her camera to help her decide how to frame a piece. When she works indoors, she shoots black-and-white film because indoor light always distorts color. She says the black-and-white photographs dramatize the values, emphasize the light, and leave her free to develop her own color.

She says she tries to keep at a distance from the photographs to avoid the hazards that they present. She would never trace from a projected slide because of the distortion of shape and color and the general flatness. She deliberately exaggerates shapes and changes colors to make her paintings more lifelike.

To get more accurate renderings of the figures, she often familiarizes herself with models by drawing them first. She says it is vital to keep in touch with drawing from life.

Sometimes she makes a preliminary pencil sketch based on the photos; sometimes she starts drawing directly on the paper. She generally uses a middle tone of Canson Mi-Teintes paper; when possible, she buys it in rolls and cuts it to size. She cuts the paper slightly larger than her proposed painting and tacks it to the wall with pushpins in the margins. She likes to work on the wall because the absolutely vertical surface allows the excess pastel to fall to the floor without affecting the painting.

She draws the image onto the paper with Othello pastel pencils, which allow a finer, more accurate line than thicker sticks of pastel. In this basic drawing she places the important contour lines and details and the darker values of shadow areas. In areas where she wants to establish a dark value, she may do a light underpainting with a watercolor wash. She uses Winsor & Newton watercolors and a round sable brush. The underpainting allows her to develop dark tones without worrying about overworking the pastel.

After she has established the basic lines and shadow areas, she works out her color combinations in a small section of the painting. Then she paints in the finished color with loose strokes of pastel in one section after another, working from background to foreground. She uses Rembrandt soft pastels, Grumbacher soft pastels, and chunks of handmade pastels.

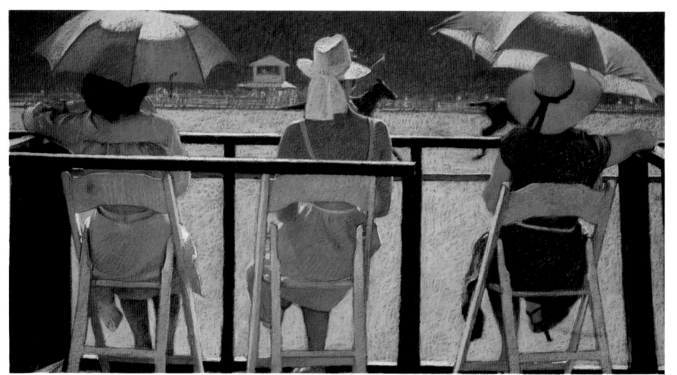

■ BOX SEAT AT THE POLO CLUB
16" × 30" (41 × 76 cm)
Pastel and watercolor on paper
Collection of Mr. and Mrs. Randall Lake

This is a painting of contrasts. Three women sitting calmly, totally relaxed under their hats and umbrellas, while the horses and riders in front of them gallop at full speed across the field. The three women are separated, each isolated in a frame created by the vertical rails, but the horizontal rails hold them all together. The composition appears to be one of absolute symmetry, with the three figures placed at regular intervals across the paper, but there are many small details that serve to break up the symmetry—the break in the back rail, the angles of the umbrellas, the direction of the chairs.

As usual, this was painted from photographs. However, before the artist started the pastel, she completed a full-color study in watercolor. In the pastel painting she worked with a tremendous range of values, not only the middle values of the figures, with their highlights and shadows, but the extreme white of the chairs and the extreme dark of the railing.

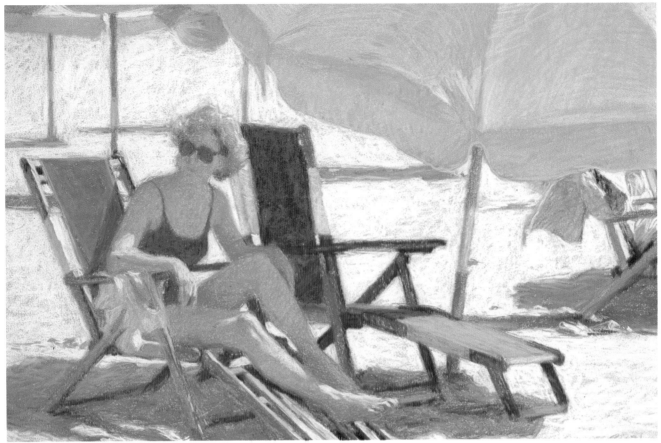

■ LINDA AND YELLOW UMBRELLA
15" × 22¾" (38 × 58 cm)
Pastel on paper
Private collection

One might say that the subject of this painting
is the sunbather in the beach chair. She is
placed in the foreground to draw attention, and
her pose conveys a sense of tension that also
provides visual interest. The real subject, how-
ever, is the color. It is an adventurous drama of
purple and yellow. Everything except the pink
skin and the brown sections of the furniture is
painted in violet and/or yellow.

Howard wanted to have fun with the colors,
using a complementary yellow–violet color
scheme that would give a luminous glow even
to the colors in the shadow areas. She started
with the middle values in violet, working up to
the light tones in yellow and the darkest values
in a dark blue-violet.

In no place did she physically blend the
yellow and violet together. Blending the com-
plementary colors together would have created
a dull gray. By simply placing strokes of the
colors next to each other, she achieved vibrant
color.

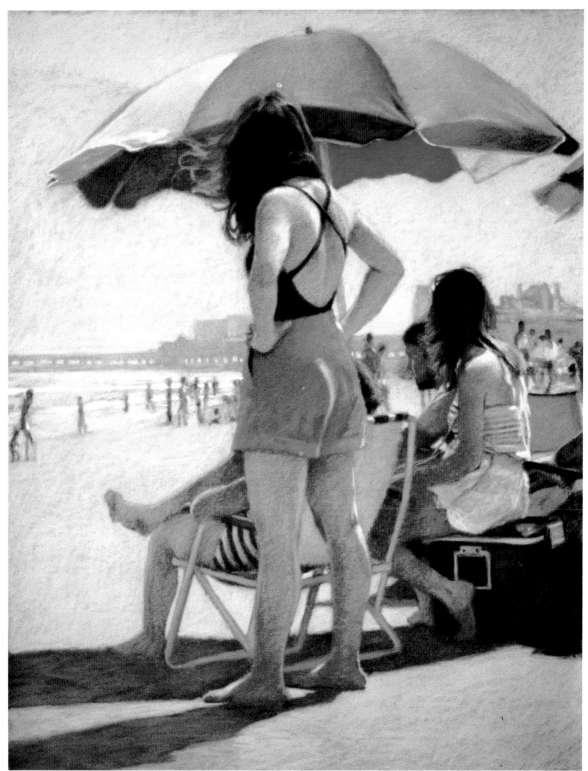

■ WOMAN IN BLUE SHORTS, HANDS ON HIPS
32" × 25½" (81 × 65 cm)
Pastel and watercolor on paper
Private collection

This is an excellent example of Howard paint-
ing as an unemotional observer of the world
around her. In this scene of young people on
the beach, we can see that the sun is shining
and there is a slight breeze. The central figures
are watching something off to the right. We
don't know what, but their gestures are not very
excited; so it can't be too important. It is a calm,
solid painting that pleases the eye without
provoking much thought or emotion.

In this piece Howard used watercolor
washes as well as pastel. First she drew the
image with a blue Othello pastel pencil onto a
sheet of Mi-Teintes paper. Then she blocked in
the dark areas with a blue-gray wash. After the
wash dried, she completed the painting with
pastel in her usual manner. The underpainting
of blue washes allowed her to develop the dark
areas into solid tones without the danger of
overworking the pastel.

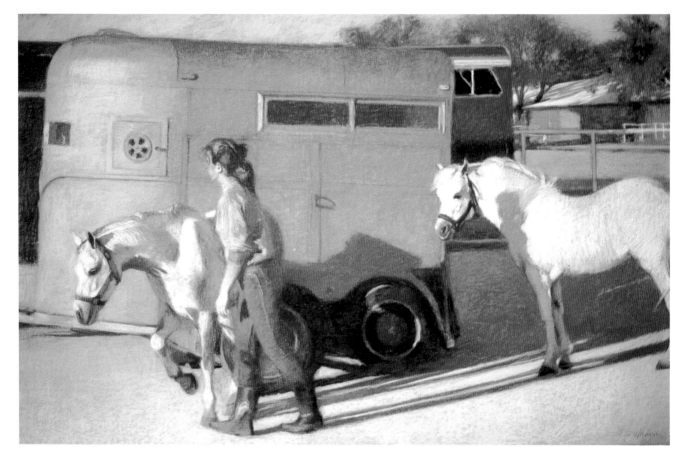

■ GIRL WITH WHITE PONIES
27" × 42" (68.5 × 107 cm)
Pastel on paper
Collection of Republic Bank, San Antonio, Texas

Howard often paints human figures shown with horses or ponies. She says that even though she enjoys drawing the animals, they are usually the most difficult part of the painting because of the need to get them anatomically correct.

She began this painting with the dark values. There was an extreme value range in this scene that was exciting to utilize, from the almost-black blues in the tires of the trailer to the brightly lit white pony. She says she enjoyed working with the cool grays of the trailer and the girl's shirt, which show how colorful and beautiful the neutral colors of gray, white, and beige can be.

The two ponies, divided as they are, provide a balance in the composition. Another balancing factor is the use of gold in the upper right and lower left. Notice how she also uses accents of gold throughout the composition.

■ DETAIL

In this closeup we can see the variety of strokes Howard uses. This painting was quite large for a pastel; so it allowed ample room for a broad range of strokes, from the definite, linear strokes of color in the hair, mane, and shirt to the very smooth application of color in the trailer. Howard says she never blends colors by rubbing them together; she always puts down separate strokes and lets them blend optically.

We see here how the girl's head was turned away. Howard was pleased that the face did not show because that allowed equal focus on the girl and on the other elements in the painting.

■ THE LYBRAND CHILDREN IN COMAL RIVER

19½" × 29" (49.5 × 74 cm)
Pastel on paper
Collection of Mr. and Mrs. Julio LyBrand

This commissioned painting shows Howard's "informal approach to doing portraits of children." The Comal River, where the LyBrands spent their summer, provided the artist with everything she needed—water, light, and active figures. She made up the composition from separate photographs of each child. The common light source and background unified the painting. Before she began the major piece, she did a preliminary study in pastel pencils on white Strathmore paper.

Step 1 The first step is a linear drawing with blue pastel pencils, which gives her more control of her line than she would have with a stick of pastel. In this initial drawing she places the figures, the background elements, and the shadows. The background is very important in this particular composition. After sketching in the three children, she is left with a big empty space in the upper left portion. Rendering the details of trees and shadows in that area helps complete the balance.

Step 2 She works out her color combinations by developing the color in one small area of the painting—the standing boy. Since she has chosen a fairly dark paper to begin with, she decides to use cool, dark colors and emphasize the highlighted surfaces with complementary warm, light colors. Notice how the warm flesh tones of the standing figure contrast with the dark innertube he is holding. In this stage she also adds more bluish colors to enrich the shadows.

Step 3 After establishing the color combinations, Howard paints in finished areas of color from background to foreground. She describes the delicate web of blue, gray, green, and violet that she uses to develop her values; we can see that clearly here in the lower center. She creates a sense of space by intensifying the value contrasts as she moves forward from background to foreground.

Step 4 Here we see the finished painting, where she has achieved her intentions of portraying the children while also creating an interesting painting. She was concerned with capturing the likeness not only in the face of each child but also in the body. She likes the idea that a person whose face is turned can be recognized by the shape and posture of the body. Beyond a portrait, she wanted this painting to present a scene—of simple figures in a landscape—so that one could enjoy the painting without identifying the faces with names.

■ DETAIL

In this detail we see the very precise develop-ment of the contours of this figure. Look at the tight rendering of the ear and the face in profile, also the elegant contours of the arms.

We can also get a sense of how the artist applies her color. Notice the many colors crosshatched over and against each other to comprise the skin tones of the face. The color is applied in loose strokes; notice how the gray of the paper shows through the pastel.

■ DANCERS WITH PIANIST
32¾″ × 27″ (83 × 68.5 cm)
Pastel on paper
Private collection

Howard says she chose this subject for many reasons: "my personal appreciation of ballet; the strong visual appeal of the composition—of the relation of dancers; the opportunity for true pastel [soft] color usage; and the lithe and fragile figures of the dancers. I selected the pose from what I thought was pleasing to the eye—not necessarily a correct ballet position, but I hope not glaringly incorrect."

Having the values already broken down in the black-and-white photos that were her pre-liminary studies, she simply chose her colors according to the warms and cools of the light and dark areas. Notice the wonderful way she handled highlights and shadows, especially the delicate play of light and dark in the floor. The negative space provides almost as much visual interest as the figures.

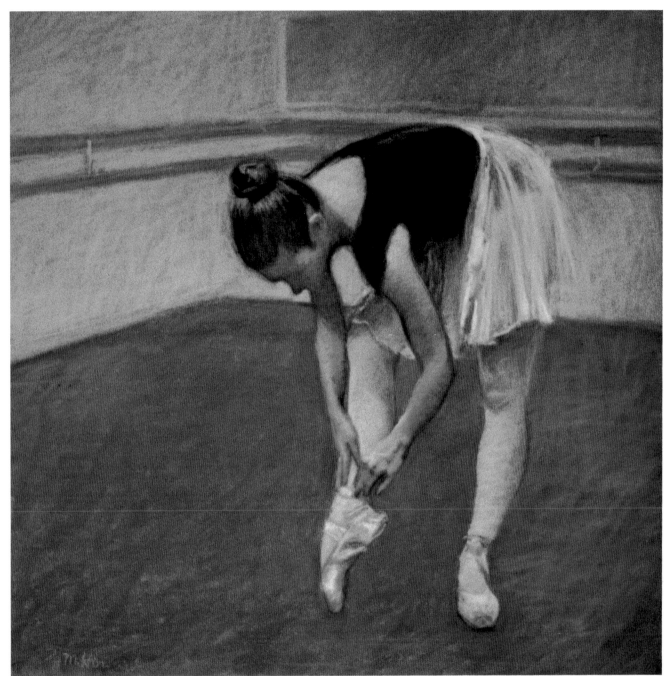

■ DANCER IN TOE SHOES

18" × 18" (46 × 46 cm)
Pastel on paper
Collection of Patty Cwalinski

This painting is simpler than most of Howard's work, showing just one figure in the middle of a very simple background. Though simple, the background is very important; the geometrical shapes of floor, wall, and barre divide up the negative space to make the total painting much more interesting.

The artist worked from black-and-white pho-tographs, adding the colors she thought would be most natural to the subject. Notice the difference in intensity between the colors in the figure and those in the background. She wanted the negative space to be interesting but not to detract attention from the dancer.

Like many of Howard's paintings, this one put the subject's face in shadow. The hands and feet, shown in brighter light, are given more definition, making this more a candid study of a dancer, which Howard wanted, and less a portrait.

STEPHEN GJERTSON
Creating a Joyous Beauty

Stephen Gjertson paints a world of the imagination. He takes elements of reality—actual models, props, and backgrounds—and blends them into a calm and graceful reality of his own. The people are beautiful; the garments are stately; the furniture is elegant. Even in his religious paintings of sorrowful subjects, he tries to emphasize what is harmonious and comforting to the eye.

Gjertson places himself in the tradition of the Boston School, a group of American artists active from the 1880s until the 1930s. These artists attempted to combine the authoritative draftsmanship of the nineteenth-century ateliers with the richly pigmented surfaces and color truth of the Impressionists. Gjertson studied with Richard Lack at Atelier Lack in Minneapolis. His training included drawing and painting from plaster casts, life drawing and painting, still life and portrait painting, anatomy, composition, and memory painting. He learned the traditional method of developing a painting through drawings and color studies (never photographs) that he still uses in his work.

"The best advice I could give anyone," he says, "is first to acquire a firm foundation in drawing—from the cast and from life! life! life! Then paint from nature—still lifes, portraits, and figures. Without this foundation, even the most talented person will be handicapped. Attempting to paint more complicated pictures without this foundation is to invite disaster."

He enjoys painting landscapes, florals, and commissioned portraits, but his favorite works are imaginative paintings, most often with religious scenes. After the subject has been established, he tries to visualize the total image in his mind and then develop each section of the painting using live models and props in his studio, usually beginning with the gestures of the figures. These paintings take great patience and skill, as well as money for materials, models, costumes, and props. Occasionally he finds a client to commission an imaginative piece, but generally he must "relegate it to the back burner," doing it in spare time between more salable paintings.

Gjertson feels that every picture is important. He won't paint something unless it truly excites him, either conceptually or visually. Since he insists that every painting be as well crafted as possible, he often spends months or even years on a major piece. "My sketchbooks are full of subjects," he says. "I have enough in my mind to paint until I'm eighty. It's a question of picking out the best ones, the ones that are most meaningful."

WORKING METHODS

After Gjertson decides on an image to paint, he sets up the scene in his studio. Since he works as much as possible from life, he is meticulous about finding exactly the right model, props, furniture, and other details. In one painting he combined three different models into one figure—one for the face, one for the body, and one for the coloring. If the image is too complicated to set up completely, he works it out in sections.

He uses the setup for his preliminary drawings, often beginning a complicated painting with dozens of thumbnail sketches to work out the composition, gestures, and values.

After he has done the final drawings and studies of the composition and the figures, he executes a cartoon. The cartoon is a full-sized drawing of the entire design, done in the medium of the artist's choice. He uses this cartoon to transfer the final image onto the canvas. For this transfer he uses tracing paper over graphite paper. For complicated figure painting, he is convinced that a careful and quite complete cartoon is essential for success and that all the major problems of form and design should be solved before the painting is begun.

As a final preliminary, he often does at least one color study in oil on paper. Even though he has done careful drawings to indicate contours and values, he works again with the models and props to establish more convincing color value relationships.

Gjertson prefers painting in oils in a direct manner. He begins with thin but opaque pastes of paint, going for the exact color values right away. This first layer of paint is made to look as close to the final result as possible; from a distance it should suggest a finished painting. He says the sooner he can get the intended look, the sooner he can see the mistakes.

He tries to mix the exact colors on the palette so that there is as little mixing on the canvas as possible. He puts the paint down smoothly, but with some obvious brushstrokes. He likes some surface texture, but not enough to give a mottled or blotchy appearance.

After he lets the first layer of paint dry, he goes on to the second step, which involves correcting the mistakes he made in the initial painting. He says one has to have the courage to rub out a section that is wrong. This step lasts as long as necessary.

In the third step he concentrates on the nuances of expression, form, and color. He refines the drawing and works toward subtlety of color and beautiful workmanship throughout the painting. He executes the last stage slowly, taking one small section at a time. He might devote a full three-hour session with a model to working on one eye. It is this meticulous attention to detail that gives his paintings their rich, refined quality.

He paints on Fredrix 111 (double-primed) canvas using Winsor & Newton or Grumbacher Finest oils. His usual flesh palette is flake white, ivory black, raw umber, yellow ochre, Indian Red, light red, cadmium scarlet, Thalo red rose (optional), and Naples yellow (real lead—Permanent Pigments).

His brushes are Robert Simmons round bristles, Strathmore bristles, and Grumbacher round sables. His primary medium is a mixture of equal parts of stand oil and poppy oil; for glazes he likes to use Taubes copal medium. He applies a coat of damar or retouch varnish just after the painting is finished.

■ **YOUNG WOMAN READING**
30" × 23" (76 × 58 cm)
Oil on canvas
Collection of Mr. and Mrs. Mark Nilsson

This was a commissioned portrait. The romantic costume, Victorian chair, and contrived pose could have made it cloyingly sweet. What saves it from sentimentality is the austere beauty of the model and the tight, classical style of the artist.

Gjertson executed this piece in his usual direct method. He traced the cartoon onto the canvas, then applied "straight, thick pastes of opaque paint," working from the beginning with natural colors. The dark background is typical of his work.

■ MIDMORNING
33″ × 42″ (84 × 107 cm)
Oil on canvas
Collection of the artist

Gjertson wanted to paint his wife and daughter simply and elegantly. For the setting he used items from his home which he had painted before and which harmonized with his theme and color design. He purchased the clothing especially for the painting. He wanted a light background to bring out his wife's dark hair and a neutral one as a contrast to the strong local colors.

This painting is a good example of the idyllic world Gjertson likes to create in his art. He achieved the grace and repose by his choice of subjects and also by his composition and execution of the painting. The main compositional element is a triangle, from the woman's head down the girl's back on one side and down to the basket of fruit on the other. He put changes of value in both upper corners to sustain our interest in the negative space and to provide balance.

Notice how he repeated colors through the painting to assure color harmony: yellow in the basket of fruit, the flowers, the single yellow apple in the foreground, and the plant hanger; red in the chair, dress, fruit, and flowers; blue in the girl's dress and the vase.

■ PENCIL STUDY
7″ × 9″ (18 × 23 cm)
Pencil on paper

Gjertson works out his compositions carefully in pencil drawings before he begins to paint. Notice how meticulously he draws each element, paying special attention to all the value changes. This drawing is close to the final cartoon, but here he was still exploring. Notice the segments of fruit in the foreground that he later removed to simplify the composition.

■ **DETAIL OF CARTOON**

This is a small section of the cartoon, the full-scale drawing in which Gjertson locates everything on the canvas and delineates contours, highlights, and shadows. He copies the cartoon onto tracing paper; then with graphite paper he transfers the information from the drawing onto the canvas. Notice how carefully he marked the shapes of the shadows and also the bright highlights in the woman's face.

■ **DETAIL**

Notice how closely the finished painting follows the structure laid out in the cartoon. Look, for instance, at the shadows of the cheek and nose. Gjertson develops his colors slowly and carefully. Even though the hair is brown, it was not painted just with brown pigment; notice the yellow and reddish strokes. He is very aware of temperature as well. The highlights were painted with warm tones; the shadows are cooler. You can see the bluish tint in the shadows around the eyes.

■ **DETAIL**

Many artists simplify children's faces in their paintings, but not Gjertson. Here we see how carefully he developed all of the shapes and volumes of his daughter's face. Notice the purple shading to indicate changes in three-dimensional contours. Also notice the blue-green on the jawline and neck, where color from the blouse is reflected.

■ **DETAIL**

The contours and shadows of the hands were carefully drawn onto the canvas from the cartoon. The process of painting was to make the hands believable in color and volume. Notice the wide range of colors that comprise the skin tones; besides the usual flesh colors, he used strokes of yellow, violet, and coral.

■ **DETAIL**

Gjertson always paints flowers from life. Since he never uses artificial flowers, and fresh flowers wilt so quickly, he left space in the painting for the flowers. Then he added them with a fast, alla prima rendering, having fresh blossoms in front of him.

■ **THE RECORDER LESSON**
27" × 22" (68.5 × 56 cm)
Pencil on paper
Collection of Lyden and Annette Hathaway

This is one of the pencil studies the artist used to develop the finished painting. By comparing this drawing and the painting, we can see some of Gjertson's compositional decisions. He moved the woman's right hand closer to the girl, giving the feeling of a more intimate relationship between the two figures. Also he eliminated the front pillow, allowing the floral pattern in the foreground to relate more fully to the patterns behind the girl.

■ **THE RECORDER LESSON**
28" × 22" (71 × 56 cm)
Oil on canvas
Collection of Mr. and Mrs. Mario Fernández

This painting was commissioned by "a friend of a friend" who wanted a small painting with a musical theme using Gjertson's Victorian couch and this particular Oriental vase. The artist shopped for dresses to harmonize with the sofa and vase, and he borrowed the recorder from a friend.

He first visualized the composition and then did a series of small drawings from his imagination. After the "thumbnail throwaways," he drew the cartoon. He first drew the sofa, carefully establishing the proportions; then he posed the models on it. He drew them together at first to properly relate them to each other and then had them pose separately to firm up the drawing.

The most difficult aspect of working in this formal way, with models holding a pose for hours and the artist redoing the same image in drawing after drawing, is to maintain a loose, natural feeling in the pose and attitude of the figures. In this piece Gjertson has succeeded wonderfully, creating an illusion of one natural moment in time.

■ **SO HE DROVE THE MAN OUT**
47" × 28½" (119 × 72 cm)
Oil on canvas
Collection of Dr. and Mrs. Rodney Dueck

Gjertson enjoys painting Biblical pictures and has drawings and studies of many more. This is one of his favorites; he has done many versions of it and would someday like to paint it life-sized.

The main reason that the color is so much warmer in this painting, the earlier of the two shown here, is that it was executed with the bistre method. In this technique, derived from the Flemish School, the underpainting is done in transparent glazes of brown as if it were a watercolor. The darkest areas of the painting remain transparent. The halftones are translucent, with some brown showing through, and the lights are opaque. The advantage of the bistre method is that it can result in a beautiful harmony of color. The limitation is that it doesn't lend itself as easily to rendering color notes observed from nature.

■ **GESTURE DRAWINGS**

Gjertson explains his reason for choosing this subject as "my guilt over my sinfulness before my coming to Jesus Christ." Consequently, his emphasis in the first studies was on guilt and the wrath of God, as conveyed by the harsh expression of this cherub. By the time he finished the painting, he was more concerned with "the coming Messiah"; so the total painting, including the cherub, became more gentle.

Gjertson says that the most difficult problem

to work out was the best gestures for the figures. He says he established Adam right away, perhaps because he personally identified with Adam, but he struggled to find the right expression for Eve and the cherub. As in all of his work, Gjertson drew from live models to work out all the problems of gesture, expression, and anatomy before beginning the painting. He says he likes to develop the nude figures first to be sure of the anatomy and then to add the garments later.

■ SO HE DROVE THE MAN OUT
47" × 28½" (119 x 72 cm)
Oil on paper
Collection of Rev. and Mrs. Dennis E. Worre

This painting on paper is the final reworking of the earlier painting on canvas. Gjertson used paper that he glued to foam core and sealed with acrylic matte varnish. After he traced the cartoon onto his painting surface, he did an underpainting in black and white casein. He painted a thin layer of oil paint over this to establish the general color harmony and finished it with thin but solid paint mixed with oil. He used Winsor & Newton oils, a medium of poppy and stand oils, and round bristle and sable brushes.

By comparing this painting to the one done earlier, we can see that the compositions are essentially the same, both having been traced from the cartoon. There are some minor changes in the gesture of Adam, the costumes, the pattern on the snake, the delineation of the sword, and the cherub's feet; however, the major difference is in the color, the later painting being cool and the earlier one being warm.

LUCY GLICK
Using the Figure to Express Emotion

In the tradition of German Expressionism, Lucy Glick paints human figures to convey emotion. She explains, "My hope is to give an idea of the joy I experience, the pleasure I feel responding to that figure in that light in that environment. I use the figures, tables, chairs, composition, colors, all to express that feeling."

She paints specific figures in specific environments, but the details are lost in the rush of color and the eruption of brushstrokes. Facial features, joints, and muscles are hinted at or implied, while she focuses on gesture. In Glick's paintings we don't see weary eyes and a frowning mouth; the emotion is conveyed with the tilt of the head, the weight of the torso, the slouch of the shoulders.

"Translating the feeling is done largely on an unconscious level, but there is a measure of control and technique," she says. "By technique I mean the selection process. I choose to use oil paint because of its rich, sensuous quality. I choose sometimes to apply the medium freely to make a juicy glob of paint; or float it into thinner paint to get a different texture; or let it form a little pool. Occasionally I tilt the canvas slightly from the flat surface on which I work to let the paint run."

In photographs her oil paintings look like enormous, wall-sized creations crafted with house-painting brushes and buckets of paint. In fact, the dimensions are moderate, often less than two feet in either direction. The illusion of large size is created by the vitality of her colors and the looseness of her strokes.

Another illusion she creates is of a simple, naive spontaneity. Although much of her color choice and composition is intuitive, her work is the result of years of training, and each painting is the culmination of numerous studies.

Even though the chairs, tables, and human figures may seem to be thrown into the composition in a random way, Glick carefully sorts and arranges each element. She is concerned with how the objects move back and forth in space and how the shapes relate to one another in an abstract way. Because she is excited by the whole environment, she uses the nude like the tables and chairs, to show how light falls.

Despite the abstract quality of her figures, Glick says she is painting real people. "I don't think the real person is just what he looks like," she states. "The essence of a person is in how he moves and talks, the form and light and the colors that vibrate."

WORKING METHODS

Glick starts with the model and the pose. She chooses models not for their features or facial expressions, but for their ability to move naturally. She begins the modeling session with a series of "croquis," quick watercolor sketches of one-or two-minute poses, changing so rapidly that the model must take poses unself-consciously. From that exercise she often finds several poses she would like to repeat for a longer session.

To create an interesting background, she fills the space surrounding the model with tables, chairs, flowers, and various other objects. She drapes colored cloths over them and pins more cloths to the walls. This background adds excitement to the pose, provides different points in space on which the light falls, and sets an environment in which to relate to the model.

After the quick warm-up drawings in watercolor, she does studies in oil (taking about twenty-five minutes) from different angles around the studio. From these she chooses her composition. She continues to work directly from the model.

For her finished painting, Glick works on a panel that has been gessoed and sanded several times to create a very smooth surface. This allows the paint to move in a fluid way.

She begins by thinly painting in the basic compositional elements. She uses Winsor & Newton oil paints and a medium made of damar crystals suspended in pure rectified turpentine until dissolved. The mix is about one part damar to two parts turpentine. She paints with natural bristle brushes which may be wide but not very thick. She often uses a fan-shaped brush that she can saturate for a wash or turn sideways for a bold line without stopping to change brushes.

Colors are suggested initially by what she sees in front of her. As she progresses, she makes changes according to the painting that is emerging rather than what she actually sees.

After she has blocked in the composition and the gesture of the figure, she builds up the volumes and intensifies the colors. With strong, loose strokes, she gradually refines the shapes, colors, and values. Since she uses a lot of turpentine at first, paint can be moved around easily or wiped off entirely. The paint automatically becomes thicker in certain areas as she builds up the structure.

"I'm not aware of technique when I paint," she says, "but work intuitively and rapidly, just focusing on the image in front of me. I like to work quickly and then put the painting aside for a period of weeks or months to reassess later. I exhibit only the paintings that are successful, that show what is exciting to me—light on form, the grace of the motion and its relationship to space."

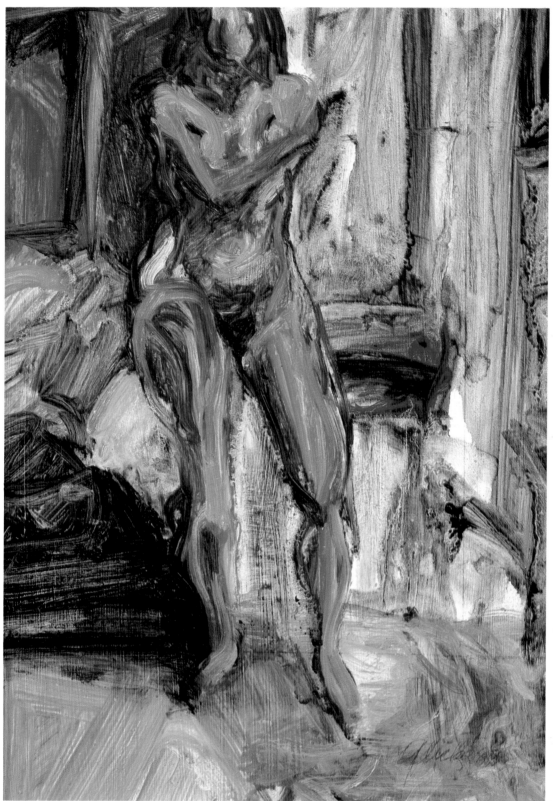

■ STANDING WOMAN
19½″ × 15½″ (49.5 × 39 cm)
Oil on panel
Collection of the artist

Glick says that in this painting she liked the
warm pink vertical figure in relation to the cool
vertical panels of blue and green behind it.
They unify the composition while focusing on
the figure. The transparent areas in the back-
ground also provide good contrast to the more
solid structure of the figure. The horizontals
across the picture plane add to the movement.

This painting is a good example of how she
balances contrast and unity. Notice the tremen-
dous variety of brushstrokes—straight, curved,
long, choppy. So much variety could be chaotic,
but Glick has stabilized the movement with the
large repeated vertical shapes.

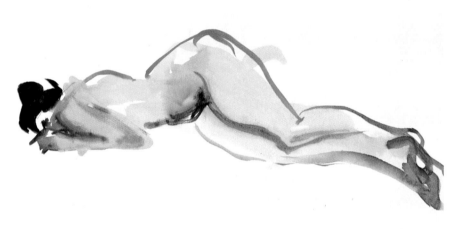

■ CROQUIS
Watercolor on paper

Croquis *are quick gesture studies painted directly from the model. Before starting a long pose, to warm up and become more familiar with the model, the artist does a series of gesture drawings, usually one-minute poses. Sometimes she walks around the model to get different views of the same pose; sometimes she has the model move quickly through a series of different poses.*

She works with watercolor and brush, a wet medium, because the fluidity allows her to draw contour lines, wash in values, and suggest color, all in a matter of seconds. She concentrates primarily on gesture but tries to record some anatomical information as well. Selected details are added with quick spots of color or value.

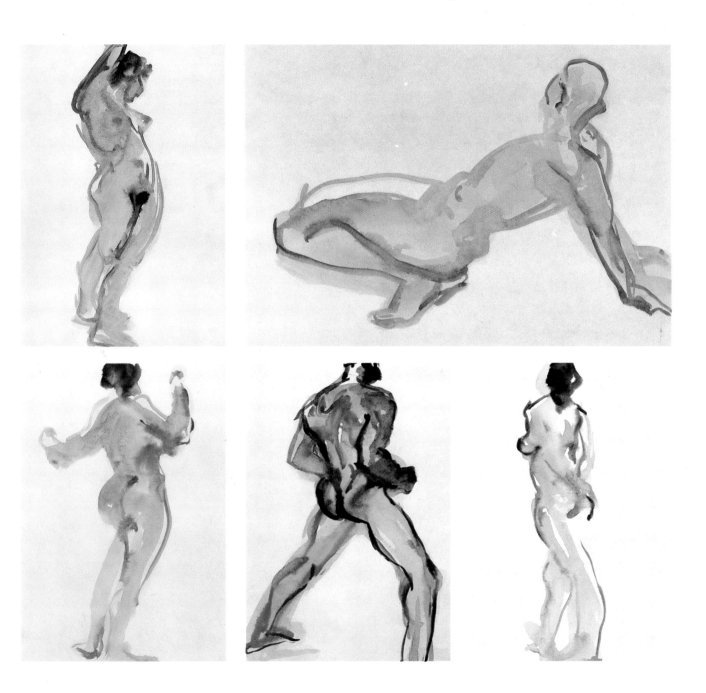

EXPRESSING A POINT OF VIEW

■ INTERIOR: SEATED MALE
18" × 16" (46 × 41 cm)
Oil on panel
Collection of the artist

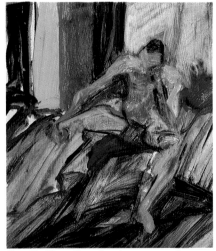

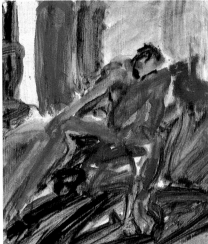

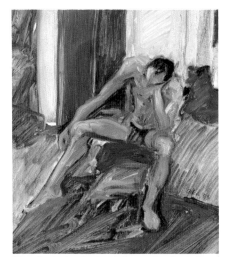

Step 1 The artist starts with a transparent wash to block in the composition and the gesture of the figure. She paints with fast, broad strokes, establishing shapes rather than lines. Her initial concerns are relating the colors, establishing the weight of the mass, and indicating the lights and darks.

Step 2 Here she fills in the rest of the negative space. Glick works on the figure and the background at the same time. She strengthens colors at this stage; they are more intense than they will be at any other time, including the finished painting. She keeps the paint fluid so that she can easily make changes. She will tone down most of the colors by painting over, blending, and wiping out. By the final stage most of the color will be softened and/or grayed to contrast with a few areas of very intense color.

Step 3 She refines the placement and proportions of figure and background objects with linear strokes. Although the painting has a linear feeling, there are very few actual lines. She introduces more opaque color here for solidity, luminosity, and contrast of flat color with translucent. Notice how she is defining light with her use of color—the warm colors on the shoulders in contrast with the cool shadows on the model's left arm and leg.

She explains, "I continue building up in this manner—refining, making corrections, and accenting as I work the whole canvas at one time, taking advantage of happy accidents that occur when one works quickly. Color drips, interesting shapes form, lovely edges appear. Some are kept and others eliminated in the search to keep the essence of the figure as well as the excitement of the whole composition."

Step 4 In the final painting notice the balance of color and shape in the opposing red shapes, for instance, or the opposing blue shapes. These are even more important because they contrast with the washed-out areas. The total painting is simpler in color; she has almost eliminated the green. We can also see here how she has developed volume by the direction of her brushstrokes. In the model's right leg it is the stroke that makes us feel the bones and muscles of the knee and thigh.

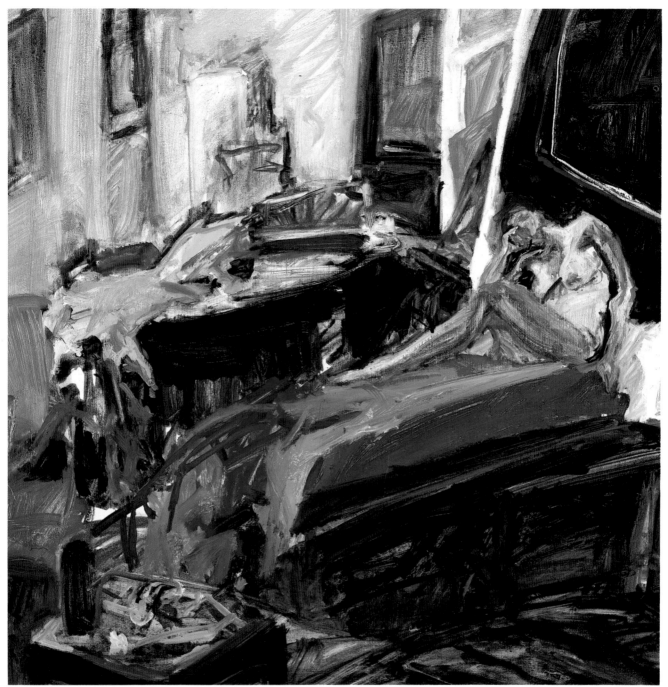

■ INTERIOR WITH VIBRANT BLUE
30″ × 30″ (76 × 76 cm)
Oil on panel
Collection of the artist

In this exuberant display of color and stroke,
we see a vivid example of the excitement that
Lucy Glick feels about her subjects. She boldly
juxtaposes colors—yellow against blue, or-
ange against violet—and applies them with a
wonderful variety of strokes; notice the soft
curves, jagged squiggles, and bold slashes. The
color and stroke are so strong that in places the
painting approaches total abstraction. When
she does nonobjective work, the same princi-
ples apply.

 "I don't think the fact that there is a figure
matters," she says. "There is an element of
pleasure in painting directly from the figure. It
is the quality of the paint and excitement of the
composition that are most important, and often
the figure does provide a bit of recognition that
anchors the painting for the viewer."

EXPRESSING A POINT OF VIEW

■ SEATED NUDE, RED VERTICAL

14½" × 14" (37 × 36 cm)
Oil on panel
Collection of the artist

One of Glick's primary concerns is how light falls on the figures and objects in her paintings. Light is the main focus of this piece, in particular, how the light from the window shapes falls across the lower part of the model. Glick achieves this sense of light with value contrasts and color temperature. The window areas are painted in light, cool colors, while all the rest of the background is dark and warm. Similarly, in the figure the head, arm, and upper torso are warm, medium tones; the lower torso and legs are primarily light and cool.

As usual there is very little specific detail in the figure. The artist has abstracted the nude and the background forms, focusing on color, light, weight, and gesture. Nonetheless, the viewer has no doubt that this is a female figure sitting or leaning back on a horizontal support with her feet resting on a smaller support.

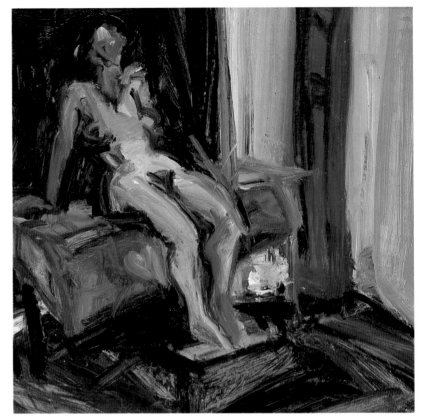

■ INTERIOR: SEATED WOMAN

18" × 16" (46 x 41 cm)
Oil on panel
Collection of the artist

In this painting of a comfortable, relaxed woman, the gesture is the key to the piece. Although there is more delineation of the facial features here than in many of Glick's figures, the face is still somewhat anonymous and does not intrude into our perception of the easy, reclining nude.

The feet are a good example of how Glick implies anatomy. The upper foot is a simple curved extension of the leg as it hangs in space. The other foot is definitely resting on the ground. It is made real by the base of the heel and the upper curve of the instep, two simple shapes establishing an entire foot.

The artist creates drama by juxtaposing the intense blue and the warm pinks and ochres of the body. Notice how many different blues actually comprise the blue area in the upper left section of the painting.

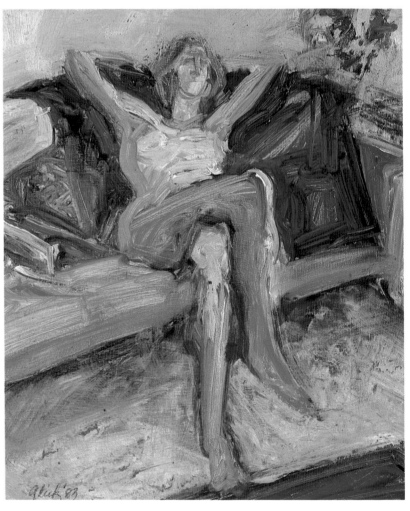

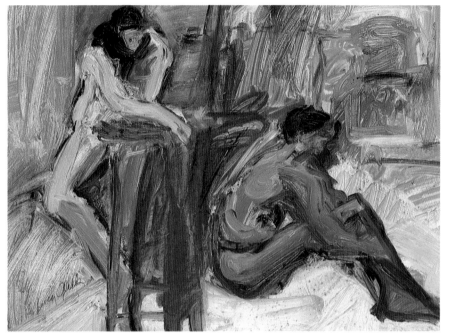

Since the beginning of her art education, Lucy Glick has been painting *croquis*, quick gesture studies of models. She suggests that this is a good exercise for any artist who is working with the figure.

Devote part of every modeling session to these quick studies. Have the model change poses every one to three minutes. Work on paper with any quick medium, watercolor, charcoal, conté crayon, ink.

Try to get down the essence of the motion within your time limit. You don't have time to think about it. You don't have time even to look at what you are doing. The sketch is created by your looking at the model and letting your vision pass, without thought, through your fingers to the paper.

■ TWO FIGURES

15″ × 18″ (38 × 46 cm)
Oil on panel
Collection of the artist

Here the artist wanted to capture "a casual moment in time," focusing on the relationship between the two figures. She was working with two separate figures divided by space, different poses, and different values in the skin tones. This division was offset by several composi-tional elements to keep the painting unified. Notice the strong diagonal that runs from the upper left to the lower right, through the female's right arm and then the male's arm and lower leg.

The piece is held together also by the repetition of colors; notice especially how the blue recurs throughout the painting. Finally, the repetition of triangles enclosing the figures and the background also creates a sense of continuity.

■ ARTISTS'S ANALYSIS OF COMPOSITION

Structurally the two figures each form a triangle and oppose a pale triangle of floor, which adds to the movement. These shapes are reinforced by small wedgelike triangles within the composition, and the whole piece is anchored by the absolute horizontal and vertical lines through the painting.

STEPHEN SCOTT YOUNG
Capturing Thoughts and Feelings

Finding a new model to paint is a long, involved process for Stephen Scott Young. He looks for a person who has an interesting face or an unusual presence, someone to whom he has a strong emotional response. When someone catches his eye, he will observe that person for days or even weeks. Then, if he is still interested, he will talk with the subject to get a sense of what the person is like. When finally he feels they have a strong rapport, he will ask the person to model for him.

The reason for this labored approach is that Young only likes to paint people he knows well. He wants to be able to paint what is going on behind the subject's appearance. He wants to be able to read the model's expression and capture that in paint. That is what Young's paintings are about—not the unusual-looking people we see, but what those people are thinking and feeling.

He paints old people and young people, black and white, all with the same intensity and respect. When he finds a model he likes, the artist will do many paintings over a period of months or years.

One of Young's favorite subjects is a young boy named Quenton, who came to his house to ask if he could work in the yard. The boy came by several times before Young realized what a strong, interesting appearance he had. Finally, after they had become friends, the artist asked Quenton to model; they are still working together four years later.

The paintings Young produces from this deep interaction with models are watercolors, but not the light, facile paintings we usually associate with the medium. Young's watercolors are rich in value and mood, a result of his glazing technique.

He explains that he started painting with oils at the age of ten. He worked with oils for years before he even tried watercolors. When he finally began to work with the new medium, he simply took his oil painting techniques and applied them to watercolor. The most obvious of these is glazing, the building up of color and value with many layers of thin washes. In some areas of intense color, he may apply as many as thirty layers of paint.

Another element that adds to the intensity of his paintings is his limited palette. Because Young develops colors often by glazing, the individual colors are richer and there is greater overall color harmony.

In Young's paintings there is usually a strong likeness of the model. He says he always tries to obtain a likeness, but more important, he tries to paint a feeling. If the model doesn't evoke a strong emotional response, the painting never succeeds. If the model is vital and interests him on a deep level, the painting almost paints itself.

WORKING METHODS

Young works from life whenever possible. He gets down as much information as he can with the model in front of him and then finishes the painting alone in the studio. The final work is mostly a matter of balancing colors.

He likes to warm up with quick pen-and-ink sketches of the subject. He says ink is the best way to learn to draw because you can't cover up mistakes. He uses a quill pen, which he holds upside down for a thin line and right side up for a thicker line. He draws with a water-soluble ink, which is almost like drawing with paint. By holding the pen in one hand and a wet brush in the other, he can drop water from the brush as he likes and draw through it with ink. This technique gives great line variation and areas of deeper value.

Young paints watercolors on two types of paper: Arches 300 lb. and 555 lb. cold-pressed and Strathmore 500 lb. Bristol three-ply high-surface. He uses only Winsor & Newton professional-grade watercolors, explaining, "Anything less in quality would be cheating yourself. I am a strong believer in good materials." He differs from most watercolorists in his selection of brushes, which are exclusively Grumbacher no. 626-B red sable oil brushes.

Young's technique varies according to the paper he is using. Arches is a highly absorbent paper that allows him to use the oil painting technique of repeated glazes. He begins the painting by drawing the image in pencil. Then he washes down the surface with a brush and water four to six times to remove the sizing and make the paper more receptive.

His method of applying watercolor to Arches paper evolved from his study of the Impressionists, Manet in particular. The theory is that all colors of the palette can be achieved by mixing the primaries. Except when he paints on nonabsorbent Bristol board, Young uses only Winsor red, Winsor yellow, and Winsor blue. Either he mixes the pigments on a white enamel palette or he blends them right on the painting with overlaid washes, getting green, for instance, by painting yellow and then blue over it. On his palette, Young makes mixtures of the primaries in divisions of gray: red-gray, yellow-gray and blue-gray. By using combinations of these mixtures, he can get any color or depth he wishes, even black.

The only other color he uses is white, which he gets by leaving areas of the paper unpainted. He says this requires preplanning; he has to know from the beginning where the whites are going to be. Once an area is painted too dark, he cannot go back and lighten it without damaging the paper.

His technique for painting on Bristol paper differs greatly from the textured Arches paper. On Bristol he can be much looser and work with greater freedom. He doesn't glaze on smooth Bristol paper; instead, he applies the pigments in a very direct manner. Also, he uses a different palette: sepia; Winsor red, yellow, and blue; raw umber; alizarin crimson; burnt sienna; and Chinese white. White paint can be used on Bristol paper, he says, because it doesn't lie flat and muddy as on Arches paper and it also helps the paint to flow smoother.

Occasionally Young paints with oils. When he does, he uses the same techniques and achieves much the same effects as with watercolors.

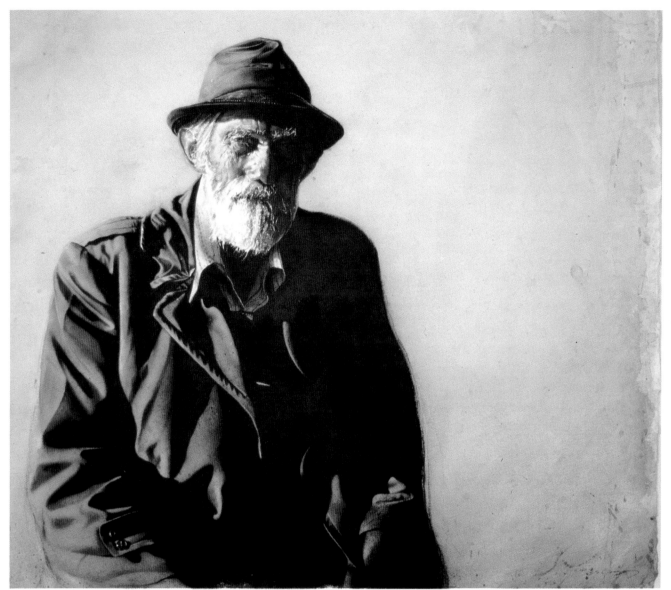

■ PORTRAIT OF CHARLES ELMER NESSER
22″ × 26½″ (56 × 67 cm)
Watercolor on Arches paper
Collection of Bill Sabis

Young says Charles Elmer Nesser is a unique character, a vagrant who drifts from Florida in the winter to North Carolina in the summer. Young noticed him walking in and out of town wearing a trench coat hanging down past his knees. The man walks with big strides as if he has a purpose or a job to get to; he has transparent blue-green eyes that light up when he talks.

The artist explains why he did this painting:

"Charles Elmer Nesser is a vagrant, some would even call him a bum, but those people have never talked to Charley. If they had, they would find an intelligent old gentleman who just decided to leave the mainstream of American life. Charles is free and I wanted to give him some dignity, something he already had, but does not show."

Young glazed in thin layers for the flesh and trench coat. For the hat he used some drybrush paint. The beard is white paper with touches of blue wash. There are some examples of scratching with razor blade in the hat, beard, and eyebrows.

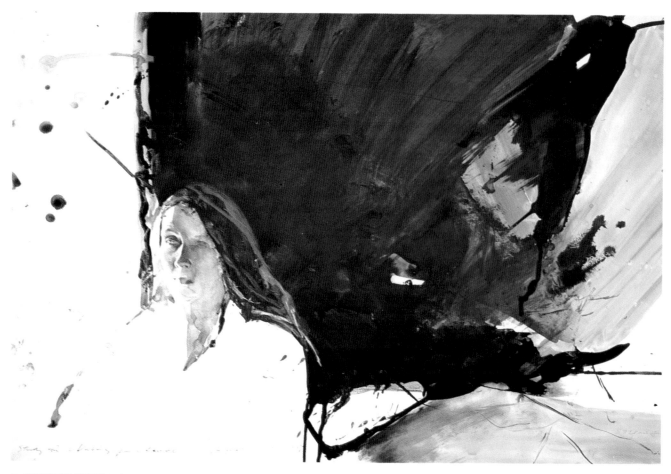

■ STUDY FOR WAITING FOR CLAUDE
22" × 29¾" (56 × 76 cm)
Watercolor on Bristol board
Collection of the artist

This painting is of Leslie, who was pregnant at the time and waiting for her husband, a sea captain, to return from a voyage. This was a preliminary study for a more "finished" water-color of the same pose.

The drawing was done hastily with pencil. In the eyes Young used a glazing technique with very careful applications of thin layers of red, yellow, and blue. He quickly washed on a veil of opaque gouache to soften the remainder of the head; then he worked in a frenzy to create an abstract background, using opaque and transparent colors. He painted the background as "a pure, abstract thought." His colors were Winsor red, yellow, and blue in the face and sepia, alizarin crimson, and Naples yellow in the background.

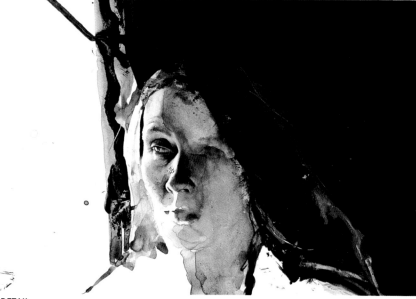

■ DETAIL

In this painting Young wanted to show both sadness and optimism, to convey Leslie's con-cern for her husband at sea and her unborn child. The focus of the painting is the right eye of the subject. Young wanted that eye to tell the whole story. Look at the contrast between the sharp rendering and color of that eye and the loose, opaque suggestion that is the rest of the face.

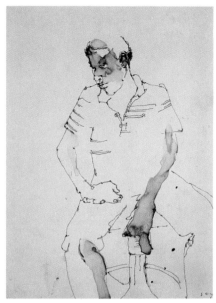

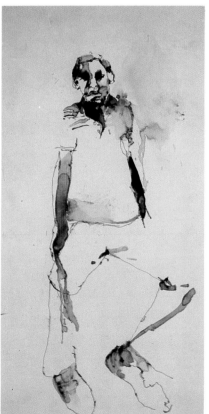

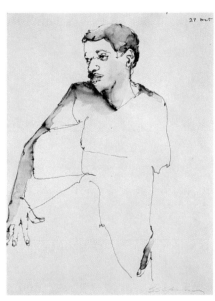

■ FOUR STUDIES OF QUENTON

These quick contour drawings were done with pen and water-soluble ink and accents of watercolor. Young uses these preliminary studies to familiarize himself with the model, to work out a gesture, or to develop a composition.

These small drawings were executed with a fast, fluid line. Young draws with the pen in one hand and a brush in the other. The pen lines primarily record the contours of the subject. Notice how the artist lets the contours of his model move in an unbroken flow around and through the entire subject. He is more concerned here with gesture and mood than with anatomical accuracy.

With the brush he wets areas of the paper where he wants a darker value. Then as he runs the pen through these wet areas, the ink spreads, creating loose areas of gray. The accents of watercolor provide a suggestion of the colors of a finished painting.

The impact of these drawings is exciting and spontaneous. Our eye flows through the sketch, following the loose line and the uncontrolled streaks and blobs of value.

In these particular sketches Young was working with a favorite model, Quenton, trying to develop a sitting pose. Notice how the artist explored different angles and different gestures, also how he used the chair in various ways in the composition.

EXPRESSING A POINT OF VIEW

■ QUENTON AND ANDRE
15" × 30" (38 × 76 cm)
Watercolor on Arches paper
Collection of Mr. and Mrs. William Davidowitz

This was the first time that Young did a portrait with two models in the same painting, the brothers Quenton and Andre. The background was chosen to create a light contrast for the dark subject matter; it is a stone wall that allowed great variety in texture.

The pose was the greatest consideration in this painting. Young wanted to express his feeling about how brothers can relate to each other in adolescence. Although he has them looking in opposite directions, he wanted to show a feeling of unity between them, a sense of bond that can never be broken. Notice how the diagonal shadow ties them together.

He did at least eight compositional studies, some in pen and ink and some with splashes of watercolor. All were very small, but to scale, maybe three or four inches wide. When he was ready to paint, he first washed the surface of his watercolor paper with clear water and then sketched onto the paper with a light pencil. He painted with a glazing technique, beginning with light, transparent washes of mixtures of the primary colors. He built these washes into deep colors through subsequent layering. With enough glazes he can achieve very strong dark values—not a flat black, but a rich, deep black. He says there are probably thirty glazes in some areas of the faces.

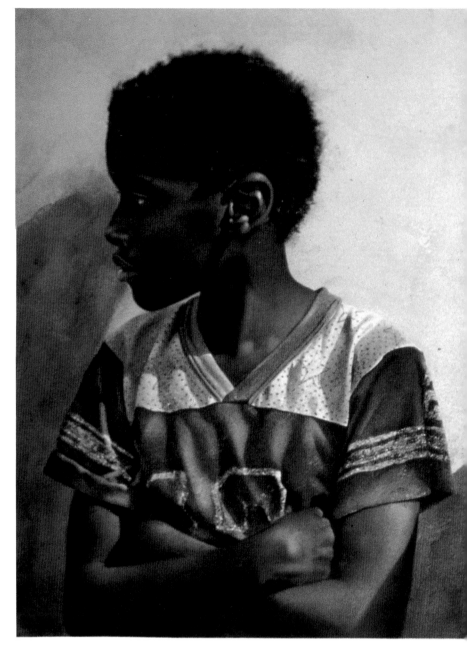

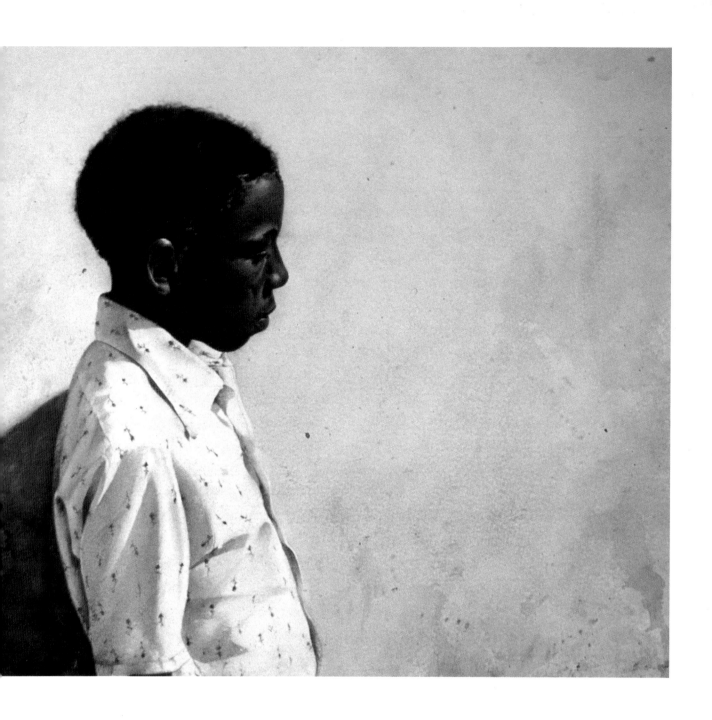

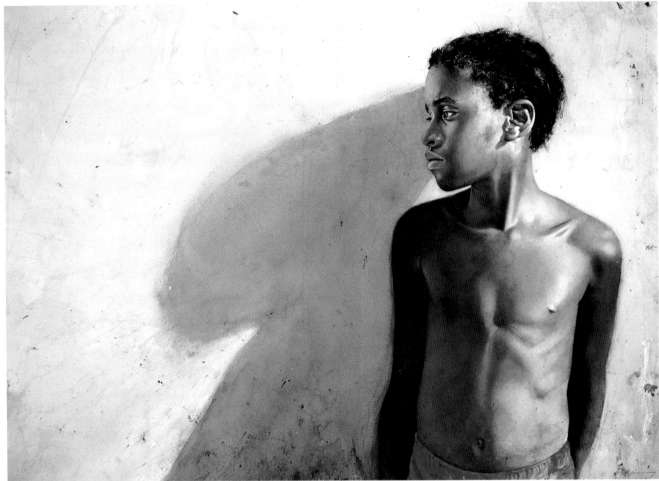

■ INNOCENT
26" × 33¼" (66 × 84 cm)
Watercolor on Arches paper
Private collection

"Innocent *is a painting of underprivileged youth," says Young. "It could represent all races of people. The shadow is the constant shadow that follows these children. The pose and expression were actually meant to look melancholy or sad—something I don't always like to show—but I felt that Andre really did have this* feeling coming from him. It seems that Andre is stuck in poverty and has no way out."

Unlike his watercolor studies, Young's finished watercolor portraits are tightly drawn and painted. Notice the fine attention to anatomical detail; look at the ear, where subtle changes of value create the intricate convolutions of skin and cartilage. Light is vital to this piece, both in establishing the volumes of the body and also in creating the shadow, which is such an important part of the composition.

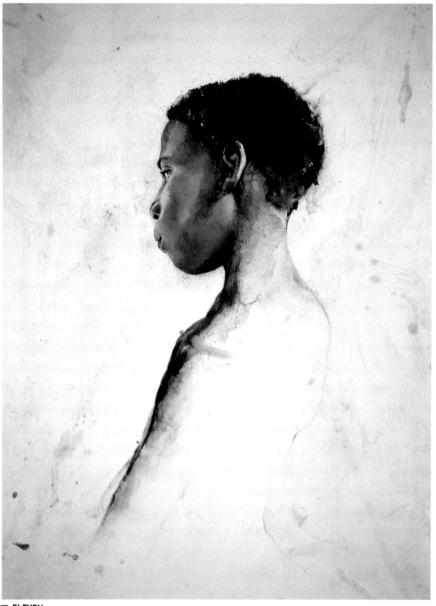

■ ELEVEN
9½″ × 12½″ (24 × 32 cm)
Oil on Masonite panel
Collection of the artist

The artist says Eleven *is simply a study of his favorite portrait model, Quenton, at age eleven. The painting is interesting because, although it has all the loose, spontaneous feeling of Young's watercolor studies, it was actually done in oils.*

The painting is a very direct one, with an underpainting of light washes and an alla prima overpainting. The Masonite surface was primed with about ten very thin coats of pure gesso, sanded with fine paper between coats; the result was an ivory smooth, absorbent surface.

Young used Winsor & Newton Professional oil colors, Grumbacher no. 626-B red sable oil brushes, and turpentine as a medium. The colors were spontaneously chosen from his palette for oil paintings, which includes ultramarine blue, raw umber, flake white, cadmium yellow, aureolin, and Winsor yellow.

This color chart shows Young's color mixtures. Working on heavy Arches watercolor paper, he uses a palette of only three colors—Winsor red, yellow, and blue. By mixing those colors together, he can achieve any other color (except white).

He gets the red-gray by mixing a larger amount of red with smaller, equal amounts of yellow and blue. He gets yellow-gray by mixing larger amounts of yellow and smaller amounts of red and blue. He gets blue-gray by mixing more blue and smaller amounts of red and yellow. The neutral gray is equal parts of red, yellow, and blue.

Try making your own color chart by mixing colors on your palette and painting squares of your own colors. Start with the primaries, red, yellow, and blue. Then mix and paint red and yellow to get orange, red and blue to get purple, and yellow and blue to get green. Then mix the grays that Young shows in his chart.

Young says that he often mixes colors on the paper by painting glazes rather than mixing colors on the palette. To try this, use a heavy, absorbent watercolor paper like Arches 300 or 555 lb. cold-pressed and paint light washes of very diluted paint. Start by painting red into four small squares. Paint yellow into four other squares and then blue. After the squares are dry, paint a red glaze over one square each of red, yellow, and blue. Paint a yellow glaze over one red, yellow, and blue, and a blue glaze over one red, yellow, and blue.

After they have dried, look at the colors you have achieved. Notice how the square with only one glaze of red is less intense than the square that has two glazes of red. Is there any difference between the square where you painted a glaze of red followed by a glaze of yellow and the square where you first painted a glaze of yellow and then a glaze of red.

BIOGRAPHICAL NOTES

Patti Cramer was born in Davenport, Iowa, and lives in Denver, Colorado. She studied art at Stephens College, Syracuse University, and the University of Arizona, where she earned a B.F.A. She also studied in Italy at Bottega D'Arte Graphica and as apprentice to Giuseppi Gatuso in Florence. Her paintings have been exhibited in Colorado, Georgia, and Arizona, as well as Mexico and Italy. She shows regularly with the Sullivan-Bisenius Gallery (Denver). Her editorial illustrations have been published in The Denver Post, The Rocky Mountain News, Phoenix New Times, *and other newspapers and magazines.*

Deborah Curtiss, a resident of Philadelphia, earned her B.F.A. from Yale University and her M.F.A. from Philadelphia College of Art. She has done independent study in Italy, France, Germany, China, Japan, and Israel. She has exhibited widely, and her paintings are in public and private collections in several countries. She is a contributing writer to Art Matters *and* New Art Examiner *and author of* Introduction to Visual Literacy, *being published by Prentice-Hall. She also has extensive experience as a teacher and professional singer.*

Deborah Deichler, born in Bryn Mawr, Pennsylvania, has attended the Pennsylvania Academy of the Fine Arts and the Philadelphia College of Art, from which she received a B.F.A. and teaching certification in art education. She has been given awards by the Philadelphia Academy of the Fine Arts, Abingdon Art Center, and Wayne Art Center. She has exhibited her paintings in numerous shows in Pennsylvania and New York and is represented by the Maxwell Davidson Gallery (New York).

Joseph Jeffers Dodge was born in Michigan but has spent much of his life in New York and Florida. In 1940 he graduated from Harvard with honors in fine arts. He left graduate studies at Wayne University to accept a position as curator of the Hyde Collection (Glen Falls, New York). After more than twenty years there, he was appointed director of another museum, the Cummer Gallery of Art (Jacksonville, Florida), where he worked for ten years. His paintings have been exhibited in museums and in one-man shows at Wildenstein Galleries and the Hirschl and Adler Galleries (New York).

Edwin Friedman, a native of Los Angeles, has lived in Colorado for ten years. From 1968 to 1972 he attended the Art Center College of Design in Los Angeles. For about

seven years after that, he worked exclusively as an art restorer. Since then he has divided his time between art restoration, commissioned portraits, and painting for exhibitions. He is represented by the Sullivan-Bisenius Gallery (Denver).

Stephen Gjertson is a classical realist who studied with Richard Lack at Atelier Lack in Minnesota; this school derives from R.H. Ives Gammell and the Boston School. Gjertson received three successive grants from the Elizabeth T. Greenshields Foundation in Montreal to study and travel in Europe. He currently paints and teaches in his own studio in Minneapolis, where he is finishing a large commissioned triptych for the Nokomis Heights Lutheran Church. His work was included in Realism in Revolution: The Art of the Boston School, *published by Taylor Publishing Company.*

Lucy Glick, a resident of New Jersey, began her art education at the Philadelphia College of Art, where she studied from 1941 to 1943. She continued her studies at the Barnes Foundation and the Pennsylvania Academy of the Fine Arts. Her paintings have been exhibited in dozens of solo and group shows throughout New England. During her extensive career she has received more awards than it is possible to list here. For several years she has been a member of the board of directors or president of the Pennsylvania Academy of the Fine Arts Fellowship.

Pauline Howard, who was born and lives in San Antonio, Texas, received her B.F.A. from the University of Houston. Since 1977 her art has been shown in numerous solo and group exhibits throughout Texas. Her work is included in many corporate collections and has been commissioned for covers of arts magazines, including Performing Arts, Symphony, *and* Houston Symphony. *She is represented in Houston by the Harris Gallery.*

Bill James is a B.F.A. graduate of Syracuse University and now lives and works from his home and studio in Miami, Florida. He is a member of the Pastel Society of America, the American Watercolor Society, the Southern Watercolor Society, and the Society of Illustrators. His works have won numerous awards and are included in corporate collections throughout the country. He also works as a commercial illustrator and has had works accepted extensively in American Illustration, The Illustrators Annual, *and the* Communications Arts Illustrators Annuals.

Carole Katchen, a native and resident of Denver, attended Ripon College and the University of Colorado, from which she earned a B.A. cum laude in psychology. She took additional art classes at numerous schools, including West Valley College (California) and Morley College and Camden Art Center (London). Her paintings and graphics have been included in more than seventy solo and group exhibits throughout the United States and in South America. She shows regularly with Saks Galleries (Denver), Hooks-Epstein Galleries (Houston), and the Gallery of the Southwest (Taos). This is her fifth published book. Her others for Watson-Guptill Publications are Promoting and Selling Your Art and Figure Drawing Workshop.

Milt Kobayashi, a graduate of the University of California at Los Angeles, has lived in New York since 1977. He has received two major awards, the Ranger Purchase Award of the National Academy of Design (1981) and a Silver Medal, Allied Artists (1982). His work has appeared in Forbes, Fortune, and Reader's Digest magazines. He is represented by Grand Central Art Galleries (New York).

Linda Obermoeller, who was born in St. Louis, attended the University of Denver, the University of Missouri at St. Louis, where she earned a B.F.A., and Washington University. Her work has been included in solo and group exhibits throughout the country, and since 1976 she has received nearly twenty significant awards. She lives in Houston and is represented there by the Harris Gallery. She is a member of the National Watercolor Society and Watercolor U.S.A. Honorary Society.

Alex Powers, born in Virginia, was a scientific computer programmer at Cape Kennedy, Florida, until he took his first art instruction at age twenty-seven. He studied in Florida, Massachusetts, New York, and Connecticut and settled in Myrtle Beach, South Carolina, where he paints and teaches. Concentrating on watercolor since 1972, he as had 38 one-man shows, participated in 122 juried competitions, won 43 awards, taught 49 workshops, and been juror for 25 exhibitions.

Constance Flavell Pratt, who lives in Massachusetts, graduated from the Massachusetts College of Art in Boston. Her pastel portraits have won awards from the Pastel Society of America, the Catherine Lorillard Wolfe Art Club, the Academic Artists Association, the American Artist National Competition, the Salmagundi Club, and

others. She is affiliated with the Clarke Gallery (Port Washington, New York), Scarborough Gallery (New York), and South Shore Art Gallery (Cohasset, Massachusetts). She is a member of the Pastel Society of America and the Copley Society of Boston. Besides portraiture, she works as a courtroom artist for a local television station.

Scott Prior, born in Exeter, New Hampshire, received a B.F.A. in printmaking from the University of Massachusetts. His art has been shown in numerous solo and group exhibits in New England, and he is represented by the Maxwell Davidson Gallery (New York). He has received many awards and grants, and his paintings are included in the collections of the Museum of Fine Arts, Boston; the Berkshire Art Museum, Pittsfield, Massachusetts; and the DeCordova Museum, Lincoln, Massachusetts.

Wade Reynolds, who was born in Jasper, New York, made his first career in electronics. Then he became a successful actor and set designer in New York. Finally he became an artist and in 1959 moved to southern California, where he still lives and paints. He has had many one-man exhibitions in galleries and museums, including the San Francisco Palace of the Legion of Honor, the Santa Barbara Museum, and the Haggin Museum (Stockton, California).

Will Wilson studied at the Schuler School of Fine Arts in Baltimore, Maryland. His art has been shown in solo exhibits at Johns Hopkins University, the John Pence Gallery (San Francisco), and the Baltimore Life Gallery, as well as in many group exhibits. He has received awards from the Butler Institute of American Art (Youngstown, Ohio), the Baltimore Life Gallery, and the American Artist National Art Competition.

Stephen Scott Young, a native of Florida, attended Flagler College in St. Augustine, and the Ringling School of Art and Design in Sarasota, from which he graduated with honors in 1981. In 1985 he was awarded first place in watercolor from among 13,000 contestants in the American Artist National Art Competition. In the same year he was given awards by the Georgia Watercolor Society, Southern Watercolor Society, Norton Artists Guild, Lighthouse Gallery All-Florida Exhibition, and Watercolor U.S.A. In 1985 he also had solo exhibits at the Anderson-Marsh Galleries and Gallery 44 in Florida.

INDEX